For H

in search of ...

CAMBRIDGE NEW ART HISTORY AND CRITICISM

General Editor:
Norman Bryson, *University of Rochester*

Advisory Board:
Stephen Bann, *University of Kent*
Joseph Rykwert, *University of Pennsylvania*
Henri Zerner, *Harvard University*

NAKED AUTHORITY

The human body, and in recent times particularly the female
body, is central to western painting. Images such as
Delacroix's *Liberty on the Barricades* and Manet's *Le Déjeuner
sur l'herbe* are so well known that the question of how the
gendered body functions in them is often overlooked. In this
detailed feminist study of the body in general and the nude in
particular, Marcia Pointon explores the narrative structure of a
series of images to demonstrate how power relations may be
articulated by visual representations of the gendered body. In
offering a critique of the relationship of images to the
discipline that promulgates them, this book re-examines
questions of authorship and explores the enabling as well as
the repressive aspects of power in representation.

OTHER BOOKS BY MARCIA POINTON

Milton and English Art
William Dyce
William Mulready
The Bonington Circle
History of Art: A Students' Handbook
Pre-Rahaelites Re-viewed

Naked Authority

The Body in Western Painting 1830–1908

MARIA POINTON

Professor of History of Art
University of Sussex

The right of the
University of Cambridge
to print and sell
all manner of books
was granted by
Henry VIII in 1534.
The University has printed
and published continuously
since 1584.

CAMBRIDGE UNIVERSITY PRESS

Cambridge
New York Port Chester Melbourne Sydney

Published by the Press Syndicate of the University of Cambridge
The Pitt Building, Trumpington Street, Cambridge CB2 1RP
40 West 20th Street, New York, NY 10011, USA
10 Stamford Road, Oakleigh, Melbourne 3166, Australia

© Cambridge University Press 1990

First published 1990

Printed in Great Britain at
the University Press, Cambridge

1004311352

British Library cataloguing in publication data

Pointon, Marcia, *1953–*
 Naked authority: the body in Western painting 1830–1908
 – (Cambridge new art history and criticism)
 1. Western paintings. Special subjects: Nudes
1. Title
757.22

Library of Congress cataloguing in publication data

ISBN 0 521 3852 88 hardback

CONTENTS

ILLUSTRATIONS

ACKNOWLEDGEMENTS

In writing this book I have benefited from conversations and discussion with many people too numerous to list, all of whom I would like to thank. I owe a particular debt to Kathleen Adler, John Barrell, Geoff Bennington, Rachel Bowlby, Evelyn Cohen, Karl Figlio, Kate Flint, John Furse, Tamar Garb, Tag Gronberg, John House, Ludmilla Jordanova, Cora Kaplan, Nigel Llewellyn, David Mellor, Lynda Nead, Sian Reynolds, Adrian Rifkin, Jacqueline Rose, Dorothy Scruton, Lindsay Smith and Lisa Tickner.

Norman Bryson has been both an encouraging and a critical editor and I owe much to his perceptive comments and suggestions. John Trevith of Cambridge University Press has enabled me to benefit from his scrupulous editorial skills, and I owe much to his close and sceptical reading. Trudi Tate has made copy-editing both interesting and creative.

INTRODUCTION

The essays collected in this book address questions of what I will call intersubjectivity. The subjectivities of artists, of makers of images, are interpolated in readings – whether consciously or unconsciously – by readers whose other, different, but in some ways complementary, subjectivities are brought into play by this process. That this activity takes place historically, across time, does not make it less important. History and reason do not have to be placed in opposition to desire and affectivity. Put simply I might say that I am interested in how makers and consumers of art invest images with communicative identities and relevances that are particular as well as communal. What happens when an individual engages with and is moved by imagery produced by another individual? By discussing subjectivities – of readers as well as of makers of visual texts – and by reading texts in the light of those subjectivities, I am suggesting that the domain of needs and desires, the psychic interrelations between and imagined and perceived historical presences of artists and the desires of consumers of works of art, cannot be adequately accounted for by the authority of a discourse that is restricted to a hypothetically homogeneous realm of production and public reception.

All the chapters originate in work done over the past five years; all derive from seminar papers or lectures and the discussion with students and colleagues ensuing from those occasions. Two have previously been published. The paintings I discuss in this book are nearly all highly visible and very popular images. Most of them would be acknowledged readily to be 'important' by any national museum or gallery director. Therefore one of the senses in which I intend the term 'authority' as it appears in the title is in respect of the intellectual institution of the discipline and the power exercised in cultural and political terms by its canonical works. The ways in which

such power is exercised can only be understood, I contend, by a critique of the affective working of those images.

In an acute analysis of the opposition between reason and affectivity, Iris Marion Young recently pointed out that feminist analyses of the dichotomy of public and private in modern political theory imply that the ideal of the civic public as impartial and universal is itself suspect. 'While the realm of personal life and sentiment has been thoroughly devalued because it has been excluded from rationality, it has nevertheless been the focus of increasingly expanded commitment. Modernity developed a concept of "inner nature" that needs nurturance, and within which is to be found the authenticity and individuality of the self, rather than the conformity, regularity and universality of the public.'[1] To write of canonical works, of 'high art', as well as a notion of privacy, is to run counter to much that has been hard won in art history's struggle for recognition as a serious historical discipline. My contention, however, is that we are in danger of positing 'high art' or institutionalised art forms as fixed terms against which popular art forms can be measured but which are themselves not considered suitable for interrogation as private experiences as well as public utterances. I want to suggest that an examination of the ways in which imagery moves us, whether to anger or pleasure, needs to be reintroduced into a theorised art-historical practice.

In a recent essay I asked what we might do about quality and connected this issue to the question of why some art-works appear to attract more serious scholarly and historical enquiry than others.[2] These questions are different but seem to be related. I asked why G. F. Watts might seem to be less interesting to a late twentieth-century audience than, say, Rossetti. The implication is, of course, that in paying attention to Rossetti and not to Watts we are somehow (albeit tacitly) acknowledging that Rossetti is better than Watts. Would this mean that the issue of quality was inescapably there, as an assumption precisely where it is refused as an explicit question? When we say that such-and-such an artist on whom we happen to be working is 'interesting' is this simply a permissible way of saying that the works we are examining are better than some other works?

Anita Brookner has contended that 'new art history' is at its most exciting when dealing with second-, third- or fourth-rate paintings.[3] The implication here is that new art history deals in bad art and old art history deals in good art. Or perhaps the view would be that new art history is at its most exciting when

it is not dealing with paintings or with imagery at all but with signs, words, modes of production, discursive fields, sites of meaning, ideologies and so forth. On the other hand, and this is what I am cautiously addressing, we presumably have the continuing appeal of certain works (those never out of the canon, those never relegated to the store). This continuing appeal may have little to do with their innate characteristics which, after all, depend for their realisation on readings as culturally determined acts. But I find it hard to avoid the recognition that some objects of material culture appear to have an abiding power to move people.

A word about the term 'new art history' is perhaps in order. It is popularly perceived to have been invented as an ironic term by the editors of the journal *Block*. But why, I wonder, should art historians squirm at having this term applied to their work? I suggest that there may be three reasons. In the first place, being labelled 'new' inevitably relegates one sooner or later to being 'old' which no one wants to be. So it's better to be nowhere. Secondly, people don't want to be described as art historians at all, for the good reason that art history suggests too narrowly defined a field for the range of their work, as well as for the bad reason that it seemed smarter to connect yourself with film or cultural studies. Thirdly, I think that the term 'new art history' suggests there might be a choice and a demand that we make it, a choice which is, by the same gesture, effectively taken away. In this the Left was pushed into a corner and endowed with a tyrannical singularity of method and a disposition to the surveillance of intellectual activity. For I don't take the *Block* advertisement (no. 9, 1983) advising readers to adopt a correct position by subscribing to the magazine to be wholly or even partially ironic or humorous in intention.

Notwithstanding the problems of terminology, Brookner's assertion that new art history is at its most exciting when dealing with inferior works of art makes me feel very uncomfortable. In the first place there is the fact that there is remarkably little 'new' art history being conducted in relation to the cultural products of fifteenth-, sixteenth- or seventeenth-century Europe. For example, however admirable Baxandall's work, on the fifteenth century, it was short-sighted over questions of gender, using criteria founded on masculine life and work to evaluate the historical significance of works of Renaissance art in general.[4] Moreover, the question of why the female nude evolves as a paradigmatic type remains unanswered if not unasked. It is not the object of this book to answer

that question, though it may shed some light on the matter. The mainstream concerns of art historians with what one might generally term aspects of civic humanism have tended to exclude the body, affectivity and desire from serious intellectual and moral debate. In a year when the Conservative Government in Britain has established a Citizenship Commission and is debating the possible inclusion of 'active citizenship' as part of the school curriculum, the very notion of individuality might be regarded as emancipatory. Secondly, and following on from that, I am uncomfortable that so much of the so-called controversial art history has happened not even around European art but quite narrowly around art in Paris and London from c. 1750 to c. 1860. Thirdly, I wonder whether Berger's *Ways of Seeing*, which attempted chronological range and which addressed the Renaissance nude, for example, has served at one and the same time as a tokenist foray by a progressive and inconclastic figure into sacrosanct territory *AND* as an embarrassing warning about the limitations of the left in dealing with images and pleasure. I am constantly surprised by how uncritically we have tended to accept an author who proposes that 'Women watch themselves being looked at' and that 'the surveyor of woman in herself is male', phrases that have become a litany for generations of students.[5] Indeed, Berger has sometimes been protected by writers who, in quoting *Ways of Seeing*, have suppressed the more embarrassing of Berger's utterances.

I have hinted at authoritarianism in my observations and I here want to turn more specifically to the question posed in my title. Much that I find troubling about feminist work with visual imagery relates to my sense of an authoritarianism that, in seeking to identify and define oppression, denies to the image any kind of authority. Art historians, it seems possible, identified the death of the author (whether according to Barthes or, on a more complex level of engagement, according to Foucault) too simply as a matter of the disposal of the notion of individual creativity. In a discipline shaped by great (male) masters we greeted those essays like besieged troops welcoming the relief battalion.[6] In literature, too, even leaving aside the issue of the woman author, who never having been alive could hardly be found to be dead, there is doubt about the wisdom of wholesale acceptance of the author's death. Peggy Kamuf wrote recently:

The institution of authorship has shown a remarkable capacity to return after being pronounced dead, and its resuscitated form may bear a remarkable resemblance to the ideological construct whose epitaphs

4

Barthes wrote too soon. The lesson should be that the authorial institution and the critical attitudes it fosters are not to be simply opposed or thrown over.[7]

I think it is worth reminding ourselves of the semantic origins of works like author, authority and authoritarianism. Author comes from *augere* meaning to make grow or propagate. This sounds very positive and laudable. It brings to mind those very qualities of nurturance that would connect with the world of inner nature which, as Young points out, the civil public excludes in order to protect its 'natural' character.[8] But authoritarian, meaning favourable to the principle of authority as opposed to that of individual freedom, sounds very negative to us. Interestingly, Raymond Williams, who has a long section in *Keywords* (1976) on 'Artist', has no section on 'Author'. Yet the slippage between author as a generator of ideas, authority as possessing power through knowledge, and authoritarian as the exercise of that power in a particular way is striking and unparallelled in the word 'Artist'. It points up our ambivalence towards propagators of forms of knowledge, whether they be individuals or texts. I wonder whether the notion of the author's death did not open up a space for a new kind of authoritarianism among art historians. Could it be that gender became a stick with which to beat art and artists? Could it be that within a fixed set of adversarial relationships (masculinity/femininity; high art/popular art; public/private etc.) representation was terroristically construed as repressive rather than seen to be a space where desire and pleasure might be produced within a divided subject and between multiple subjects in ways other than through a unified public discourse but ways nonetheless political?

The question of institutional authority with which I commenced is a much wider one than merely now art history is carried on or even how the heritage industry functions, though we have learned from writers like Edward Said and Jean Baudrillard to be vigilant in our relationships as scholars with institutions, be they academic, commercial or civil.[9] British Rail's annexation of Titan's *Venus with a Mirror* for the purposes of advertising its services and the deployment of Delacroix's *Liberty on the Barricades* to sell a whole range of products, of which the most recent may be the so-called new technology, is effective in the marketplace because paintings such as these are signs of high-status commodity.[10] But this is not the only reason that they work well; it is because they enable, indeed demand, a dialectical reading that brings into play readers' conscious and unconscious affiliations to the visual

historical that they are successful in the role thus assigned to them. It is perhaps particularly because they demand the impossible task of resolving ambiguities posed around questions of gender and power, questions that are grounded in the aporia of authority, that images such as these are marshalled in the global marketplace. Of course, this also raises important questions about reception, about the transmission and transmutation of motifs from the cultural arena of 'high' imagery into and across 'popular' art forms. It raises questions of the construction of fictions of the past in relation to an equally mythic present and invites identification and scrutiny of discourses of cultural production. My interest here, however, is not first and foremost with these questions; what concerns me is the question of what it is about such images that singles out some and not others, as it seems, for circulation. My argument is predicated upon a notion of quality which is not that of the traditional museological sense but has to do with what I am calling communication as intersubjectivity. I want to investigate whether going back to the image and interrogating the ways it appears to make an impact in the present (and this may instruct us also about the past) can enable us to understand why and how those images produce contested and (often violently) disputed meanings. I don't wish to trace in any instance a history of reception. I seek to identify properties in texts and to examine how texts instil, reinforce or unsettle readers' subjectivities. And if this means finding theoretical tools that enable us to identify the inscription of an authorial subject (or its evacuation from texts), then this is a worthwhile task.

Foucault remarked that 'Power would be a fragile thing if its only function were to repress, if it worked only through the mode of censorship, exclusion, blockage and repression, in the manner of a superego, exercising itself in a negative way.'[11] In so far as this book focuses upon questions concerning the way the body, and particularly the female body, works in the discursive formations of nineteenth-century Western painting, it is concerned with repression in the particular sense of the construction and organisation of the female body in patriarchy. And here there are, of course, historical issues relating to the fact that nineteenth-century painting, not exclusively but nonetheless very markedly, works within 'Realist' imperatives. It is also, however, concerned with enabling aspects of power in so far as it examines affectivity and pleasure in the production of meanings around visual communication.

In offering a critique of the relationship of images to the discipline that promulgates them we would seek to re-examine

the question of authorship and to ask what happened to the text with the 'death of the author'. The author whom we thought, following Barthes, was 'dead' turns out to have an uncanny way of reappearing in readings of the text and we have to decide what to do with 'him'. Derrida's 'post-Freudian' reading of Freud, published first in 'Freud and the Scene of Writing' and then in *The Post Card*, offers a model not only for looking at how language consistently appears to be searching for ways of saying what is felt but also for understanding how authorship and intention might be reintroduced into textual analysis.[12] In so far as there are similarities in the ways in which langauge and painting are understood to communicate, it can be said to be doing the same thing. Moreover, paintings which seemed somehow to have been taken care of intellectually, or which because they were politically repugnant (due to content or due to their ascription to high art traditions) had been academically censored, have a strange habit of reappearing as questions, perhaps even appalling us with their power, their longevity and their resistance to appropriation of explanation.

The patriarchal authority that is the condition of production for these canonical works should not – indeed cannot – be dismissed but nor, on the other hand, should the recognition of the authority (in its institutional or in its authorial manifestation – academies or great masters) be permitted to determine the parameters of an analysis. Rather than asking how woman is viewed/imaged by the male gaze we might, therefore, ask whether more complex things are going on and what happens when femininity is invoked or obscured in an image. To appear not to possess authority may, after all, be one of the most effective ways of exercising authority. A feminist critique of cultural production consequently needs to address the affective as well as the elements of composition or design in our own language and in a painting's.

It is important to examine the relationship or our own subjectivities to subjectivities of the past, whether those of artists, reviewers or art-historians. A lack of awareness of how art historians relate as sons to their fathers in art history is, to me, very striking in much of what I read from scholars of many persuasions. Subjectivity is already in play in academic writing but it will assist us as historians, as students of ideologies and their past and present formations, if we declare this to be so and make use of it.

The representation of the body, a privileged province of academic theory and practice and consequently also of traditional art history, has recently reappeared in another guise as a

progressive discourse of representation. On the planar surface of postmodernism the image of the body is perpetually intrusive, refusing to be accommodated into theories of representation, disrupting our linguistic and diagnostic frameworks, power-fully raising the intersubjective question of communiction, of what we feel in relation to discursive fields where we believed we had meaning(lessness) well in hand. I would cite here, as one example, the strange experience of reading Victor Burgin's 'Diderot, Barthes, Vertigo' part II, in which he tracks back and forth across the female body constructing a schema through which to link Freud, Lacan, Klein, Barthes and others in a theoretical concatenation that is intended to articulate desire. Through the dutiful explanations of fantasmatically displaced bodies, the maternal body that is the unexamined rationale for this piece of elucidation silently maintains its call for attention.[13] And here we may observe both the process whereby the author claims affiliation to fathers in learning *and* the process whereby the female body is appropriated and yet disregarded.

For woman as reader the 'death' of the (male) author was not followed by his 'burial'. The problem of a conceputal and analytic space for the woman writer/artist was only just begin-ning to be addressed when authorship was pronounced dead. Readership posed and still poses its own set of difficulties in feminist practice. Reading as a woman must mean a self-reflex-ive practice which does not construct a simple alternative hermeneutic. Reading as a woman inevitably raises questions of subjectivity, of who is looking and how. And, by extension, it should repudiate any notion of a unitary reader/viewer, male or female. Art history, in its anxieties of the 1980s and in its justly urgent search for theoretical ground and a set of objectives in common with other disciplines – a ground which would outlaw a discipline defined by connoisseurship – looked to Althusserian Marxism and to structuralism for its paradigms. In this process the text as frequently seen to signify in relation to ideologies produced elsewhere. Paintings became sites for the production or reinforcement of meanings in a regime whose hierarchies, divisions and categories were primarily defined in advance. Paintings were compendia of motifs or structures which could readily be extrapolated and identified with agri-cultural depression, patriarchal oppression, cultural imperialism or other all-embracing and all too often unquestioned con-structs. Or they were de-historicised puzzles of denotative and connotative signs waiting for the skilled deconstructionist to open them up. Did the text then die with the author?

The political implications of this history are serious since at a

time when in Britain, at least, and almost certainly also in Europe and America, more people than ever are interested in art but art history fails to offer what they want. Intellectual activity must always be to some degree independent of others' expectations or demands. But intellectual activity that forecloses on historical and textual evidence or ignores the engagement with imagery experienced by a public (in the interests of a particular, already known, line of argument) is not intellectual activity at all.

To return finally to the question of readership, I think gender might be viewed not as a fixed state but as a range of viewing possibilities or as a set of relationships. There is no absolute and inalienable correlation between the gender of a reader and the experience of reading. Gender is, in this instance, a set of possibilities. The uncertainty of the gender of the patient in *The Gross Clinic* by Thomas Eakins might provide a paradigm. A part of the human body dramatically lit at the centre of a painting is of indeterminate gender; acts of interpretation provide an imaginative completion and thus a gendering of this body. Around this axis turns the question of the painting's meanings and thus of its politics.

Michael Fried identifies this fragment of the body as belonging to an adult male patient whose mother, 'an older woman', is witness to the operation and the only female presence in the painting. If I were to construct a masculine position as viewer, I might recognise that my wish to find a mother in the painting had made me read the woman (whose face is hidden behind her hands) as an older woman, a woman able to be my mother. And it would follow from this that the patient would have to be adult though he still needn't be male. But if, as a notional male reader, I wanted the vicarious satisfaction of seeing the law of the father enacted in respect of the successor to that law, the son, then the recipient of the doctor/teacher's skill (a form of preventive surgery that will restore full movement to the leg) must be male. And this is not to suggest that a woman reader might not also wish to see that law enacted. Linda Nochlin fantasised substituting Rosa Bonheur for Courbet in *The Painter's Studio*.[14] What I'm proposing here, however, is that the ambiguity of the patient's gender *enforces* a gendering in the process of reading. In order to produce his account (discussed in chapter 2), Fried ignored the historical evidence available when the painting was first exhibited, in Eakins's lifetime – namely, that the patient was a child. The gender of the child was not stated. I don't want to suggest that Fried is therefore wrong; in fact by one set of criteria he is obviously

right. What seems lacking in his account is any acknowledgement of how he reached that, for him, right account or any awareness that there was a questionable process at all. If we construe the patient as female, the link between the female witness and the prone and fragmented body is stronger and the woman's pain more poignant. Moreover, the opposition between the amassed and phallic body of medical authority (masculine) and the fractured female body (both of the mother and the patient) becomes almost unbearable to observe. If the patient is a child then the mother may be construed as daughter to the father in medicine; if the patient is an adult then it is perhaps not a mother but a sister ... and so on. What this discussion demonstrates is that the ungendered lack which is the *matrix* of the image – and I use the word matrix deliberately – requires the subjectivity of the viewer not only to be brought into play but to be inscribed in any account that might be offered. Nor is it only in cases where the gender of the imaged subject is uncertain that the issue of the reader's sexual identity is brought into play. The process of looking at the female nude – the 'straightest' of images of the female body, equivalent perhaps to the beautiful female heroine in film – is demonstrated in the examples of Renoir and Manet in chapters 4 and 6 to be unsettling both to the man and to the woman as viewer. It is the aim of this book to open up and examine the productive process of this unsettling.

READING THE BODY: HISTORIOGRAPHY AND THE CASE OF THE FEMALE NUDE

I

In the succeeding chapters of this book I shall be undertaking a series of close analyses of particular images and groups of images of the body. In this first chapter I shall map historiographic and theoretical issues within which the nude in Western art poses itself as problematic. That the subject is 'extremely difficult to handle' was acknowledged by Kenneth Clark in 1956;[1] apart from Clark's *The Nude* and *Ways of Seeing*, published by John Berger and others in 1972,[2] to which I shall return later, the nude has received scant attention from art historians. Most significant have been studies by feminist writers of particular artists or individual works.[3] This paucity is surprising in view of the prominence of discourses of nudity from the continuing pornography debate to the Gian Bologna symposium held in Bologna in August 1989. But perhaps on reflection it is not so surprising. The nude has been (inappropriately) associated almost exclusively with high art forms and art historians seeking to challenge the direction and boundaries of the discipline have with good reason looked to objects of study outside the canonical register. Moreover, the notion of an oppressive 'male gaze' with the female nude as the privileged object of a particular form of capitalist connoisseurial voyeurism has enjoyed widespread currency and a revolution against opening up questions around the nude has prevailed.[4] These are perhaps plausible reasons for avoiding the nude as a subject. A further reason might be the difficulty of guarding against generalisations about matters that are historically specific. Yet these risks seem worth taking if we are to confront, and question, some of the premises of a history which – however limited in terms of its texts – has been enormously influential in terms of its popular readership. It is for this reason that my point of reference in this map are those texts which (though

written by established scholars) are intended 'for the layman of no specialised knowledge', texts which promise to be 'endlessly informative and entertaining'.[5]

The 'difficulty' identified by Clark in relation to the 'handling' of the nude may be seen to derive, at least in part, from the fact that the nude is not in principle an artistic category or a genre, something remarked by Max Friedlander in 1942.[6] Its pre-eminence in academic theory and in studio practice since the Renaissance (first exclusively as the male nude and then later, from the eighteenth century, as the female) is striking and indisputable in histories of Western painting and related theory. Yet in terms of the organisation of knowledge it has no place of its own either in the genre system or in the systems of museum classification of German origin. There is no national museum, to the best of my knowledge, with a nude room even though Rodin's *The Kiss* remains the focus of attention for visitors to the recently re-hung Tate Gallery. In the age of postmodernism, Rodin's *The Kiss* occupies the space at the Gallery's heart. The nude is everywhere, yet has no place; it is 'difficult to handle', yet wholly familiar; it is the least known and the most popular of art forms. Above all it is understood to be *Art*.

The notion that the nude encapsulates art is manifest in three ways. In the first place, since the Renaissance, the measure of professional attainment in artistic practice has been (to use the kind of vocabulary Clark uses) the master of the plastic essentials of the body.[7] Sequences of binaries, whether grounded in theology (the body given by God; the clothing made by man), in sociology (nakedness as nature; clothing as culture), or in philosophy (nude as ideal; clothing as real) are ways in which scholars – and I include myself – have attempted to get a lever on this present and yet never-to-be-grasped topic. William Aglionby's definition of the nude (quoted on p. ooo), provided for the benefit of artists and educated gentlemen, indicates the role of the unclothed female body in art. Clark's brilliant adoption of the binary construction of naked/nude allowed free rein to his personal and learned journey through Western art. But the application of this distinction (taken over by Berger with rather different results) evades the signifying relationship between the body and its apparel as well as collapsing into the homogeneous category of the nude forms of material culture which – even excluding all but the high art forms with which Clark and this present study deal – offer immensely varied evidence as textual fields and as historical objects. Indeed, Clark maintains a grip on his concept of

nudity, the basis of which is the 'search for finality of form'[8] only by caricaturing a real body to which the nude is other. And one of the notable sub-texts of Clark's book is the author's evident distaste for the human (and particularly the female) biological body which is described variously without specific reference as 'huddled together and defenceless', 'shapeless' and 'pitiful'.[9]

These kinds of binaries, of which Clark's has become the most celebrated, have permitted the nude to become assigned to a timeless space.[10] The idea of the correct or incorrect borrowing of a set of motifs by which a tradition is continued lies at the heart of art-historical discourse and, despite recent challenges, remains a powerful orthodoxy.[11] So the second way in which the nude has attained the status of *Art* in the abstract is through its very centrality to that tradition. This centrality has permitted its elision into a history of style on the one hand and iconography on the other. In Honour's and Fleming's *A World History of Art*, for example, roughly four pages are devoted to

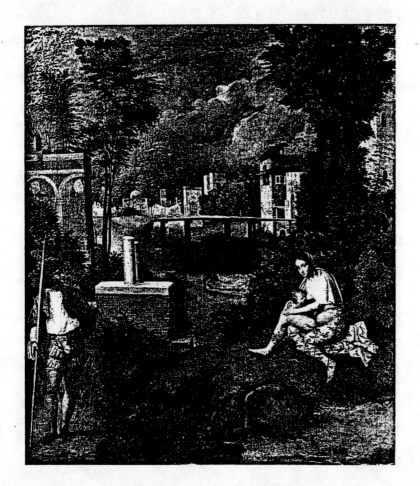

1. Giorgione, *La Tempesta*

discussing and illustrating sixteenth-century art that is usually termed Mannerist. Although mention is made of a 'sophisticated eroticism' and of the investment of 'sexuality with a stylish perversity' in the work of Bartholomaus Spränger for the Emperor Rudolf II, this otherwise useful account is fundamentally a story of the transmission of style, of *contraposto* from Italy to France and then to England.[12] E. H. Gombrich in his justly celebrated and many times reprinted *The Story of Art* displaces problems of meaning in Giorgione's *Tempesta* (Venice, Accademia; see plate 1) by saying that perhaps the female figure is a mother of some future hero from a story as yet unidentified but that 'it is not due to its content that the picture is one of the most wonderful things in art'. The 'weird light of a thunderstorm' and the landscape are the 'real subject of the painting'.[13] Our attention is thus deflected from the unusual configuration of an immensely fashionably dressed urban male figure and a nursing nude female. For she is surely as much a nude as, say, Correggio's *Danäe* (Rome, Borghese Gallery) though her metre of drapery is disposed over the upper rather than the lower part of her anatomy.

What I am raising here is, of course, the question of what constitutes a nude. Can, for example, an unclothed or semi-clothed nursing female figure be understood to be a nude in the same sense as, say, Botticelli's *Venus* (*The Birth of Venus*, Florence, Uffizi)? One of the things that will be explored through the chapters of this book is how the nude functions not as a category with clear parameters but as a form of rhetoric. It is the way the body functions in the grammar of representation, invoking ideologies of the body and its economy, that is significant rather than its erotic power as estimated by any particular viewer, or its pose, or the extent of its covering.

The third way in which the nude has come to be associated with the notion of Art is a consequence of what certainly began as a challenge to orthodox art-historical accounts but which has often served to reinforce those histories. One of the inroads into the seemingly intractable matter of the nude made by recent feminist work has been to identify the figure of women, and particularly the nude, as a sign for male creativity.[14] Woman can thus be understood in representation to signify not only the objectified female body that constitutes Art but also the very creativity through which it comes about and which is male. The popularity of the Pygmalion story with nineteenth-century artists in a period when discourses of creativity were especially powerful has not gone unnoticed. But it is worth emphasising that the shaping of woman as the primary act of

male artistic creativity was by no means confined to the tradition of western oil painting. The difficult task facing Giuliano de' Medici in the third book of *The Courtier* is that of shaping his ideal woman courtier whom, like Pygmalion, he will take as his own.[15] The very title of Henry James' *Portrait of a Lady* links into a powerful network of cultural associations in which woman is the raw material for the making of literary magic. One consequence of this trope of exclusion is the problem of the means by which a woman practising her art might be represented. It is a parallel and equivalent problem to that of woman in relation to authorship that has been extensively examined in critical theory in Europe and the USA.[16]

In this book I seek to demonstrate that the body – and particularly the female body, clothed and unclothed – works like a series of terms constantly shifting and yet structually related, rather than as a category that is fixed either historically or conceptually. Paintings like Artemesia Gentileschi's *Self Portrait as La Pittura* (Royal Collection) or Manet's portrait of the artist Eva Gonzales (Dublin, Hugh Lane Museum and Gallery) have received attention and are worthy of closer scrutiny as moments of confrontation with the trope of exclusion cited above. In the last part of this chapter I will return to this question but I shall look beyond the notion of the female model as sign for male creativity to see how the idea of the nude, even when no nude figure is represented, works in the context of creative practice, and what this might mean if the artist is female.

Before proceeding further, something must be said about the text which, more than any other, has informed a whole generation (at least in Britain) not only one the nude but on art in general. *Ways of Seeing* was written by five authors in the wake of a television series in 1972 but it is signed by (and generally ascribed to) John Berger. The most influential part of chapter 3, devoted to the nude in Western art, is that which distinguishes between spectator-owners of paintings (usually men) and persons treated as objects (usually women).[17] Berger adopts Clark's naked/nude distinction but grounds it in an unrelenting moralism disguised only by the epigrammatic form of writing, a form which also permits Berger to juxtapose units (Ingres's painting and a photograph from a 'girlie' magazine) without exploring their similarities or differences:

to be naked is to be oneself.

To be nude is to be seen naked by others and yet not recognised for oneself. A naked body has to be seen as an object in order to become a

nude. (The sight of it as an object stimulates the use of it as an object.) Nakedness reveals itself. Nudity is to be placed on display.

To be naked is to be without disguise.

To be on display is to have the surface of one's own skin, the hairs of one's own body, turned into a disguise which, in that situation, can never be discarded. The nude is condemned to never being naked. Nudity is a form of dress.[18]

The central tenet of Berger's chapter, that the spectator (who is male) sets in train the textual filiation in which woman is not only passive object and possession but colludes in that role, is summed up in the chapter's final paragraph: 'But the essential way of seeing women, the essential use to which their images are put, has not changed. Women are depicted in quite different ways from men – not because the feminine is different from the masculine – but because the "ideal" spectator is always assumed to be male and the image of the woman is designed to flatter him.'[19]

It is a measure of the hunger for a challenge to the timeless nude of Friedlander and perhaps, also, a measure of the failure of art history to address issues pertinent to the intersection of the intellectual life with lived everyday experience, that Berger's censorious *ex cathedra* utterances on the nude were so enthusiastically embraced by the Left in Britain and that they continue to have a considerable following. Berger's essay merely inverts Clark's construction of 'bad' naked and 'good' nude by inviting us to contemplate an alternative formulation in which the nude is a regime which can 'never reveal itself' whereas by implication the naked is a desired and attainable state which nudity has lost as a consequence of its of permanent disguise. This dubious proposition and the series of premises with which the chapter opens and which propose woman's social presence as defining 'what can and cannot be done to her' have aroused surprisingly little criticism even though it is upon this sequence of grotesque generalisations that the subsequent discussion of 'the category' of the nude in European oil painting is predicated.

Perhaps the greatest testimony to the power of Berger's simple equation is that generations of readers have been prepared to overlook (or ignore) his new and privileged register of 'the great sexual image of the naked', paintings of 'loved women more or less naked'.[20] Berger tells us that, in the case of Rembrandt's *Danäe* and Rubens's *Het Pelsken* (Leningrad, Hermitage; Vienna, Kunsthistorisches Museum) 'the painter's vision binds the woman to him so that they become as inseparable as couples in stone'. The poetic simile prefaces an

interpretative strategy in which the critic, Berger, mediates for us the reader, the artist's expressed feelings towards the model, his wife. We are thus presented with a body which is not culturally encoded or subject to the conventions of representation, but is 'real'. Turning Clark's proposals on their head we end up with something equally untenable. The nude is here no longer an idealisation separate from the body which it has moved beyond and discarded; here the nude is a veil, a curtain of imagery which once recognised as such can reveal a true woman, Saskia or Hélène Fourment, translated from life into art by Love.

II

In the Princes Gate Collection in London hangs a horizontal canvas upon which is depicted the figure of a semi-naked female figure reclining in a meadow (plate 2). The figure has been identified as Venus on account of its similarity with another painting by the same artist containing the figure of Cupid though mythological references are here entirely lacking. The figure occupies a substantial proportion of the field of vision and her flesh is painted with a degree of finish that is absent from most of the background and particularly from the landscape at the right. There is evidence that the woman's head was originally painted full-face and glancing downwards instead of, as now, turned slightly to her left and gazing straight ahead. There are several similar paintings in existence by Palma Vecchio who signed this work on the lower right in a carellino on the stump of a felled tree.[21] There are ingredients about this painting – the position of the woman's hands with slightly splayed fingers, the complicated arrangement of half-plaited and half-flowing hair, the relationship between a relatively high degree of finish in the body and a comparatively unfinished treatment of the landscape, the uncertainty about the subject's identity, the evidence of indecisiveness around the question of her gaze – that might appear to invite the kinds of questions we have been wont to ask of Manet's paintings of the 1860s and particularly of Le Déjeuner sur l'Herbe and Olympia, questions which I shall be approaching in chapter 6. There may be material reasons for the varying degrees of finish in this painting, for Palma Vecchio is known to have earned a living supplying middle-class Venetian patrons with paintings like this in very considerable numbers, of which few now survive. It constitutes not only in its origin but through its more recent history (it was acquired in the mid-

1930s by the Austro-British Count Antoine Seilern) a paradigm of Berger's spectator-owner's object of pleasure. Whatever the reasons for the discrepancies in facture, those discrepancies as well as questions of tonality and colouring (aspects that Berger deliberately rules out of consideration with respect to the paintings he discusses) do not dispose me to read this painting as an unambiguous image of woman as passive object of possession. If we suppose it as something equivalent in terms of its production and marketability to an original photograph by David Bailey purchased by, say, a young stockbroker we would still have to acknowledge that such an image would inscribe encoded forms of probably conflicting and certainly complex ideologies. It is, for example, noticeable that the torso and particularly the breasts offer a somewhat evasive and uncertain image in comparison with the crisp clarity of the drapery and the precision of the flowers. There are, on inspection, ambiguities about Palma Vecchio's painting. While the sophistication of argument about the nature of woman displayed in Castiglione's court of Urbino may have been unavailable to the kinds of men who patronised Palma Vecchio in the early 1520s, it would surely be foolish to assume that the question of woman's actual as well as her moral power was not one of more general interest in this period. The debate at Castiglione's court (and it is by no means clear who wins that debate) should alert us to woman as a possible site of moral, intellectual and philosophical enquiry.

In an essay first published in 1974, Sherry Ortner asked the question: 'could women's pan-cultural second-class status be

2. Palma Vecchio, *Venus*

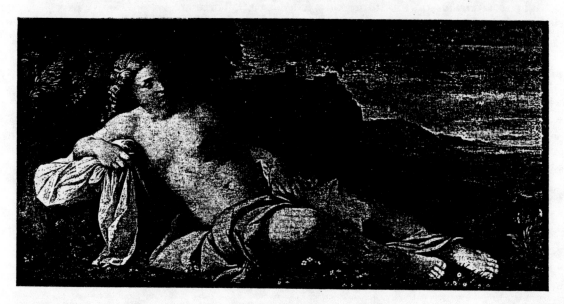

accounted for simply by postulating that women are being identified as symbolically associated with nature, as opposed to men who are identified with culture?'.[22] 'Since it is always culture's project to subsume and transcend nature, then culture would find it "natural" to subordinate, not to say oppress them.' Noting that feminine symbolism, far more often than masculine symbolism, manifests a propensity toward polarized ambiguity, she concludes that woman is seen as closer to nature than man and that culturally viewed she acts as an intermediate between nature and culture. Ortner asserts that 'the view of [woman] as closer to nature is in turn embodied in imitational forms that reproduce her situation'.[23] Ortner is an anthropologist and undoubtedly had in mind here institutional forms such as the family, education, the state etc. The painting of the female nude in Western post-medieval culture might also be seen as one of the institutionalised forms that most effectively functions to reinforce and reproduce woman's intermediate situation between nature and culture.

If we set aside for the moment Berger's imperative of the male gaze and all the problems it entails for the female viewer and for the history of patronage, and if we also set aside Clark's chapter headings: 'Venus I and II', 'Energy', 'Pathos' and 'Ecstasy' with all their connotations, we can notice the relationship of Palma Vecchio's figure to its environment and we may even begin to see a female figure dominating if not possessing her surroundings. For this figure is pivotal to the relationship of the different parts of those surroundings. And it is an inadequate response to the complexity of visual experience as well as to the many-layered structures of signiication that any audience reads off from such an image to explain – and hence to dismiss – it is an object for the male gaze (as would Berger) or to euologise it as the embodiment of an abstract principle of beuaty (as would Clark).

A male figure in a similar pose, whether Antique River God or eighteenth-century portrait, would connote power, ownership and inluence. While a simple reversal (a game that Berger invites his readers to play at the end of his chapter 3) does not transform this reclining woman into an image of phallic power; it does not dispose of the question of what the relationship between the masculine and the feminine in the same pose might mean. Indeed, this question appears to be foregrounded by the factor of the dead stump of the tree (mutilated sign of the absent male) upon which the artist chose to append his signature, the mark of his particular and individual existence as well as his claim of authorship. Palma

Vecchio's female figure is certainly depicted as an object of sexual interest and the painting was very probably commissioned for a private apartment. But if we fail to recognise that the subject is endowed with power in the circuit of sexual desire, we miss the tension that opens up not just one space for the viewer (the notional male viewer) but many spaces.

Unlike the hypothetical eighteenth-century male portrait, Palma Vecchio's figure has only the merest suggestion of clothing; dress is denoted in the red and white drapery which lies close to her body and which she holds. That body serves to activate its surroundings; the meanings are produced at the points at which the female body as sign intersects with other signifiers in the visual field: discarded drapery, flowers, trees, hills, a town in the distance. The body dominating the picture-field is thus located between clothing which is an extension of the body and the town or city on the hill. Moreover, the lines of the landscape can only be read in relation to the lines of her body. She reclines, supporting herself on one elbow; in a meadow where the flowers superimpose into the space of her unclothed body. The landscape, that is the material world, is entirely organised around this body, creating an opposition between flesh and earth that is at one and the same complementary and a binary opposition. Woman here is inscribed as the intermediary between nature (the flowers and landscape) and culture (as signalled by clothing and dwelling). So we might see such an image as enshrining the position woman occupies as intermediary between nature and culture as proposed by Ortner. But what is more problematic is the notion that this is crudely and straightforwardly oppressive.

The gendered body (whose presence in representation can always invoke its other) has widely been the axis upon which the relationship of nature to culture has been structured. In the film *The Draughtsman's Contract*, Peter Greenaway deepens the mystery and underlines the questions about perception he has raised by making a statue come to life and behave in a strictly indecorous and unstatue-like fashion (by urinating, for example). Greenaway here subverts in two respects a long tradition. Firstly the statue should rightly be female and secondly the suspension between artifice and nature that Palma Vecchio's *Venus* maintained is deliberately broken revealing the underside of that convention for what it is: absurd and impossible. In Watteau's *Fêtes Venetiennes* (c. 1718–19, Edinburgh, National Gallery of Scotland), female nudity, a cultural construct produced by artifice, is represented as artefact, as a stone carving (see plate 3). The discourses of reality and fantasy hinge

upon the relationship between the construction of woman as nude in art and the construction of woman as social, both functioning here within nature. It is therefore social woman that here serves as the interface between man and nature.

Modernism has, if anything, served further to reinforce these structures and tensions. The equation which views woman as closer to nature than culture underpins *Cézanne's Bathers* from the 1880s through to 1905.[24] The female body in Henry Moore's sculpture is actually sited in nature, underlining the connective and interdependent meanings. We are accustomed to paintings like those of Palma Vecchio and Cézanne; time and the art market lend legitimacy. The annexing of the female body in contemporary art remains, however, primarily a strategy for defining nature in opposition to man's culture. It is a strategy in which the female body may be mobilised precisely to point up, by its absence of the natural, those differences that are so pivotal to this debate. Allen Jones's *Chair* (1969, London,

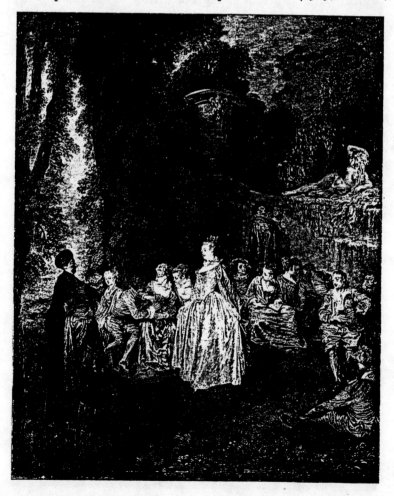

3. Antione Watteau, *Fêtes Venetiennes*

Tate Gallery) may be objectionable to female and male viewers alike. Indeed Laura Mulvey has argued persuasively for a case of fetishization here.[25] The fact that we acknowledge the furniture as fetishised sexual object, a defence against fear of castration, may explain this individual artist's preoccupation with such cult objects. It doesn't explain other levels of cultural signification. Jones unpleasantly but effectively constructs woman as the site of discourses about culture (furniture, girlie magazines, men's clubs, hostesses, etc.). Criticism of an object such as *Chair* tends to be precisely around the absence of the natural. In asserting the 'thingness' of the female body Allen Jones not only works within the Modernist aesthetic predicated upon Cézanne's *Bathers* but also overtly declares the dominant role of the female body in cultural discourse, as an item of appropriation, the object of fetishisation. Criticism of Jones's work is often founded upon an unavowed identification of woman with nature; it is the evacuation of the natural that therefore offends. Jones's works challenge that very category of

4. Roger Hilton, *Dancing Woman*

nature that Roger Hilton, in his *Dancing Woman* (1963, Edinburgh, Scottish National Gallery of Modern Art) seeks cheerfully to reassert and which a recent writer on the nude endorsed as a celebration of female sexuality that neither threatens the male nor overtly invites (see plate 4).[26] But dance is the art form most closely associated with the limitations and possibilities of the physical and biological body; it is, again, the point where nature is seen to become culture and is inextricably linked with ritual and social practice.

III

Woman's special position in the nature/culture debate is most clearly adumbrated in Western art in images within which the female nude is posited as a cypher for male creativity. There are, of course, historical reasons for the popularity of the Pygmalion story with nineteenth-century artists such as Gérôme and Burne-Jones,[27] reasons that must relate to the

5. Thomas Eakins, study for *William Rush Carving the Allegorical Figure of the Schuykill River*

imperatives of mimetic art forms and debates around 'Realism' in the capitalist West in that period. The competitive structures of exhibiting and patronage contributed to the pre-eminence of ideas about artistic genius. Nonetheless, it is significant that the female body is the sign for male creativity, for that which can 'bring to life' inert material by imaginative projection. Furthermore, we might notice that in such works woman is twice removed from the point of production; she is represented within a re-presentation. This insistence upon her presence as re-presentation is precisely what lends legitimacy to the concept of the artist as 'real', as living, breathing flesh, as the creator of art capable of creating more art.

The high status attached to work from the model in the nineteenth century results in the model being constructed as the

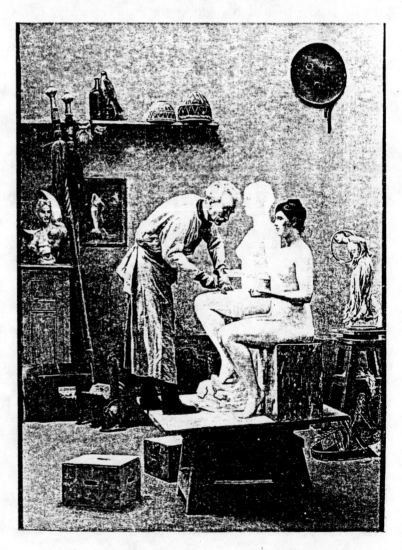

6. Jean-Léon Gérôme,
 The Artist's Model

24

official professional imprimature of the artist. The female body in general and the naked female body in particular announce the artist's professional status; it is evacuated of other meanings in order to achieve this almost heraldic effect. This is evinced in the calculated reinforcement of that double displacement to which I have already referred. In Thomas Eakins's *William Rush carving the Allegorical Figure of the Schuykill River* (oil sketch, 1876, New Haven, Yale University Art Gallery) the female body appears three times (see plate 5). The elderly chaperone fully clothed and sewing (an activity that serves strictly to underline by contrast the masculine and creative contemplation of the artist himself) occupies the same register as the artist. The naked model is woman re-presented at one remove from the construct of woman in the everyday (i.e. sewing). And the sculpture is woman re-presented within that register of re-presentation already established through the positioning of the focally lit model. In the oil sketch (as opposed to the finished painting) the two 'live' women are shown in close proximity – as a pair – and both are facing away from the viewer, an arrangement that serves to emphasise this equation.

The equation is even more clearly established in Gérôme's *The Artist's Model* (*Le Travail du Marbre*, 1895, Stockton CA, Haggin Museum) in which the imaging of a symbiotic physical relationship between model and work means that the flesh of the female body is valorised *only* by reference to the carved marble (see plate 6). The sculptor chips at the stone but the pose of the model implies that he has also created her. It is worth noting that the figure of the sculptor is a self-portrait of Gérôme, who was primarily a painter, not a sculptor. When it came to re-presenting himself as a professional, the Pygmalion myth was invoked to underpin his self-projection.

The topos of male artist/sculptor creating art which is female appears to have no credible cultural reversal. Moritz Von Schwind's *Sabina Von Steinbach* (the subject, of which a version on canvas exists in the West Berlin National Gallery, was painted in 1844 in fresco in the Karlsruhe Kunsthalle) shows the legendary daughter of the master builder of Strasbourg Cathedral at work in the mason's yard (see plate 7). However, the authority which her practice seems to lend her is simultaneously denied both by the appearance of a bust of her father overseeing from a niche above her head and by the fact that the figure on which she is working is featureless, incomplete as art and unrealised as human analogue. This is the figure of Blind Synagogue, the epitome of sighless ignorance, who stands in

contrast to her sister Ecclesia by the great sculpted south doorway of the cathedral.

The female body in representation, particularly the naked female body, is often a way of encoding male cerebral processes. Within the context of mid-sixteenth-century art, a painting like Bronzino's *Young man with a Lute* (c. 1534, Florence, Uffizi) can be seen as an emblematic portrait signifying a cultivated young man, knowledgable about the antique, who employs sight, touch and hearing (see plate 8). But the re-presentation of a re-presentation of the naked female body occupies a crucial position at the apex of the triangle formed by his hands, his ear and his eyes which, like those of Renoir and Cézanne as photographed by their contemporaries (see

7. Moritz von Schwind, *Sabina von Steinbach*

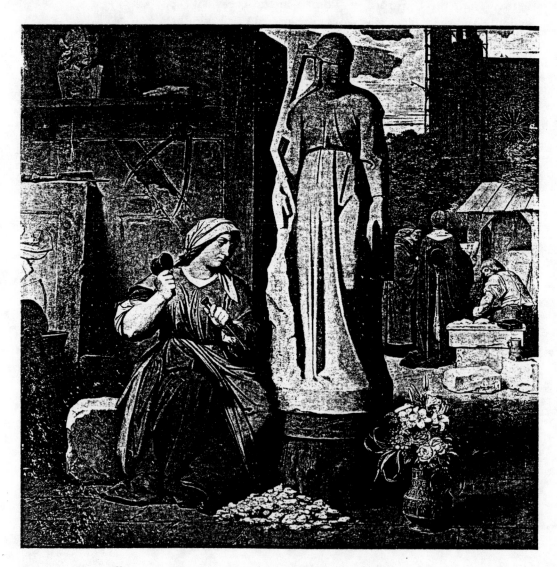

plate 31), look into the distance without need to examine the object. the figurine is no larger than the hands which, crucial to the implementation of the brain's intentions and distinguishing man from beast, appear powerful in relation to it.

The collector, Ambroise Vollard, is depicted by Renoir over 350 years later with his figurine (actually by Maillol) in his very hands and gazing at it (1908, London, Courtauld Institute; see plate 9). He owned the object in life so it is not unreasonable that he should be depicted with it in art. But representation functions powerfully at symbolic levels. The figurine represents the female body caring for itself, combing the hair, an imaging of the female body as natural in relation to man who is culture. The table covering with its re-presentation of animals and flowers, the laid-by and disinvested (because horizontal) statuette on the table, are floating and detached, functionless in their decontextualisation. By contrast the figurine in the hands of the man attains meaning just as it lends him meaning in turn.

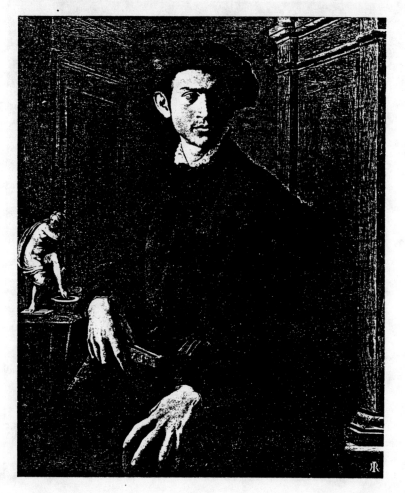

8. Agnello Bronzino,
Young Man with a Lute

27

Male eyes and hands endow the female body with meaning via representation.

If we set alongside these images a painting exhibited at the Royal Academy in 1890 by an artist called Bedingfield and entitled *Le Modèle s'amuse*[28] we can observe, I think, how absolutely gender specific this discourse is (see plate 10). Here the looking is done by the woman but she is looking at herself. The man, creator of art, is here literally outside representation, positioned as voyeur. Not merely re-presented in a different register, but actually evacuated from the image. Berger proposes that the mirror in relation to the female body is a manifestation of hypocritical moralising, a *Vanitas* symbol produced by men who covertly enjoyed the spectacle of female nudity. He suggests that the woman looking at herself in the mirror joins the spectators of herself.[29] But, as Lacan has shown, the subject can never see herself as she is seen.[30] Berger

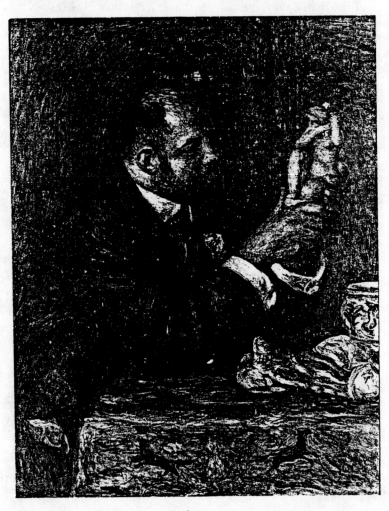

9. Pierre Auguste Renoir,
Portrait of Ambroise Vollard

wishes to co-opt the object of desire into the company of
voyeurs but the self-reflexive circuit is not disrupted in this
way. S'amuser is a reflexive verb and Le *Modèle s'amuse*
presents, therefore, an auto-erotic act.

Berger recognises the mirror as a *Vanitas* symbol but fails to
see that it is also a mechanism within a discourse on art and
nature. Woman looking at herself whether in a mirror or in the
form of a sculpted bust of herself is locked into a cycle of
re-presentation outside which she has not existence. She is
defined exclusively within the closed system of circulating
reflection. The mirror in post-sixteenth-century culture (for
the mirror as myth is as old as Narcissus but the mirror as
readily available manufactured artefact has much to do with the
Venetian glass industry) corresponds to art as a practice; it is the
artefact through which nature is viewed and processed, art
becoming a mirror to the world. In Bedingfield's painting the
'mirror', that is, the modelled bust of the young woman who
has posed, does not reflect self-knowledge; it defines and
confines the model in a systematic practice of re-presentation;
she does not re-present herself but, with the brush (not the
modeller's tool with which the miniature was made), decorates

10. J. Bedingfield, *Le
Modèle s'amuse*

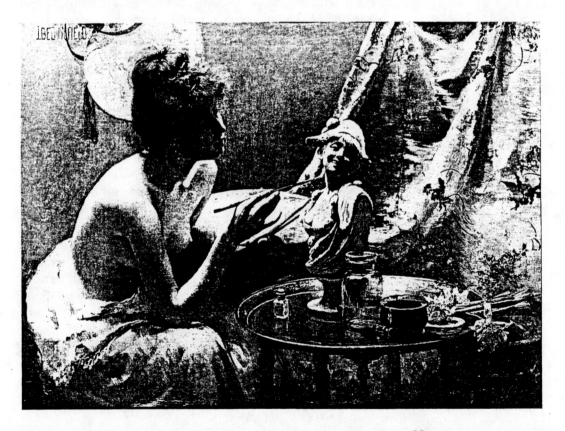

or paints herself, adding to the embellishment of a simulacrum that reduces her in dimensions and fixes her in space. The woman cannot by this measure be an artist; she can only amuse herself with the replica of herself produced – as the discourse of masculine creativity insists – by the absent male artist.

In Bedingfield's *Le Modèle s'amuse* nudity is interpolated rather than offered as genre. In nineteenth-century British painting the nude featured prominently in a variety of modes of re-presenting classical antiquity and was the focus of debates about style, morality and art. The debate was complex and was by no means confined to a prurient censorship of the body.[31] That Queen Victoria sought out and purchased a Life drawing by the highly regarded artist William Mulready at an exhibition of the artist's work in Marlborough House in 1853 should not seem, therefore, surprising.[32] It is clear from reviews of the work of artists such as Etty and Mulready that the nude as a subject for art in the nineteenth century connoted all that was pure and artistic provided it was free from too many particularities. What is interesting is that the institutionalisation of the female nude in the nineteenth century allows for the interest in the permitted boundaries symbolised by clothing and the female body to be displaced into narrative images such as the one I have just been discussing. Thus the nude is present as discourse in images that may not represent the nude *per se*. The enumeration of detail across a pictorial field serves to introduce a profound note of ambiguity in which such questions as which is more real – the woman as represented or the representation of the woman represented – have to be asked. And here I would draw attention to the fact that *Le Modèle* can mean either the model who poses or the *modello* which is the object.

Titles of paintings function as texts in complex relationships with paintings which are also texts and which they narrate but do not deine. I want finally to discuss Octavius Oakley's *A Student of Beauty* of 1861 (Collection of David Daniels; see plate 11). A female student studies Beauty in the form of a classical bust of Clytie (or in the form of a vase of flowers, or in the form of any of the beautiful objects that surround her). But she may also be a beautiful student, a student whose defining feature is beauty. The second reading of the title might seem less readily accessible but the presence of a recently opened letter on the table implies, in the conventions of pictorial narrative of the age, that the woman is/has been recipient of admiration if not courtship. Moreover, Clytie (the sunflower) is a deserted lover who continues faithfully to gaze upon the

object of her affection, Apollo, as he moves across the sky.[33]

A writer recently suggested that this painting raises some interesting sociological questions regarding the education of women in the fine arts in England in the nineteenth century. 'The fashionable blue-and-white china and bric-a-brac in this fashionable upper-class home remind the modern viewer that the decorative arts – teacup painting and other amateur realms – were often suggested as alternative fields for talented women artists' who, due to Academy regulations about the Life Class, lacked formal training.[34] This is to pre-suppose that the painting re-presents a real life situation. I want to suggest that the contemporary detail (executed with great finesse in water-colour which is not the medium being used by the student)

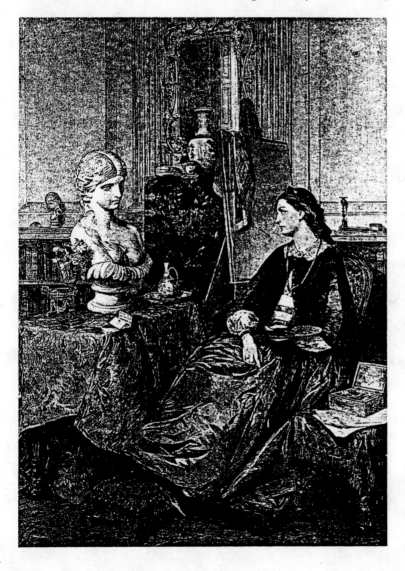

11. Octavius Oakley, *A Student of Beauty*

serves to produce an authenticity effect, a realism, which locates class and social environment. But it is also the case that our desire to read such a painting as evidence of an ideological construct obscures the dialectic that this narrative proposes. The punning title signals a series of structural similarities and contradictions, a set of relationships within which the imagery functions. As with other nineteenth-century Realist art forms, such as the novel, there is no simple question of a narrative development here. Rather there are, if you like, a series of openings to be explored, a range of clues to be picked up, a sequence of closures to be decided upon.

The classical bust which seems to be the main object of the student's attention (but even that is not certain) represents Clytie, and while not nude is certainly suggestive of nudity both by its relation to a set of conventions through which goddesses are depicted naked in Antique art and by contrast with the very thoroughly clothed student (see plate 12). It is also, unlike Bedingfield's *modello*, larger than the woman with whom it is in symbiotic relationship, and therefore suggestive of an hieratic presence. The student does not paint in this instance – she is in suspended animation – frozen in contemplation. The history of narrative picture-making (with its roots in Hogarth's *Progresses*) would lead us to expect that the inanimate objects in the room would offer an interpretative strategy in relation to the living character portrayed. In this painting, however, the reverse is the case. The represented female student gazes upon a re-presentation of herself, larger

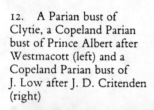

12. A Parian bust of Clytie, a Copeland Parian bust of Prince Albert after Westmacott (left) and a Copeland Parian bust of J. Low after J. D. Critenden (right)

than life, and transformed into a cypher of the faithful, devoted female. A cypher because cut down, or concentrated into, synthesised as, the form of a classical bust. The bust, as classical, as revered fragment of Antiquity embodied in the female form signifies Art at its most essential. The manufacture of Parian busts of Clytie and their distribution by the Crystal Palace Art Union in the years after the 1851 exhibition illustrates at the social level how woman mediated the discourses of art and antiquity in the bourgeois domestic interior. Since it is indubitably Clytie, it also signifies Nature (and in case we were in doubt about Clytie and the sunflower, we are provided with a little vase of flowers containing in particular a yellow flower that casts its shadow over the statue's shoulder). Furthermore, as Clytie pledges perpetual love to Apollo (God of Sun and God of the Arts as well), femininity construed as fidelity as well as idelity construed in terms of adherence to an artistic ideal are also enshrined in this figure.

So what has happened here to the imagery of woman and, in particular, of the woman artist? The mirror on the wall which might have reflected the outside world is obscured by artefacts. But more than that the student in her contemporary dress does not and, presumably, cannot paint. Not for reasons of training opportunities, class or social background but because the notion of individual woman so vividly constructed here in all its authentic detail is obliterated at the symbolic level by the reaffimation of woman's mythic role in relation to man's creativity. She can only exist in a represented world created through man's artistry; there she symbolizes the interface between nature and culture, the space that is occupied by Clytie, the sunflower, as she moves according to the motions of the sun.

In this chapter I have tried to establish dialectical readings of imagery in which woman's body is constructed as a terrain where different kinds of knowledge compete. I have sought to demonstrate how any consecutive history of the nude which proposes a natural body outside culture against which art can be measured is a misrepresentation of cultural data and of the processes whereby it functions. I have also argued that an epistemological framework posited on the acceptance of a pre-constructed male viewer in a relationship of opposition and oppression to a female subject is deeply flawed. The ways in which images work in terms of sexual oppression are determined by the relations between the viewing positions of spectators as gendered subjects and the viewing subjects as constructed in images through forms of visual rhetoric which

are not of themselves oppressive but which may be seen to function in the articulation of power. Discussions of the gendered body and its representation must always be acknowledged as shifting, as lacking secure boundaries. It is precisely by examining these unstable boundaries that we can begin to understand how the body in representation works in the formation and exercise of authority.

PSYCHOANALYSIS AND ART HISTORY: FREUD, FRIED AND EAKINS

I

As institutions, psychonalaysis and art history have much in common. Indeed, it might be argued that they share a point of origin – Vienna around the turn of the last century – and that they work within a common body of material. Much art history traditionally deals with individual creativity and in this might be regarded as sharing a common point of origin with Freud's work which drew on a vast range of cultural evidence both verbal and visual to supply the deficiencies which the narrowness of his practice necessarily entailed. Indeed, it might well prove fruitful to examine closely the continuing Viennese epistomology in art-historical writing in the West today. Sir Ernst Gombrich's early collaborator, Ernst Kirs, in his 1952 *Psychoanalytic Explorations in Art* deployed psychoanalytic methods in his attempt to examine the act of creativity on thed part of the artist. It is out of this same tradition at the same historical moment that Gombrich was, by moving in the direction of clinical psychology rather than psychoanalysis, developing his highly influential theories of perception. While we might question the term 'style' in the following passage, Kris's comments of nearly forty years ago still have resonance:

We have long come to realize that art is not produced in an empty space, that no artist is independent of predecessors and models, that he no less than the scientist and the philosopher is part of a specific tradition and works in a structured area of problems. the degree of mastery within this framework and, at least in certain periods, the freedom to modify these stringencies are presumably part of the complex scale by which achievement is being measured. However, there is litle which psychoanalysis has as yet contributed to the meaning of this framework itself; the psychology of artistic style is unwritten.[1]

In so far as art history is part of an institutional network that incorporates a commodified economy (dealers, auction houses

and the 'heritage industry'), a practice of consultancy as well as an organised system of education and a body of theoretical knowledge, art history and psychoanalysis operate as parallel and, as I hope to demonstrate, intersecting discourses. Dominick LaCapra has drawn attention to the way in which Freud's specific conern with the body as an organising trope might offer a matrix in the investigation of socio-cultural processes. 'What is good to "ingest" in a given group or discipline, what should be "expelled" as indigestible, and what metabolism is considered "normal" in the rhythm of social life are only some of the pressing questions in this respect."[2] Lisa Tickner, recognising that the question of meaning 'turns on the psychic as well as (as part of) the social formation of artist and viewer' has recently argued that feminism 'requires some grasp on the mobility of identifications and desires if it is to provide a fully materialist history'.[3] But Tickner distinguishes psychoanalysis from 'conventional methods' in art history. What I want to point to is the unacknowledged investment of art history in psychoanalysis.

Freudian terms are commonplace in art history, as in history.[4] Wolfflin notably talks of the transformations in cinquecento architecture as 'a projection of man and his sense of solidity to the outside world'[5] and Pevsner refers to the abject inferiority complex of the English.[6] Moreover, we might go beyond the routine observations of Freud's own comparisons between his methods and those of Morelli,[7] or of the way in which the look is central both to art-historical mythology (the proverbial 'eye' which enables recognition and identification) and to Freud's account of castration. Given the traditional preoccupation of art history with missing objects (a search that produces scholarly documentation in *The Burlington Magazine* and commodity fetishisation in the art trade),[8] it seems reasonable to propose that art history in its institutional processes perpetually replays the narrative of castration.

So why has art history been so hostile to psychoanalysis? Whereas psycho-history is a recognised (albeit contested) branch of history, psychoanalysis invoked as a method in art-historical discourse usually provokes only animosity. Freud, as is well-known, misrecognised a motif in his analysis of Leonardo owing to an incorrectly translated word — kite became vulture – in the text he was using. This has been widely used as a way of discrediting the whole of psychoanalysis theory in relation to art history, manifesting thus a considerable confusion between theory and praxis. It is as though Freud has been seen to be untrustworthy as an art historian and so *all*

Freudian theory is suspect.[9] In his 1953 Ernest Jones Lecture, Sir Ernst Gombrich made a stand against psychoanalysis on the grounds that you can't put dead artists on the analyst's couch. He may have been responding to the ongoing debate about the evidence of psychosis apparent in the work of the Viennese sculptor Messerschmidt.[10] It is, however, significant that, in a lecture that grounds the psychoanalytic method in art history in the question of intentionality, Gombrich adopts a defensive stand in relation to the two disciplines, ironically proposing Ernest Jones as a rival 'in my own proper field – the history of art'.[11] Certainly there has been a tradition of art-historical writing which is open to the accusation of attempting to raise the dead; among the more strenuous and scholarly examples in this mode of psychoanalytic Vasarianism are Wayne Andersen's *Gauguin's Paradise Lost* (1972), Marcelin Pleynet's essay on Matisse in *Painting and System* (1977) and Ronald Paulson's work on Turner in *Literary Landscape: Turner and Constable* (1982). The tradition originates with Salvador Dali's spectacular essay *The Tragic Myth of Millet's The Angelus* (1963), re-examined by Naomi Schor in *Reading in Detail* (1987).

The apparently ahistorical nature of investigations into the nature of objects and their audiences has also provoked profound scepticism; Peter Fuller's personal voyage of discovery from the damaged image of the mother through art (the Venus de Milo) to the Modernism of Rothko tends to create profound unease in both traditionally empiricist art historians and those with theoretical concerns.[12] History as applied psychoanalysis fails, as LaCapra has pointed out, to 'confront the broader problem of how psychoanalysis can lead to a basic reconceptualization of historical self-understanding and practice or even to a mutual rearticulation of both history and psychoanalysis as implicated in a reciprocally provocative exchange'.[13]

The unconscious, whether of viewer (contemporary or historical) or artist, might seem to underlie a body of writing in art history that would not claim to be traditional. On scrutiny, however, the unconscious may be shown to have been set aside in favour of the materialist explanation. Arguments therefore focus primarily on class at the expense of gender. Tickner cites the proposition of wish fulfillment in a collusion between artist and patron in John Barrell's *The Dark Side of the Landscape: the Rural Poor in English Painting 1730–1840* (1980).[14] But Barrell's thesis also disavows the unconscious in its insistence on an account which stresses the economic. In discussing Manet's *Olympia*, T. J. Clark draws attention to the kinds of insults

levelled at the painting and suggests that 'confronted with classic paradoxes like these, it is tempting to move straightaway into the Freudian mode': he then disclaims commitment to any further analysis in this mode, arguing that, although it is 'certainly appropriate to the material in hand' and he does not intend to avoid it, 'it should figure alongside other kinds of questioning, more literal and for the most part more plodding'.[15] Having indicated that the Freudian might form part of a pluralism of modes, as he calls them, Clark ignores the possibilities of a psychoanalytic theory in the book as a whole.[16]

It is precisely around questions of gender that art historians – the objects of whose study have been radically revised over the past decade – have found psychoanalysis most pertinent. Concluding a pioneering presentation of several French texts which use psychoanalytic and linguistic concepts in relation to visual material, Claire Pajaczkowska says:

> If the revolution of Marx consisted of understanding the product of capitalist economy not as commodity or object (which is what it appears to be) but as the surplus value produced by the production of the object, then we too should fully recognize the value of the structural method and understand the product of signifying process to be the production of identity rather than the art object or text.
>
> The analysis of this process of production of identity, if it is to be of any use, has to include at a fundamental level an understanding of sexual difference, and feminist practice must begin to incorporate into its questioning of the representation of women an understanding of masculinity.[17]

Questions of sexual difference have been addressed in film theory since its inception; more particularly the issues raised by an interrogation of Freud's theories of castration and fetishism have helped to explain the structures of classic cinema and its politics. That interrogation has taken place around the writings of Jacques Lacan, who proposed an unconscious that is structured like a language and in whose work enculturation is seen as instrumental in the construction of the (gendered) subject. A Lacanian loss or lack which both threatens and secures the spectator has been identified as a spectre haunting film theory:

> This fundamental lack reveals a remarkable propensity for displacement. Sometimes the absence which structures cinema would seem to be the foreclosed real. At other times it is equated with the concealed site of production. On yet other occasions, lack would appear to be inscribed into cinema through the female body. Random as they seem, these displacements follow a very specific trajectory. The identification of woman with lack functions to cover over the absent real and the foreclosed site of production – losses which are incompatible with the 'phallic function' in relation to which the male subject is defined.[18]

Psychoanalysis in film studies such as Kaja Silverman's allows for a gendered viewer; it also permits the interrogation of desire – the 'pleasurable emotions aroused at first sight', as Wolfflin put it when writing about Raphael's madonnas – and examines the relationship of spectator with the point of production or authorship.[19] It is not perhaps surprising that in relation to visual imagery and material culture, rather than film, methods such as these have been used mainly to open up discussion of photographic practice in particular and of contemporary art in general.[20] Griselda Pollock, in an essay which deploys theories of castration and fetishisation, locates the origins of a regime of representation to which 'woman' is central (a regime so powerful that we no longer recognise it as representation at all) in nineteenth-century depictions of woman.[21] If this is so it might explain the fact that, with a few notable exceptions, the examination of gendered looking has been confined to a body of cultural material dating from the mid-nineteenth century to the present.[22] It may also, however, be the case that the institutional hostility to psychoanalytic methods that was so manifest at the time of the publication of Leo Steinberg's *The Sexuality of Christ in the Renaissance and Modern Oblivion* (1983) is only seriously aroused when the object of scrutiny is the canon of 'great masters' or works that, accommodated within the acknowledged Schools, are high in market value.[23] *The Art Bulletin*, representing a conservative art-historical constituency in the USA, carried a substantial review article in 1987 on the state of Renaissance art-historical studies. Here Steinberg is credited with having the 'special gift to make us look twice or thrice at things we think we have already seen'.[24] The political implications of Steinberg's work both for power relations in the discipline and for the art historian's relationship wit his or her material are utterly subsumed within this compliment. And it is worth recalling that precisely the same sort of recognition was accorded T. J. Clark's 1970s work on Courbet.[25] The implication is that things have been seen 'afresh' but that nothing has been dislodged by the experience. This form of accommodation is the most insidious of all strategies within academic criticism.

In general, interpretative methods, both historical and deconstructive, have been much less variable in art history than in literature. The currency is simply smaller – and has less range. There are fewer 'readings' of canonical texts in the visual arts than in the verbal fields. Frederic Jameson speaks of the 'bewildering variety of competing and commensurable inter-

pretive options' available in relation to Conrad's novels. He lists them:

> The 'romance' or mass-cultural reading of Conrad as a writer of adventure tales ... the stylistic analysis of Conrad as a practitioner of what we will shortly term 'a properly impressionistic' will to style ... the myth-critical, for instance, in which *Nostromo* is seen as the articulation of the archetype of buried treasure; the Freudian, in which the failure of Oedipal resolution is ratified by the grisly execution of Conrad's two son-heroes (Jim and Nostromo) by their spiritual fathers; the ethical, in which Conrad's texts are taken literally as books which raise the 'issues' of heroism and courage, of honour and cowardice; the ego-sychological, in which the story of Jim is interpreted as the search for identity or psychic unity; the existential, in which the omnipresent themes of the meaninglessness and absurdity of human existence are foregrounded as 'message' and as 'world-view'; and, finally, more formidable than any of these, the Nietzschean reading of Conrad's political vision as a struggle against *ressentiment*, and the structuralist-textual reading of Conrad's form as immanent dramatization of the impossibility of narrative beginnings and as the increasing reflexivity and problematization of linear narrative itself.[26]

If the nineteenth-century novel occupies a privileged place of analytic enquiry within literature, the Renaissance *istoria* might be said to occupy a comparable place in art history. The masters of the Italian Renaissance have, at least until very recently, always been the objects of extensive scrutiny, and through a variety of methodologies. But the range of critical option is narrower. Carlo Ginzberg, summarising recent contributions to the critical study of Piero della Francesca's *Flagellation*, is able to distinguish only *findings* and not *method*.[27] Moreover, psychoanalytic theory is notably absent from those critical options that do exist. Freud's essays on Leonardo and Michelangelo may have been exposed as wanting but little attempt has been made to put anything into their place.

The criticism of psychoanalysis as a bourgeois activity derives in part, as Stephen Frosh has suggested, from psychoanalysis *practice*, particularly from immanent moralism and from theory being used to explain away oppressive practices.[28] Psychoanalysis, however, is a theory which addresses contradictions. Thus, in so far as art history has traditionally striven for absolute certainties – the magisterial iconographic reading consequent upon a body of knowledge accessible only to a master, the unassailable provenance, the normative mode of a sealed system of inherited convention, the historicist goal of a plenitude of recorded reception and function in the public domain – psychoanalytic method is a disturbing intrusion.

With its late nineteenth-century Germanic origins, the insti-

tution of art history is a place where the displaced repetition of
the oedipal scene that is central to the analytic situation is
powerfully felt. Transference, as LaCapra points out, is found
in the historian's relations to other students of the past whose
renditions of it must be taken into account in his or her own
work. The nexus between students and teachers perpetuates the
anxieties produced around these relations.[29] The great names of
Warburg and Panofsky, of Wolfflin and Riegl have generated
an apostolic success of great power. Anthropologists may face a
similar patriarchy through confrontation with Lévi-Strauss and
Malinowski; literature would appear to be a considerably more
dispersed field. Psychoanalysis in academic work is capable
both of confirming the transferential situation of academic
scholarship and teaching, and thus affirming a patriarchal lineal
descent, and of disrupting that relationship. The second part of
this chapter is devoted to a reading of an art-historical account
which falls within the first of these categories. the third part is
devoted to a re-reading of the text that produced that account
and which aims, therefore, to challenge the account and to
disrupt the transferential situation.

II

In 'Realism, Writing, and Disfiguration in Thomas Eakins's
The Gross Clinic', Michael Fried makes a provocative interven-
tion into a field in which, as he says, 'the pressures of a
normalizing discourse have kept interpretation under the tight-
est of reins'.[30] It is difficult adequately to summarise the
arguments of such a rich and complex essay but, as I wish firstly
to discuss the positionality of the author and secondly to open
up interpretative questions that I believe he has overlooked, a
brief account is required. Thomas Eakins painted The Gross
Clinic in 1875 (plates 13 and 14). While it did not achieve
recognition in its time – indeed its exhibition was the occasion
of much adverse criticism – it has since been much explored
from an empirical point of view and much admired as a work
of high Realism. The personae are a patient undergoing an
operation for the removal of a bone in the leg, the celebrated
American surgeon Gross, his assistants, an audience of male
students which includes a self-portrait of the artist, and a
woman spectator. Fried takes it as self-evident that the patient
(whose partially exposed body is extremely difficult to read) is
male and he does not refer therefore to the gender of this
figure.[31] This is not a case of the use of the universal male
pronoun; it is crucial to Fried's argument that the patient

should be strictly analagous with that of Eakins himself and that these two figures should be read as 'sons' of the father-figure of the surgeon. In the case of the figure of the woman, Fried points out that she has been 'traditionally characterized as the patient's mother'.[32] Not only does Fried unquestioningly accept this traditional identification, he proceeds, presumably as a result of assuming that the patient is a grown man, to define the woman as 'an intrusive, highly emotional *older* woman'.[33] We should notice here that one consequence of presenting these as a set of givens is that Fried's account forecloses on the question of gender in the 'center of action'. Another is that it foregrounds the issue of generation.

Fried's method in approaching this arresting image is to compare it with other works by Eakins rather than to relate it to what it claims to represent. But those works, as I shall demonstrate, are selected to make a special case. The notion that

13. Thomas Eakins, *The Gross Clinic*

14. *The Gross Clinic,*
detail of patient

the configurations in the image are as they are because of the imperatives of a Realist fidelity to the facts of perception is rejected and attention is directed, instead, to Eakins's choices, conscious or otherwise.[34] At the same time, Fried skilfully locates *The Gross Clinic* in visual traditions relating to anatomy lessons and artists' studios; he also discusses earlier Realist moments in the history of art. Gross is cast thus in the stamp of a painter (like Velazquez or Courbet) and his bloody scalpel is seen as synonymous with the colour-lade brush. This leads Fried to examine a series of fascinating transpositions and elisions between pens (Eakins's father was a writing master), brushes and scalpels and to the incidence of writing and a preoccupation with planar mirror surfaces in Eakins's work. *The Gross Clinic* unites the theme of writing with that of admiration for an older man. The masculine world of shooting, rowing and punting – characterised by shotguns, oars and poles – is equivalent to the medical arena of pencils, scalpels and surgical probes; horizontal surfaces of lakes and fields are like operating tables and writing desks. What is seen as the excessive action of the woman in *The Gross Clinic* is related to the fact of Eakins's own mother's mental illness. The 'absorptive' mode of Eakins's domestic pictures is contrasted with the authority and *éclat* of *The Gross Clinic* even though a thematic linkage between the two is recognised through the incidence of red, a vehicle for extreme feeling, in paintsings of young women and in *The Gross Clinic*.

The Gross Clinic, in Fried's analysis, brings together three

affective moments: a Caravaggesque moment of shock (a wounding of seeing); the Burkeian sublime; and Freudian family romance. The first two stand independently but are also interpreted through the third. Pointing up the ambivalence that characterises the sublime and the oedipus complex, Fried identifies the figure of Gross as master healer *and* bearer of the threat of castration. He proposes two competing structures: firstly a successful resolution of the oedipus complex via the fantasmic identification of father with son (or artist with predecessor) and secondly the pathological wish-fantasy of being sexually possessed by the father. The second structure is mobilised through the recognition of the (male) patient's exposed buttocks and through the functioning of the 'mother's' hand as a figure of castration. The figure of 'Gross in particular, suggests', says Fried,

a further, ideologically charged contrast *between thematizations of castration* – the one chaotic, hysterical and unassuagable (ie 'feminine') and the other regulated, masterly, and in the end healing (ie 'masculine'). This is virtually to say that the second thematization may be understood in part as a defense against the first, which would mean that the mother rather than the patient-son is the painting's ultimate scapegoat, the personage who more than any other has been sacrificed in the interests of representation.[35]

The privileged starting point for Fried's examination of *The Gross Clinic* is his own psychic history. *Realism, Writing, Disfiguration* opens with a declaration of the author's rationale in bringing together two texts, one by Eakins, one by Crane. That rationale is his own subjectivity:

This book consists of two long essays ... The Crane essay *in particular came as a surprise*: although my interest in him predates by many years my involvement with Eakins it was only in the course of working on *The Gross Clinic* that I began to see what might be made of a series of texts by Crane, culminating in 'The Upturned Face', that I had always hoped to be able to do something with. The two essays go together, then, not only in their concern with intricately analogous issues but also because, *as if accounting for a priori fascination, the first irresistibly gave rise to the second.*[36]

It does, therefore, seem reasonable to probe (a word that Fried himself likes to use, along with 'penetration') the manifest narrative of the author's subjectivity in relation to the text that is his object of study. For, if we are to endorse or criticise his argument, the foundations of that argument must be open to scrutiny.

Fried acknowledges in passing the work of Jacques Derrida by means of a general note in his preface. However, he never specifically mentions Derrida and, most remarkably, there is no

mention in his text of Derrida's chapter 'Freud's Legacy' in *The Post Card: From Socrates to Freud and Beyond*. Fried must have been aware at least of the version of Derrida's essay (entitled 'Coming into one's own') that is published in G. H. Hartman's collection *Psychoanalysis and the Question of the Text*, for he cites an essay by Neil Hertz in the same collection.[37] Equally surprising is the absence of any specific reference to Derrida's essay 'Freud and the Scene of Writing' in *Writing and Difference*.[38]

The first part of Derrida's essay 'Coming into one's own' is subtitled 'Keeping it in the Family'. This appears to have been a touchstone for Fried's work on Eakins. In this essay, Derrida proposes the psyche as a kind of text. He is concerned to elucidate Freud's act of writing the late and influential essay, *Beyond the Pleasure Principle*. Derrida suggests that Freud was guilty if not of disavowing then at least of deflecting attention from his own immediate emotional involvement in what he was observing. For it was Freud's own grandson whose repetitive game of throwing away and retrieving his toy triggered the theory of *Beyond the Pleasure Principle*. Freud was also, of course, father of the child's mother who died while the essay was being written, an event to which Freud alludes merely in a footnote. Derrida thus proposes a structural relationship between Freud's text and the subject matter he is analysing:

If we consider the argumentative framework of the chapter, we notice that something repeats itself, and this process of repetition must be identified not only in the content (the examples, the material described and analyzed) but also in Freud's very writing, in the 'steps' taken by his text, in what it does as well as in what it says, in its acts as much as in its 'objects'.[39]

I shall return to this passage but first I want to draw attention to a subsequent passage which appears to contain the embryo of Fried's own argument:

The description of Ernst's [the baby's] game can also be read as an autobiography of Freud, not merely an auto-biography entrusting his life to his own more or less testamentary writing but a more or less living description of his own writing, of his way of writing *Beyond the Pleasure Principle* in particular. It is not merely superimposition or a tautological reversal or mirror – as would be the case if Freud wrote down what his descendents dictated and thus held the first pen, the pen that is always passed from hand to hand; if Freud made a return to Freud by the mediation of his grandson. The auto-biography of *writing* at once posits and deposes, in the same motion, the psychoanalytic movement.[40]

Fried's account of Eakins's painting stresses mirrors and reversals and, above all, sketching/writing/probing with

pen-like instruments, establishing psychic and metonymic connections between Eakins (who autobiographically inscribes himself in the painting *The Gross Clinic*) and Gross (the father of his students), Eakins's father)a writing master), and Gross's son (also represented in the painting). Gross's clinic is, if you like, in Fried's account the equivalent of Ernst's game and Eakins is, like Freud, drawing/writing his own autobiography, via the pen that is passed from hand to hand, the burden of influence.

My object in drawing attention to Derrida's essay is not, as it were, to catch Fried out. It matters little whether or not he acknowledges Derrida's essay; by the same measure as he applies to Eakins, all we can conclude is that the thematisation of *The Gross Clinic* in Fried's account is indebted to Derrida's post-Freudian reading of Freud reading which Fried may have used, consciously or unconsciously. But is this all we can conclude? Returning to Fried's discussion of the single female figure in Eakins's painting, we find that Fried attributes his reading of the 'mother' and his discovery of paranoiac elements in the work (that is, those features capable of being clinically named) to conversations with two named male colleagues.[41]

If Freud's arena is that of the bourgeois family (with his own interest implied only in a footnote), Fried's is that of patriarchal academic discourse (with his affiliation to that discourse similarly suggested only in a footnote). By drawing attention to these equivalences Fried and Freud are brought together. And here, to use Fried's own self-protective formulation, 'the pun is unavoidable and might just be significant'.[42] The father-figure whose shadow looms over Fred's writing also stood before a learned audience in a lecture theatre. Fried, like Freud and like Gross (or Eakins), the cast of Fried's drama, thus performs an examination; Fried mobilises Freud for an analysis and dismemberment of the body of representation in a painting depicting clinical and bodily opening up or exposure. Thus Fried posits himself in a role of supreme academic authority as the interpretative linke between the Father in Psychoanalysis, the Father in Medicine and the Father in Art. These fathers are elided in Fried's account into a dominant and closed structure of authority.

There are many criticisms of an empirical kind that one might make of Fried's essay. The appearance of writing and inscription in Eakins's painting is overdetermined; texts in and on images are a commonplace of nineteenth-century painting and are to be found in a Hogarthian tradition from Wilkie to Ford Madox Brown as well as in a townscape tradition that

includes Thomas Shotter Boys, Béraud, Manet and Seurat. The practice of inscribing texts on frames was highly developed in late Pre-Raphaelitism, for example. This does not, of course, preclude the kind of interpretation that Fried favours but given this context it seems an overstatement to attribute this characteristic to an 'obsession' on the part of the artist.[43] The dependence of Fried's arguments on his own, at times highly formalistic, transcriptions of the visual (see, for example, his passage on empathy[44]), testifies to his own pedigree as a follower of Clement Greenberg but diminishes the strength of his argument. His insistence on locating Eakins in relation to Courbet and Manet; his perpetual reiteration of his own invented categories of absorption and theatricality (so widely recognisable as to be all but meaningless here, however effective they may have been in relation to Fried's work on the eighteenth century);[45] and, above all, his omission of any reference to the relationship between Eakins's imagery and the ideology of medicine as institution, profession and practice are all matters on which Fried might reasonably be challenged.[46]

The one point that I want to pursue, however, relates back to Derrida's identification of a connection between the content (the examples and materials described and analysed) and the steps taken by him in his text. It is via this means that I wish to draw attention to a different set of connections which the imagery of the painting sets in circulation. Fried's account, as I have established, is predicated upon his identification of the patient's status as male. The uncertainty of gender – which is reinforced by the fact that the face and body of the only woman present are invisible – is passed over by Fried with extraordinary rapidity in view of his punctiliousness elsewhere. This omission is also surprising in the light of his declared intention to relate *The Gross Clinic* to Eakins's other paintings. For the analogous painting *The Agnew Clinic* (1889) apparently offers no such ambiguity (plates 15 and 16). The only points at which Fried refers to *The Agnew Clinic* are, firstly, when he cites it as one among many paintings which contain the artist's portrait though it appears that this is not a self portrait but one painted by Eakins's wife, Susan Macdowell, and, secondly, when he underlines his point about reflections by citing the inverted imprint on the sheet in *The Agnew Clinic* and, in a long footnote, states that Agnew, unlike Gross, insisted that all traces of blood were removed from his hands.[47] The involvement of the artist's wife – surely peculiarly resonant in an essay so dependent upon forms of biographical evidence – elicits no comment from Fried.

There is an important sense in which the oedipal and paranoic models that provide the framework for Fried's reading of *The Gross Clinic* determine the act of writing his essay and its narrative format. For woman is effectively expelled from Fried's account. Though her death is not recorded in a footnote, she is absent just as Freud's daughter is absent from the writing of *Beyond the Pleasure principle*. Woman, is, Fried argues, scapegoat in the thematics of *The Gross Clinic*; she is also relegated to pre-oedipal obscurity, to an ungendered condition of negativity, in the process of Fried's argument towards this conclusion or (as Fried would have it) climax. Having raised the spectre of Eakins's own mother's madness, Fried admits a tenuous connection with the excessive actions and visual disjuncture of the figure he presumes to be the patient's mother in *The Gross Clinic*. He then moves suddenly (with the kind of 'cut' characteristic of cinematographic effects and presumably justified by reference to his own 'prior fascination') straight to a discussion of Eakins's domestic scenes. These he views as examples of domestic absorptive realism which are essentially preparatory for, and anterior to, 'the complete authority and eclat of The Gross Clinic'.[48]

If motherhood is mad or even distraught does this not

15. Thomas Eakins, *The Agnew Clinic*

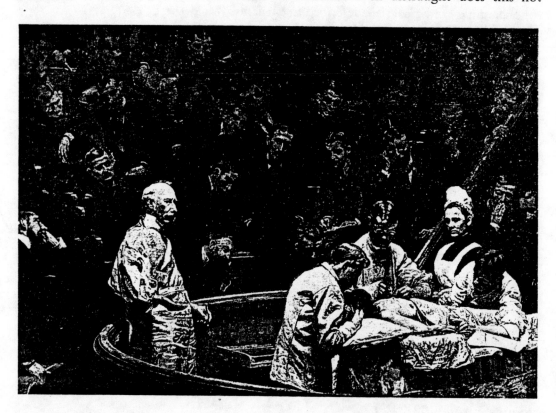

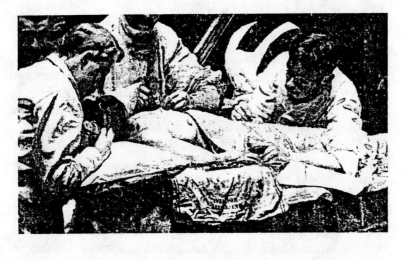

16. *The Agnew Clinic*,
detail of patient

intrude, one might ask, into that vision of domestic absorptiveness? The relationship of the domestic scenes to *The Gross Clinic* is one of the places where Fried seems most determined to subsume a major register of difference into a minor and formalist point of similarity. 'The almost wholly male environment of the operating room would seem to have nothing in common with the distinctly female expressive register of the interior scene', Fried tells us. But nonetheless 'the apparent contrast between the decorousness of the first and the violence of the second' is lessened when we realise the obsessive recurrence of red also in the domestic pictures. This, says Fried, finds its climax or fulfilment in the open would and bloody hands in *The Gross Clinic*. The exploitation of red (pain/paint) in paintings of young women is thus a 'vehicle for extremities of feeling' that can only find a place in *The Gross Clinic*.[49] Here, instead of telling us what those extremities of feeling are and how they might relate socially to the construction of domesticity with its incipient violence, Fried cuts again and, in the repetitious mode that Derrida remarks in Freud's essay, moves to masculine rowing paintings and attendant theories of drawing and perspective – that is, to the safe arena of scientific calculation.

Fried has raised the question of masculine and feminine spheres and my own reading of Eakins's work is thus far indebted to him. But the question – like other questions his essay raises – needs to be followed through. We need to ask what it means to represent female hysteria (if that is what it is) in the male arena of medicine. We should be asking what the effect might be of proposing a sphere of domesticity characterised by the appearance of blood-red pigment and a male sphere of work characterised by an operating theatre. What

sort of inferred inversion or intrusion might this be and how would it relate to those other graphic inversions and reflections upon which Fried meditates? By not enquiring into the question of the patient's gender in *The Gross Clinc* and by ignoring a second painting (*The Agnew Clinic*) Fried relegates woman in Eakins's oeuvre to a pre-oedipal condition. He cuts (as though terminating an interview) at the precise points in his discourse when woman becomes an issue in his narrative. In so doing he shuts off his account at precisely that juncture at which the psychoanalytic theory and case history he invokes would prove most fruitful. The consequence is that he offers what is undoubtedly a fascinating account but one which fails to recognise the margins between categories and the slippages between definitions that are so significant in this form of hermeneutic. In this failure is also implied his failure to recognise the role of subjectivity and transferrence in his own analysis. Thus not only is the narrative of patriarchy that is inscribed in Eakins's painting reinforced but – at a very different level – the very enterprise of a 'progressive' art history turns back upon itself in Fried's final (and climactic) celebration of the single masterpiece to which all else is subsumed.

III

What does it mean to read – or to look – as a woman? The question has been asked many times by women and by men in recent years in relation to a range of cultural forms.[50] In the previous section of this chapter I argued that Fried, in his essay on Eakins's *The Gross Clinic*, passed a cluster of texts through a Freudian grid and produced an interpretation which I, reading as a woman, find unconvincing. Fried grounds his argument in the founding moment of sexual difference as described by Freud but then proceeds to ignore the questions that sexual difference raise. His use of the castration theory involves the argument that the fear of loss experienced by the male subject derives from fear of a superior power (fear of the father). Fantasmic identification with that superior power is one way in this instance to protect himself against the threat of loss (leading also to homosexual wish-fulfilment).

My argument will centre on the contention that the difficulty in reading the body of Gross's patient and its indeterminate gender are part of the condition in which this figure functions in the image as fetish, as 'a brilliance, something lit up, heightened as under an arc light'.[51] According to Freud, the

fetish is a substitute for the 'lost' penis of the mother and an object upon which the desire of the subject can focus to protect him from his own threatened loss.[52] Fetishism functions not so much to conceal woman's castration, her lack of the phallus, as to deny man's. I concur with Fried in seeing *The Gross Clinic* as a painting about lack but I see that lack as relating less to Gross's particular psychic and professional career (as a woman reader I am less concerned with the patriarchal authorial succession as I cannot inscribe myself into that trajectory overtly or covertly) than with the conditions of viewing as they pertain in art and in medicine.

As the phallus is the sum of all speaking subjects, the gaze denotes power in the institutional sense as well as in the theoretical sense. The gaze – as differentiated from the process of looking – is predicated, according to Lacan, upon the lack that constitutes castration anxiety.[53] Fried found it necessary to bracket the question of Eakins's realism but I want to foreground Realism, not in order to demonstrate that Eakins was capable of some kind of special transcription of the real world but in order to draw attention to the viewing of the Realist painting as what Silverman calls the story of a missed encounter.[54] For the Realist painting – especially when it deals, as here and as in *The Agnew Clinic*, with performance or demonstration (a public enactment) – parallels the conditions of viewing in Hollywood cinema in which the foreclosed real and the concealed site of production (studio and operating theatre) produce conditions of lack. They are objects of desire that can never be fulfilled. The very mythologising of Gross's clinic in critical history as a moment so realistic that it had to be transcribed is evidence of this.

Fried correctly states that the positing of an original scene leads to arguments about Realism that are tautological. The artist produces a work so realistic that we feel we know how the historical episode looked and the historical episode as known by this means confirms the artist's skill in transcribing the real. But Fried interposes into this construct the question of the artist's choice (conscious or unconscious).[55] In this Fried remains with the idea of an original scene that offers special ingredients to an artist, the results of whose choices (almost to obscure one of Gross's assistants, for example) are accessible to us through the evidence of pictorial representation. The notion that the scene, a moment of high Realism, demanded its own transcription, is clearly flawed. But so is an argument that invests so heavily in the artist's choice 'consciously or otherwise'. If we set aside *The Gross Clinic's* dependence upon the

scene it claims to represent, then we also set aside the issue of desire and the question of history.

If we move our focus of attention away from the actors in this scene to the audience, away from the father figures in life and art, we might arrive at a different understanding of the way this painting works. For what strikes me, reading as a woman, about *The Gross Clinic* and, even more, about *The Agnew Clinic*, are those serried ranks of male observers that block any notion of escape from the confined spaces of the theatre. These observers confront our gaze as they stare down at the operations. Lolling on their elbows, erect and surveying the scene, leaning back in their seats, resting their heads on each others' shoulders, peering with their heads on one side, these men are masters of the scopic. And there are a multiplicity of these masters – a positive army. Indeed, compositionally these figures, who barely merit a mention in any of the books on Eakins, occupy at least half of the canvas. Nor is this concern

17. Thomas Eakins,
Between the Rounds

with the attentive and exclusively male audience confined to
the two medical paintings; it is also found in Eakins's series of
paintings of boxing matches, wrestling matches and other
sporting events.[56] Certainly the mimetic imperatives of a
representation of a doctor in the act of lecturing require an
audience but it seems significant that none of the works that
have been suggested as influences upon Eakins's clinic paintings
has an audience whose presence dominates the canvas in this
way. Rembrandt's *The Anatomy Lesson of Dr. Tulp* (1632) and
Feyen-Perrin's *The Anatomy Lesson of Dr. Velpeau* (1864) both
offer a less dramatic angle of vision and leave a suggestion of
substantial space behind the observers.[57] Having produced the
formula in *The Gross Clinic* without outstanding popular
success, Eakins went on to repeat it in *The Agnew Clinic*,
suggesting a psychic investment in this compositional type.

Scenes like *Between Rounds* (plate 17), depicting a hiatus in a
boxing match, and *The Gross Clinic* are gender specific in terms
of their audiences and in terms of their actors. Thematically
they relate to the gladiatorial scenes of Eakins's master Jean-
Léon Gérôme; by recognising this connection we can also
recognise the element of cruelty that the institutional motifs of
medical professionalism barely serve to obscure. Eakins
defended Gérôme against accusations of cruelty in a letter
home.[58] Gérôme's victims are usually male *and* female but a
particularly unpleasant scene *Gathering up the Lions in the Circus*
shows the bleeding and naked corpse of a young woman in the
foreground.[59] Audience scenes were also common in paintings
by artists associated with late Impressionism where the subject
matter was contemporary. What Eakins does in *The Agnew
Clinic* (where the gender of the patient is never in doubt) is to
combine the contemporaneity of Seurat with the inherent
violence of Gérôme and to structure it within the legitimising
discourse of medical authority. The presence of the audience
establishes the distance between the viewer and the object of
desire that is a requisite of voyeurism. The fragment of human
flesh upon which Gross's audience and Eakins's viewers gaze
creates the essential condition of spectacle.

The differences between *The Gross Clinic* (1875) and *The
Agnew Clinic* (1889) are summed up by Johns in terms of the
changes in medical practice in the intervening fourteen years
(the introduction of white coats, developments in anaesthe-
tics).[60] The most important change for me as a woman viewer,
however, is that the *Agnew* patient is now clearly female and
that the operation is for the removal of breast cancer. For a long
time the breast has been regarded as the epitome of 'female

softness', as a visible signifier of female sexuality.[61] The operation that Agnew is conducting will result in the removal of the woman's breast. Mastectomy then, as now, was an operation that mutilated women and, even with the use of anaesthetics (which was more than the glass of wine with laudanum that Fanny Burney had for her operation in 1811),[62] the operation was physically painful and emotionally traumatic. It is this operation rather than tonsilectomy or appendectomy which this male audience observes. The unconscious (overpowered) object of the gaze, whose vulnerable and instantly recognisable anatomy is carefully exposed in such a way that we, as well as the medical students, can see it, is accompanied by a female chaperone institutionalised as nurse and trained, judging by her absence of emotion, not to see what the men watch. The horror that was displaced in *The Gross Clinic* through the sign of the woman with the covered eyes is here on open display and concentrated upon the wounding of the breast.

The examination of the body internally and externally was common in the nineteenth century to both artistic and medical training; the institutional power structures then, as now, strongly resembled each other both in their forms and in their practices. The lecture room in the medical school was constructed in ways similar to the Life Class in the academy and art students received lectures on anatomy as did medical students. The same kinds of exclusions founded on gender operated in both institutions; women were excluded from the Life Class (and thus from the higher echelons of professionalism) and were debarred from becoming doctors. The male audiences depicted in Eakins's paintings might just as well have been artists in training as doctors in training. Paris – the focus of artistic ambition for European and American men and women – was also the place where a woman could get a medical degree in the nineteenth century.[63] This centre, where Eakins trained as an artist, operated at this time to enable or to exclude in medicine and in art.

Anatomy was central to medical and artistic practice, and central to anatomy was sexual difference. As Charles Bell put it in his popular and many times reprinted *The anatomy and Philosophy of Expression*: the study of anatomy permitted artists to grasp 'the contrasts between manly and muscular strength and feminine delicacy'. It also pointed to other sets of binary oppositions: health and sickness, life and death, youth and old age.[64] Eakins's wife was a serious artist whose career came to an end with her marriage; Eakins worked with women students,

had disagreements about the Life Class at the Pennsylvania Academy School over which he was compelled to resign his post as Director,[65] and was certainly in a position to appreciate the similarities between the two institutions.

The events of Eakins's life are not germane to my argument but it is, nonetheless, interesting to notice in the context of the exclusion of women from acts of seeing in Eakins's painting and the exclusion of Susan Macdowell Eakins from artistic practice that so many of Eakins's portrait sitters are women with eyes downcast and that his favourite sister (sitter, to use a Freudian pun) died aged 29 in 1882. She is portrayed as a young woman in *Margaret in Skating Costume* (early 1870s; see plate 18). There would appear to be a relationship between loss of the sister in life, the iconography of portraits of women whose unseeing condition renders them absent in some way, and the ambivalence of Eakins's professional relationship with his artist-wife. Professor Ranking, whom Eakins painted in 1874,[66] and who, portrayed in the alchemistic environment of his study, is a precursor of Grossand Agnew, is seated in a room that contains not only a rose (that may or may not have belonged to an absent woman) but also a crimson shawl flung over the chair for whom it is hard to imagine a male owner. One might also cite the way in which women are portrayed in claustrophobic interiors or isolated in rooms lacking signifiers for the real (the painting of a concert singer in which only the conductor's directive hand emerges from the bottom left corner is a peculiarly resonant piece in this respect[67]) in contrast to the eroticised rowing and sporting studies of male subjects. Finally, Eakins's habit of painting over the canvases on which he had depicted female subjects, including his wife, might also be mentioned as a form of exclusion.[68]

The forms of exclusion outlined above can be followed through on a theoretical level. Woman is excluded in Eakins's work actually (she is not a member of any audience, she does not participate in masculine sports) or theoretically (she is shown as a nurse with subordinate honorary status in the masculine world of medicine or she is unconscious, like Agnew's patient). If present she is strictly confined either by loss of movement (she sits at the piano or in an armchair) or by loss of sight (she covers her face or looks down). The equation of woman with lack follows from the identification of man with specularity which we have established above. But, as Mulvey and Silverman have pointed out, there is a paradox inherent here for if woman is identified with lack how can she retain the gaze of which she is the object?[69] There are two ways

in which this paradox is resolved in Eakins's work.

In the first place, the male subject is protected against the lack that is constituted by his absence from the point of production (that is, from the phallic authority of the artist and from the encounter with Gross's clinic in actuality) by his ability to identify with all the phallic characters that Eakins offers to use like football players waiting for the photographer to arrive. There is no enigma about *them* – they are perfectly vislbe and would remain so wherever we notionally moved around the stage of the operation. They literally encircle us and we, as viewers, occupy their seats. It is for this reason that it is so difficult – and so necessary – to posit a female viewer for this painting.

The second way concerns the figure of woman. Fried proposes the empty and contorted hand of the woman in *The Gross Clinic* (see plate 13) as a figure both for the act of castration and for castratedness as such.[70] At the same time he declines to discuss this castrated female figure, concluding only that 'the figure of the mother functions psychoanalytically as a pivot around which both structures [the successful resolution of the oedipus complex and the pathological wish-fantasy of being sexually possessed by the father] turn'.[71] He seems by this, though it is not entirely clear what is intended, to be locating the woman outside the narrative as some kind of emblematic representation. In any case, it is surely not the gesture of her hands that is significant (though this is certainly provocative) but that she holds them towards the viewers of the painting as though it were them she would not see, that she renders invisible a scene which she would not be able to catch sight of given the position of Gross and his hidden assistant, and that she possesses no defining facial or physical characteristics apart from her hands which render her 'blind'.

This woman whom we cannot recognise represents lack and (by *her* refusal to recognise both the vent taking place and the audience, including the painting's viewers) raises into question the whole matter of the Realist enterprise. But the prize that is won when the (male) viewer wins the battle of recognition over the patient's naked thigh and stockinged foot is ample compensation for those moments of anxiety. For the fragmented body that is object of the gaze functions as a fetish and as a reified human subject, confirming both phallic authority and the functioning of Realism as an art form.[72] It denies the lack that Realism invariably constitutes for the viewer and the lack that the suppressed female subject invokes.

On a biographical level – that is, on the level upon which

Fried often works in his essay – the fetishised patient's body
denies the lack that Eakins's allegedly persistent (and fruitless)
requests to women to pose for him in the nude would have
revealed,[73] and denies the recognition of the foreclosed real
from which even the study of the academic model absolutely
naked (an issue over which Eakins lost his academic teaching
position) would have failed to protect him.

In *The Agnew Clinic*, which is painted in lighter times than
The Gross Clinic, the audience of male students is more clearly
visible (see plate 15). The object of the authoritative medical
gaze is woman. The split functions of *The Gross Clinic* (lack and
restoration) are here dealt with through this one figure whose
body has become the site of scientific knowledge and medical
power. If power is phallic then this operation, which will
mutilate woman's breast (symbolically damaging and desexua-
lising her), will confirm phallic authority and deny the lack that
the carefully veiled lower half of her body (over which one of
Agnew's assistants is poised) would declare.[74] Woman stands

18. Thomas Eakins,
*Margaret in a Skating
Costume*

here, therefore, as a sign of lack and simultaneously is treated in such a way as to marshall the full armoury of knowledge and institutional power against that lack. Two discourses of power, that of Art and that of Medicine, intersect at the moment of high Realism over the incapacitated body of a semi-naked woman. For this reason *The Agnew Clinic* represents an 'advance' over *The Gross Clinic*, an advance to which developments in surgical practice are only one contributory factor.

Fried acknowledges that he stands squarely opposed to scholars who see later work by Eakins as paradigmatic for his entire production and therefore insist that Eakins was from the outset a portraitist.[75] In so far as it involves a confrontation with an other (as with Eakins's paintings of women, starting with his portrait of his sister in skating costume; plate 18[76]) portraiture involves a re-enactment of the scene of splitting and of difference, whether of the castration scene or whether of those earlier scenes which the castration scene may be designed to protect against.[77] The relationship between the portraits and the clinic paintings may well, therefore, be one of thematisation as well as one of genre and style. The clinic paintings allow for the elaboration of those problems of sexual difference that portraiture invokes but does not address.

In an analysis of this kind issues of reception are equally open to interpretation. It is, therefore, appropriate to suggest finally that if the clinic paintings permitted the construction of a system of defence against sexual difference and the unavailability of the real, the means employed by the artist in painting those pictures with their arresting images of blood and the human body, as well as the particular circumstances of their exhibition,[78] ensured that a scenario which featured both profound rejection and profound affirmation – a repetition of the primal scene of castration – would be enacted.

For Fried, the 'masterpiece' – and the very word would bear scrutiny in the context of a Freudian analysis – of Eakins is promoted as the successful resolution of the oedipus complex. Fried deploys psychoanalytic theory in a dense analysis that serves to reaffirm a third institution, that of the history of art, and the role of the male writer within that institution. My argument hinges on a psychoanalytic theory of viewing and, by using this as an approach to historically specific questions of Realism and of discourses of power, I have proposed that Eakins's *The Gross Clinic* and *The Agnew Clinic* can be understood as works that address for a male audience the crisis of sexual difference and the crisis of Realism by assigning to woman the specific role of lack.

LIBERTY ON THE BARRICADES: WOMAN, POLITICS AND SEXUALITY IN DELACROIX

Eugene Delacroix's painting *Liberty Guiding the People*, more often popularly known as *Liberty on the Barricades* (plate 19), is one of Europe's most familiar images. The picture, and especially its central figure, has effectively never been out of sight. To state what the painting represents, however, is to imply that everyone sees the same thing. For Eric Hobsbawm it shows 'a bare-breasted girl in Phrygian bonnet, stepping over the fallen, followed by armed men in characteristic costume'.[1] For T. J. Clark, however:

in Delacroix's *Liberty* it is the worker and the street-urchin who predominate. the National Guard lies dead in the foreground, his tunic torn and his helmet off: the cocked hat and the immaculate jacket of the Polytechnicien are glimpsed in the background, over the young bourgeois' shoulder to the right. And around Liberty cluster the student and the mob; there are five figures close to us and four of them are the canaille, the rabble.[2]

It is significant that Clark emphasises only living figures, ignoring for the most part the recently dead in the immediate foreground, closest to the viewer. I shall return to these figures later.

In so far as it is possible to be precise about the circumstances surrounding the picture's production, they are as follows. The July Revolution broke out after publication of Polignac's four notorious ordinances, signed on 25 July 1830. In three days Charles X's monarchy was overthrown by a spontaneous uprising of the Paris workers led by former soldiers, National Guardsmen and students of the Ecole Polytechnique. Delacroix himself was not present, though Alexandre Dumas tried hard to identify him with the figure of the top-hatted bourgeois in the foreground now generally agreed to be Etienne Arago, director of the Théâtre de Vaudeville.[3] Delacroix's own political alignment was Bonapartist, but in 1830, as opposed to 1848, Bonapartism and republican sentiments were confused

and not incompatible. His intention to paint *Liberty on the Barricades* is first recorded in a letter of 12 October which makes clear his lack of active involvement. 'I have undertaken a modern subject, *A Barricade* ... and if I didn't fight for my country, at least I will paint for her.'[4] He completed the picture by December and it was accepted by the Salon jury on 13 April 1831.[5] Byt the time the exhibition opened on 1 May, Lois Philippe was well installed and republican views were judged subversive. Finally Louis Philippe purchased *Liberty* in order to placate republican opinion. But despite efforts to put it out of sight, the picture was acclaimed in 1848 in a way it never had been in 1831. It was engraved in 1848, shown with the Emperor's permission at the 1855 Exposition Universelle where it again created a stir, and engraved again in 1870.[6]

The figure of Liberty, usually wrested from her context, has appeared on the sleeves of record albums and the covers of books, on German, Russian and Spanish revolutionary posters, in protests against the building of the Centre Pompidou, on bank notes, postage stamps and advertisements for a variety of

19. Eugène Delacroix,
Liberty on the Barricades

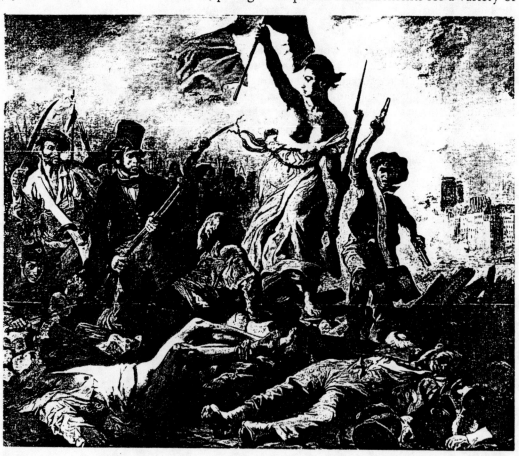

products ranging from wallpaper to computers.[7] Writing in
Encounter in 1972 about the trial of a Baader-Meinhof terrorist,
Melvin J. Lasky headed his essay 'Lady on the Barricades' and
declared: 'Her full right breast exposed, as in Delacroix,
Marianne angrily climbs on to the barricades. For 30-year-old
Margit Czenki the barricade at the moment happened to be the
cashier's grille in the Bavarian Hypotheken und Wechsel-
bank.'[8] John Heartfield's photo-montage *Liberty Fights in their
Ranks, Madrid 1936* and Paul George's *My Kent State* (1971–2)
take up the theme, while Alexander Moffat's portrait of a
group of contemporary Scottish poets, *Poets Pub* (1980) features
a depiction of Liberty on the wall in front of which the sitters
are gathered.[9] Red Grooms's *Liberty* of 1982 (plate 21) both
replicates Delacroix's image and interrogates its currency. Her
bland face and simpering smile derive from media stereotypes
of the feminine visage, the breasts (constructed of cardboard)
project into the viewer's space and Liberty's freedom-fighters
are reduced to two token male faces barely visible over her
shoulder.[10] For a painting that was received with marked lack
of enthusiasm at the time of its exhibition, *Liberty on the
Barricades* has attained an extraordinarily privileged status
within cultural history. By contrast, Jean Victor Schnetz's
massive painting *Combat de l'Hotel de Ville, le 28 juillet 1830*
(Salon of 1834), had little or no after-life. This may have
something to do with the fact that the central figure in this
striking image is not a woman but a man supporting a dying
boy in his arms.[11]

If Delacroix's painting has been so prominent in cultural and
critical discourse why should we wish to examine it yet again?

20. French postage stamps

In particular Hadjinicolaou has done a very thorough job and
Marina Warner in 1985 addressed the role of the allegorical
woman in a specifically feminist project.[12] But Warner's book
contributes nothing new to an analysis of this particular
painting, fails to address the question of gender on anything but
a very overtly narrative level, and presents the imagery of
Liberty on the Barricades as an essentially unproblematic expres-
sion of the artist's political 'disquiet' and the 'clash of cynicism
and optimism in his feelings'.[13] Hadjinicolaou, in a generally
excellent analysis replete with a massive amount of empirical
evidence, does not consider gender either and addresses sexual-
ity only through the materialist questions around class as
communicated through the isolated figure of Liberty.

21. Red Grooms, *Liberty*

The prime object of this chapter is neither to chart the role of Delacroix's *Liberty on the Barricades* in cultural history nor to offer new light on the painting as an object produced within any identifiable art-historical tradition. I have no new evidence to adduce on the specific relationship between the production of the painting and the events of 1830s. And I have no new information on Delacroix, the artist. *Liberty on the Barricades* is 'the most enduring image of the July revolution'[14] yet at the time of its execution its meanings were surrounded with uncertainty and they have been disputed ever since. Paradox- ically the very visibility of Delacroix's painting, and especially the visibility of the central figure, has rendered the painting virtually invisible as a totality. In so far as I refer to the literature of social and cultural history and of art history, it is to demonstrate how the complex and contradictory relationship between allegory, actuality, politics and sexuality is never confronted but always negotiated or side-stepped. My object is to address the question: what happens when you introduce the figure of a woman into a text?

During the British miners' strike of 1984, a *Guardian* corres- pondent reported seeing a naked woman posing on top of a taxi holding a National Union of Mineworkers' poster.[15] This incident – in which an anonymous unclothed woman posed on a public vehicle – demonstrates the abiding power of woman as a symbol in revolutionary politics. The fact that for the participants at the male rally a naked female on a taxi holding a strike-banner probably constituted at best entertainment (a living manifestation of page 3 fantasies) and at worst an example of bad taste, does not alter the fact that the presen- tation of female nudity or near-nudity in the context of a call to arms has an exceedingly long pedigree. We are not always aware of why we pick on stereotypes at particular moments; the explanation lies embedded in the general cultural conscious- ness. The *Guardian* reporter found it 'bizarre' but in fact this woman raised to a height above a crowd and bearing the insignia of the insurgents was a twentieth-century version of a living allegory, signifying an alliance of the erotic and the political, which would have been readily recognised in nine- teenth-century France. Whether or not she, as an individual, had any connection with the National Union of Mineworkers was immaterial; her role was symbolic. While absence of clothing may at one level signify the erotic, at another level – especially when accompanied by a banner or a flag into which the identity of the bearer is subsumed – nakedness signifies Truth. And the well-recognised iconography of Truth in

Western culture bears this out. The anonymous woman on the taxi as well as named women who participated in picket-line activity were particular and individual women. But they are valorised in discourse not for who they are but as aspects of womanhood culturally constructed.[16]

The process whereby actual characters participating in historical events are mythicised is common to women and men. Napoleon, Boadicea, King Alfred, Mussolini, Margaret Thatcher have all been in one sense transposed into the arena of the symbolic. It is a characteristic of powerful rulers to collude in this process. What we are considering here is rather different because we are not concerned with powerful rulers but with individuals who, if they ever did exist and possess an identity in actuality, have altogether lost that identity in the process of mythicisation.

Liberty on the Barricades (see plate 19) may originate in an actual event within the historical specificity of the 1830 July Revolution. It has been suggested that Delacroix was inspired by an anonymous pamphlet of 1831, headed 'An unknown event of July 1830', describing the heroic action of a poor laundry-girl Anne-Charlotte D. who dressed only in her petticoat ('*jupon*').[17] went in search of her young brother, Antoine, an apprentice gilder who was fighting on the streets on 27 July. At length she found his naked corpse, so the story goes. Counting ten bullets she swore to kill as many Swiss. She shot nine and was killed herself just as she was about to shoot the tenth.[18] Whether or not this is a 'true' account does not matter; the notion of a 'real' woman behind Liberty is amply reinforced in contemporary and subsequent commentary on the painting.[19] Liberty was perceived to be an allegory who retained her womanhood. Like the naked woman on the taxi, Liberty is simultaneously real woman and allegorical female. My concern is to examine the invisible seam where the one shades into the other and to consider what implications the ambiguities arising from that shading have for the painting's meanings. What cultural meanings are generated in the shifts, uncertainties and ambiguities between the axes of real and allegorical? They are ambiguities more readily manifest in visual than in literary forms.

To begin with we must ask why *Liberty on the Barricades* cannot adequately be explained by recourse to traditional art-historical procedures. Although a study of convention, of iconography and of reception is essential to any serious examination of the painting, it leaves unacknowledged and unexplained the central ambiguities of the work. Why, for a start, is

the painting not straightforwardly an allegory? There has
always been a tradition for introducing allegorical figures into
actual historical situations, most notably in Rubens's work.
The cycle of paintings relating to the Life of Marie de' Medici,
itself a programme with an overtly political aim, would have
been very familiar to Delacroix as it was located in the Palais de
Luxembourg.[20] Allegory, when she appears in a 'real' context
like this, can be said to constitute quite simply the visual
manifestation of an idea in someone's head. Thus art historians
may argue over whether the figure of Liberty derives from the
winged Victory of Samothrace or the Aphrodite of Melos,
both in the Louvre, and how far Géricault's *The Raft of the
Medusa* (1817) contributed to the foreground figures. But the

22. After Karoly
Kisafuldy, *A Magyar*

overall view would be that Delacroix's Liberty is essentially an unproblematic embodiment of a communal idea that drives these men forward towards the opposing forces defending the Hôtel de Ville. The fact that, unlike the Aphrodite or the Winged Victory, she has hair under her arms and the fact that she was widely repudiated by contemporary critics can be set aside. 'La femme est ignoble.' Her skin is dirty, she has only one leg, her figure is gross, wrote the critics.[23] But we with hindsight, the argument would go, recognise the convention for the representation of allegorical females in actual situations, and that is what matters. The picture is thus part of a tradition within which the relationship between real and ideal is explored in French nineteenth-century painting. Thus its successor is Manet's *Le Déjeuner sur l'Herbe*, discussed in the final chapter of this book (see plate 40), which presents the locus of contemporaneity and realism (which is male) in a setting redolent of allegory (which is female) but stripped of any evident iconographical meaning.

Art history, focusing on Delacroix's Liberty, can produce arguments of importance to feminist history *and* help to locate Liberty within a different tradition. We might point out that

23. Fred Roe, *Revolution*

there is a tradition for the representation of humble and often unnamed women engaged in heroic acts of warfare. They constitute a form of symbolic sexual inversion that serves to reinforce the existing order for, as Davis remarks, a world turned upside down can only be righted not changed.[24] Many of these Amazons acquire or are endowed with the attributes of great figures of the past such as the biblical Judith or Joan of Arc. Kisafuldy's image of a Magyar leading the troops is a type reiterated throughout Europe (see plate 22). The Napoleonic wars produced memorable modern versions of this brand of female heroism by Wilkie and Goya and the motif remained a crucial form of encoding in the class conflict. Fred Roe's *Revolution* (plate 23), probably painted in the last decade of the nineteenth century and apparently referring to the events in Paris of 1870, depicts a buxom red-lipped woman whose bared breasts, straw-stuffed clogs and courageous stance are enhanced by the genteel clothing and evident terror of the woman who clings to her.[25]

.Delacroix's Liberty certainly belongs with this lineage and also itself generates a great progeny especially after 1848 when, as T. J. Clark has demonstrated, many testified to the presence of individual women on the barricades.[26] Millet's drawing of a fierce woman trampling on men and dragging a woman by the hair is the best known of these.[27] In the most famous of the testimonies of 1848 we hear how:

a young woman, beautiful, dishevelled, terrible appeared on the barricade. This woman, who was a whore, lifted her dress to her waist and shouted to the National Guard: 'Fire, you cowards, if you dare, on the belly of a woman!' A volley of shots knocked the wretched woman to the ground. She fell, letting forth a great cry.[28]

Clark defines this reporting as travesty which is part deliberate invention. 'The image of the whore and the tricolour was not simply a lie or a piece of propaganda', he says. 'It was an attempt to match ... the horror of events.' Women, as Agulhon tells us, became standard-bearers, living allegories.[29] Nevertheless the motif remained an inversion, however fixed in social consciousness, and when Courbet adapted Delacroix's composition for the cover of Baudelaire's radical journal *Le Salut Public* (plate 24) in 1848, he subsumed Liberty into the male fighter with the silk top hat.

Reception aesthetics has drawn attention to a considerable disturbance around the exhibition of Delacroix's *Liberty on the Barricades*. Explanations for this disturbance are offered by reference to the current political circumstances within which

the painting was produced. Bellos has drawn attention to the wobble over the date and title of the picture – Delacroix gives 29 July and the official Salon catalogue gives 28 July which, given the speed of events, does make quite a difference in what the painting might be thought to represent actually. He also points out that the title varies between *La Barricade* and *La Liberté guidant le peuple*, with or without the date, and *La Liberté*. The curious uncertainty between the two dates – whether or not its cause or origin lies in a printing or a scribal error – is a movement between two different historical interpretations of the image and also between two different interpretations of history.[30]

The contradictory stances of critics around the issue of dirt in the painting are less readily explained by reference to the confused politics of 1830. Several commentators remarked on the muddy tones of the painting; 'a dirty and shameless woman of the streets', 'the most shameless prostitute of the dirtiest streets of Paris' are among the phrases used to describe the figure of Liberty.[29] Five of the critics identified by Bellos quote the well-known poem by Auguste Barbier which is generally accepted as providing a correlative for viewers of Delacroix's painting at the Salon:

24. Gustave Courbet, *Le Salut Public*

The truth is that Liberty is not a countess
From the noble Faubourg Saint-Germain,
A woman who swoons away at the slightest cry
And who wears powder and rouge
She is a strong woman with thrusting breasts
A harsh voice and a hard charm
Who with her bronzed skin and her flashing eyes
Walks agile with great strides
Delights in the shouts of the people, in the bloody melée
In the long drum rolls
In the smell of powder, in the far-off pealing
Of church bells and the rumble of canons
Who takes her lovers only from the people
Who lends her wide flanks only
To people who are strong like her, and who want to embrace her
With arms soaked in gore.[30]

Hadjinocolaou regards the accusation of dirt as deriving from the colour of the pigment with which Liberty's flesh is painted. This, like the suggestion of hair under the arm, ruptured the conventions of the Salon nude[31] and had, as T. J. Clark has established in his more recent study of Manet's *Olympia*, profound political connotations.[32] Bellos rightly points out that the identification of the goddess as whore comes from a wide political spectrum. He puts forward an argument which, without reference to gender or sex, explains the issue of dirt by reference to the political uncertainty of the context and the issue of class. Thus the goddess is seen as a 'common prostitute'; her role on the barricade can be seen as confirming the aristocratic-legitimist opinion of the reign of Louis-Philippe, brought to power by the rabble; *and* her role can also be seen, within the same general vision, as supporting the left-wing liberal view, namely that Louis-Philippe had betrayed a genuinely *popular* uprising.[33]

Persuasive though this is as a class analysis, it leaves unopened the question of why a 'dirty' woman, if that is what she is (rather than simply a proletarian), should be a symbol that is so widely recognised. As Mary Douglas says: 'Dirt ... is never a unique, isolated event. Where there is dirt there is system'.[34] Moreover this analysis pre-supposes one single meaning (and two opposing interpretations) inscribed in the image of the woman as Liberty, the evacuation of all other meanings and the isolation of the main figure from its pictorial context.

The iconographers, chief among whom are Agulhon and Hobsbawm, have also concentrated on the figure of Liberty removed from the pictorial construction of which she forms a

part. They examine her role as bearer of meanings relative to gender. For Hobsbawm she is 'an active emancipated girl'.[35] For him, as for Heinrich Heine, whose response to the painting (which he saw in the Salon of 1831) has been examined by Margaret Rose, Liberty is a Venus of the streets, her semi-nudity a sign for Saint-Simonian sexual and social emancipation.[36] With astonishing facility Hobsbawn discards Liberty's function as allegory. The figure's 'concreteness removes it from the usual allegorical role of females', he says. 'She does not inspire or represent; she *acts*.' This is the cue for Hobsbawm to ask why, in the imagery of the labour movement, women become images of suffering (as in the figures of Käthe Kollwitz) while the clothed male appears to begin to replace the unclothed or semi-clothed female as image of the heroic proletarian.[37]

Hobsbawn desevedly gets severely reprimanded both by feminist historians and by the French historian Agulhon. the former point out that Hobsbawm is guilty of comparing images and emblems with 'the social realities of the period' as if we were unquestionably in possession of a full and accurate knowledge of what these realities were.[38] Agulhon in turn gives a detailed account of the genesis of the figure of Liberty

25, The first seal of the French Republic

and of her assimilation into the personification of the Republic in official iconography after 1792, and establishes the importance of convention in the dissemination of this particular image, a question wholly ignored by Hobsbawm. Thus in 1792, we learn, it was decreed that the Republic should be represented by a seal (plate 25) which was 'to bear the image of France in the guise of a woman dressed in the style of Antiquity, standing upright, her right hand holding a pike surmounted by a Phrygian cap or cap of Liberty, her left resting upon a sheaf or fasces; at her feet a tiller and as an inscription, the words: in the name of the French Republic.'[39]

Agulhon's work establishes the frequency of images of Liberty and the process whereby Liberty appropriates the traditional role of the Virgin Mary in popular cults. Whether Liberty is a saint or a trollop depends on how you view the politics of liberation. Agulhon distinguishes between the alluring Liberty who is a child of nature and therefore semi-naked, and the nourishing life-giving Liberty who suckles her children (as in Daumier's celebrated image of the Republic).

On the question of nudity Agulhon states that a chastely clad Liberty represents the politics of moderation and that the exposing of parts of the body has a fundamental democratic significance. We must not, says Agulhon, equate nudity with sexuality, otherwise all allegory is sexual. If Hobsbawm makes misguided assumptions about the relations between art and society, Agulhon is in danger of assuming that there are no such relations. The account in his book *Marianne into Battle*, essential though it be to any student of the subject, does not explain the trainsition from the chaste and emblematic representations of Liberty that were a commonplace of the period to Delacroix's arresting figure.[40] Agulhon's argument excludes multiple meanings or metonymic connections. While nudity does not *necessarily* imply sexuality it is absurd to insist that it never does so. And allegory need not, *per se*, render imagery immune from representations of sexuality.

Now here we come to the main focus of my concern: how, if at all, are questions of gender and sexuality a part of this image's complex and many-layered communication? Hobsbawm recognises the latent eroticism but accounts for it in terms of class. Hadjinicolaou, too, separates Liberty from her surroundings and reads her sexuality represented through the medium of dirt as a sign for class: 'From all points of view, this dirty woman can only be a *woman of the people. Liberty guiding the people* is no more than a woman of the people guiding the people.'[41] T. J. Clark, evidently profoundly uncomfortable

71

here with the notion of sexuality, says: 'It is not, of course, that the final Liberty is sexless, far from it. But her sexuality is a public one: her nakedness is not one with which Delacroix was endlessly familiar: her breasts and shoulders are those of Marie Deschamps' (a working woman on whom tracts and pamphlets had been published).[42] Clark turns back to the artist and, by looking at sketches, proposes a figure that has grown into pulbic image out of the habitual private fantasy, a fantasy that can be pictorially related to female figures in non-contemporary themes. He sees the sketch as privately erotic and the painting as publicly sexual. The implication is that if female sexuality is made public it becomes as a consequence politically identifiable with a position on the left. Agulhon refuses the question of sexuality altogether by insisting that nakedness is exclusively a convention and, as such, cannot carry other meanings beside those that belong in tradition with the convention.

Without rejecting the historical appropriateness of the various political readings of the painting that have been proposed, I would like to suggest that there is a further hitherto unexplored level of meaning within this work, a level which centres on the politics of sexuality and the recognition of gender/power relations. The central paradox of Liberty as a concept (freedom is good but licence is bad) is represented through the visual paradox of the exposed body in which nakedness symbolises Truth but nudity suggests sexuality. The relationship of women's bodies to history is, as Brown and Adams have pointed out, complex and, as yet, unfathomed.[43] They speak of the 'ambiguity which allows the body to be ever present and hence a witness to history and yet never implicated in that history and always there only in a repressed form'. We might add, in relation to a discussion of *visual* representation, in a conventionalised form. 'We cannot know in advance the precise intersection (if any) of questions of sexuality with questions of the body with respect to any particular issue.'[44] In the issue of revolutionary struggle it would seem that the presence of woman is requisite to representation as a symbol of the ireconcilable duality of the feminine (hearth and home in opposition to war and the picket line) and the sexual as socially constructed (naked women with banners, whores with dirty skins). It may well be that this duality is an essential component in the psychology of aggression. Sexuality is a powerful agent in political discourse (we only have to look at the imagery of fascism to recognise that).[45] What I want to suggest here is that it *does* matter beyond the consideration of convention and its

operation that Liberty is a woman, that her function in the painting is more than the simple embodiment of an idea in people's heads, that she cannot be explained as an unproblematic cypher for proletarian struggle. We must ask what happens when you introduce the figure of a woman into the picture. There is a discourse of sexuality in the picture such as cannot be adequately explained by the iconography of republican or proletarian imagery. In other words, the recognition of sexuality in the figure of Liberty, a recognition that has been historically mediated through her identification with prostitutes and dirt, cannot simply be assimilated into an argument about republican or anti-republican sentiment.

In opposition to the usual practice of looking for sources for particular motifs (comparing Liberty with the sun images of Delacroix's teacher, Guérin, for instance),[46] I want to look at the imagery in terms of its deviancy. We might call them negative comparisons. In the first place we will ask not what the source is for the figure of Liberty but where in the canon we find the figure of a woman singled out and surmounting a pile of bodies. In military scenes it is normally a male function;[47] the female equivalent is the harvest waggon. Here wholesome images depict a buxom woman surmounting an energised mass of humanity.[48] Delacroix's painting calls up this image and in an apparently unnatural alliance fuses it with notions of military conquest, forging a connection between what is male and what is female. Liberty, for all her fine, wholesome, thrusting breasts, surmounts a pile of debris and bodies – male bodies. She is a powerful woman striding towards the viewer over the bodies of dead men.

Liberty's allegorical status does not protect her from direct association with violence and death. Indeed, as Bellos points out, the overt message of a painting featuring both Liberty and a barricade has to be that violence is necessary to the attainment of liberty.[49] Earlier representations keep Liberty, in her allegorical role, clean of violence; she enters the stage at the final point in the narration, as a divine witness to the goal having been attained as in Bernard Debia's *L'Arbre de la liberté* (Montauban, Musée Ingres; see plate 26). In pictorial imagery, once a woman is associated with violent confrontation even if she is symbolic or token rather than individual or participatory, the accusation of prostitution is frequently levelled at her. And this is true of life as of art. The accounts from the 1984–5 British miners' strike of women observers at the picket line being told to 'get back home, you whore, you prostitute' by the police were legion. The perturbation over the question of dirt in this

image is a direct consequence of the deviation which substitutes a harvest of death (of whatever side is not important at this level) for a harvest of corn. The filth is metonymically transferred, in the minds of the viewers from the barricade to the woman just as class and political hatred are focused on sexuality when the police allegedly abuse miners' wives.

The concreteness of the figure of Liberty (the hair under the arm, the hand grasping a contemporary firearm) is not only a feature that can be interpreted as an image of emancipation and enthusiasm on the part of the proletariat. It is rendering visible that which should remain implicit and which, having been made visible, is extremely threatening. Nakedness in its guise as Truth has the power to inspire. But sexuality is inherently dangerous; it is the recognition of sexuality that leads to the naming of Liberty as a whole.

Historians of sexuality have drawn attention to the construction of woman both in terms of gender difference and around the polarity virgin/whore. 'the bourgeois lady's (a)sexuality

26. Bernard Debia,
L'Arbre de la liberté

was defined against not only the prostitute but also a sexuality imputed to working-class women in general.'[50] It is also significant that one of the 1831 critics described Liberty as 'une pensionnaire de Bicêtre' (an inmate of one of the Paris lunatic asylums) and that Du Camp in 1855 suggested that she had escaped from St Lazare.[51] These identifications of Liberty with

27. Anon., Polish cartoon

lunacy suggest that she may well have been apprehended as precisely the type of the hysterical woman whom Foucault names as a privileged object of knowledge and also as a target and anchorage point for ventures of knowledge in the construction of sexuality.[52] The line between inspiration and fear is a very narrow one. the eroticism of the partially clothed can give way to terror before the wholly exposed as an anonymous Polish cartoon with its nexus of sex, danger and power indicates (see plate 27). The woman soldier here exposes herself above the dug-out and the men run away clutching their grenades.[53] The sexuality of Liberty is, as Clark points out, very public. One might draw attention to the disjuncture between the profile cameo head of Liberty and the three-dimensional body with breast as the composition's centre. But it is a mistake to locate sexuality in Delacroix's painting exclusively within the figure of Liberty, for all that it is upon her that the critics' attention focused and continues to focus. Sexuality is constructed within the picture as a whole by a complex concatenation of images. The whole painting becomes the site for the construction of sexuality within imagery *and* within history. And here I want to move on to a second deviant point or negative comparison.

David's *Oath of the Horatii*, it has been suggested, divides male activity from female passivity; in *The Intervention of the Sabine Women* by the same artist, female activity merely constitutes a screen between us the viewers and the world of male violence.[54] In Delacroix's painting Liberty in full-bodied vigour strides towards us; we are separated from her predominantly by the corpses of two men. Both are sexually suggestive and the one at the left is manifestly erotic with his finely featured head flung back, his abundant dark hair falling away, his shirt open to reveal one nipple, his naked legs arranged to show his pubic hair (though not his penis) and one sock — suggesting the déshabille of the boudoir as much as the spoilation of the battle-ground.[55]

It may be said that in so describing this figure I am guilty of precisely the same subjective defining of the erotic that feminists have rejected in male discourse. As the photograph of the man in swimming trunks posing on top of a motor car in parody of the motor-show advertiser's cliché demonstrates,[56] we are culturally conditioned, in a society in which heterosexuality dominates image-making, to recognise the erotic via images of women. Leo Steinberg's work has shown, moreover, how we can be culturally conditioned to be oblivious to parts of images that disrupt a dominant received notion.[57] In this case

the received notion is that the figure of Liberty constitutes the image and she, in isolation, is the site for the sexual or political discourse. Contemporaries noticed the corpse in the foreground and attention is drawn to it by the gaze of the terrified young freedom-fighter at the left which passes directly over this body in its confrontation with the enemy; it is a body which, in its exposed finesse of limb, is as deviant from its source among the emaciated corpses in Géricault's *The Raft of the Medusa* as it depends upon them. The tension between the exposed flesh of the living Liberty and the deceased flesh of the man is striking. The phallic gun of the *sans-culotte* to the left explicitly reinforces the theme, making visble what, on the corpse, is hidden. The complex metonymic structure of Delacroix's picture can, perhaps, most clearly be apprehended if we set it alongside the celebrated documentation of 1851 and 1870

28. Jacques-Louis David,
Marat assassiné

by Meissonier and by Manet from which this tension is absent.[58]

It is significant that posterity has frequently lifted the figure of Liberty away from her barricade. The picture, taken as a whole, is poised uncomfortably on the threshold where subtext becomes text. In attempting to examine this seam or juncture, it is worth noting two facts from Delacroix's life. Firstly, his diaries contain many accounts which suggest a fundamental fear of women. He longed for women, was very disturbed by them, but needed their presence. He was often impotent. Baudelaire, in a testimony that is not without ambiguity, said of Delacroix:

Long before his death, he had expelled women from his life ... In this question as in many others, Oriental ideas got the upper hand in him in vivid and despotic fashion. He considered woman as an *objet d'art*. If permitted to cross the threshold of one's heart, she would ravenously devour one's time and strength.[59]

29. Evard Munch, *Marat assassiné*

In the second place, we should remember that Delacroix himself regarded the whole enterprise of *Liberty on the Barricades* as a sublimation for his own non-participation in the actual violence: 'if I didn't fight for my country, at least I will paint for her'. So that the visual image itself constitutes, for Delacroix, a kind of vicarious involvement with life.

Delacroix's has allowed into his picture an implicit alliance between the erotic and the political which transgresses in so far as it begins to transform into an imagery of sexuality that is, essentially, an imagery of power. And here I come to the third example of deviancy from the expected or the anticipated. In David's *Marat Assassiné* (plate 28), the murderess, Charlotte

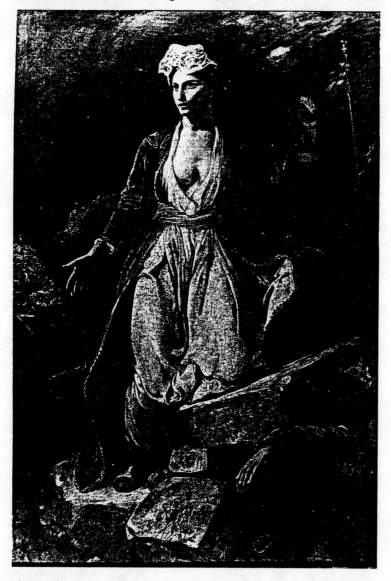

30. Eugène Delacroix,
*Greece on the Ruins of
Missolonghi*

Corday, is expelled from the narrative. Only her handwriting – annexed as a document of history – remains. Marat's murdered body is sanctified, purified, de-sexualised. It is in striking contrast, for example, to the corpse in the foreground of Delacroix's painting. In fact we know that Marat had a very fancy bathroom and was stabbed by a young woman. Munch's lithograph *Marat Assassiné* (plate 29) restores to the narrative the explicitly sexual motif that David carefully evacuated. The events surrounding the death of Marat would have had sexual implications: an unknown young woman enters the famous man's bathroom and stabs him while he sits naked in the bath. David recognised the need to neutralise those implications if the painting were to be about anything but sex. The option of neutrality is not one chosen by Delacroix; on the the contrary he chooses to play upon precisely that conjunction of violence, sexuality and death that David avoids. Given that the naming of woman as whore constitutes recognition of sexuality inscribed in imagery, the indecision among critics about whether Delacroix's Liberty is a whore or a heroine is a response not only to political uncertainty but also to ambiguity in the construction of sexuality within the picture, and by implication within history.

The same ambiguity is apparent in Delacroix's earlier painting *Greece on the Ruins of Missolonghi*.[60] The image is, like that of Liberty, essentially contradictory. Is she a personification of Greece or is she a Greek woman who symbolises her country? Her half-open lips, heavy-lidded eyes and clothing which reveals most of her breasts and falls in suggestive folds between her legs make her an erotic and desirable image. Her gesture is one of surrender, or one of appeal. The connotations may be sexual and/or political. In the distance a Turkish warrior stands guard but it is Greece who occupies the painting's space and kneels with her weight upon a great boulder from beneath which appears the hand of a dead man. The lower foreground contains, at rhythmically defined intervals from left to right: the artist's signature (his verification of the painting and his sign of affiliation to the text), a splash of blood and a disembodied human hand very similar to the hand at the bottom right of *Liberty*. The severed right hand functions on a symbolic level in association with the artist's signature whose position it matches on the paint surface. It represents the artist's creative effectivity and, imaged thus, has powerful connotations of castration. It is the sign on a simple pictorial level for the castration anxiety that is metaphorically expressed in *Liberty on the Barricades*.

To ask whether the painting is sexual or political is to ask the

wrong question because *Greece* is a painting in which – in a less complex manner than in *Liberty* –the political in the sense of the war between the Greeks and the Turks is communicated via the intensely personal exploration of the ambiguous relationship between sex and power. In this relationship the vanquished possesses power, female sexuality is both bloody and inviting, and male individuality is reduced to a limp token hand under a stone.

It is significant that for most of its life this painting has gone under a title other than its original one. It was not possible to describe Greece as dirty or as a whore; Greece was the beautiful cradle of western civilisation, the home of Antiquity, raped by the Turks. But is was possible to mis-recognise her. When the picture was exhibited in 1829 it bore the title La Grèce (Allégorie). 'She is represented with the appearance of a woman weeping on the ruins.' Until very recently, however, the picture has habitually been known as *Greece expiring on the Ruins of Missolonghi*.[61] The process whereby a strong woman, powerfully pleading, is recognised as a woman at her last gasp, expiring, is curious indeed.

Delacroix's own political displacement in 1830 finds expression not only through a narrative which celebrates an alliance between the bourgeoisie and the proletariat but also – and on a profoundly disturbing level – through the visual exploration of his own ambivalence towards sex and power. The partially clothed, naked woman introduced into the discourse of contemporary politics can never been exclusively allegorical *or* exclusively 'real'. Sex is a metaphor for confrontation and violence is a means of exploring sexuality. Violence is, as we have seen, inextricably connected with Liberty in Delacroix's depiction of 1830. In *The Death of Sardanapalus* (1828, Paris, Louvre) and many other paintings Delacroix depicts violent acts perpetrated on women by men. In *Greece* and *Liberty*, however, powerful women hold sway in a world of male violence. They do not intervene like the Sabine women, they are not shadowy figures seen in the distance like emblems of the feminine in Millet's 1848 *Liberty*. They reign triumphant. And the visual statement of Greece is thus in contradiction with the narrative. She cannot logically be both defeated and dominant. But this is the central paradox of the relationship between realism, allegory, politics and sexuality. Both Greece and Liberty are sexually dominant in a world of male carnage. Misrecognitions of Liberty as a prostitute or of Greece as a dying figure are in no sense 'incorrect' since the powerfully affective central paradox of both images demands a contradictory response.

As this chapter has drawn upon questions of collective response and their relations with artistic intention, it is appropriate to conclude by bringing together two aspects of *Liberty* and *Greece* which may seem to reinforce – and to some degree explain – the ambiguities of images which simultaneously eroicise and demonise woman. *Liberty* and *Greece* are both signed by the artist within the image field. As Peggy Kamuf has pointed out, 'the signature points at one extremity, to a properly unnamable singularity'. In this instance thesingularity of Delacroix stands in opposition to the precisely unnamable generality of woman as Liberty and as Greece. 'As a piece of language', Kamuf continues, 'the signature touches at its other extremity, on the space of free substitution without proper reference.'[62] The signature pulls in two directions at once, appropriating the image under the sign of the name and expropriating the name into the play of the image. In *Liberty* Delacroix's signature is inscribed on a spar of wood which makes up the barricade over which the figure of Liberty strides; in *Greece* it can be seen clearly on the rocks upon which the weight of Greece bears down. The position of the signature in the first instance (and this is a question that is important in visual imagery in a way that has no equivalent in writing) invites a theoretical bringing together of agent and theme, of sign of practitioner which is masculine with figure of violence which is feminine in the space of representation. In the second case this trait of common language marks the rocks of Greece which are the territorial and material analogue to Greece as woman. We have observed the ways in which these particular images have been interpreted and mobilised collectively since the time of their production. Readings that also bring into play the psychic dimensions of individual creativity have been offered. Pulling in two directions and demanding to be understood as conceptual and as denotative, as historical and as actual, as writing and as image, Delacroix's signatures finally seek to disrupt by their linguistic authority the play of feminine power that those images have proposed.

BIOGRAPHY AND THE BODY
IN LATE RENOIR

I

Some time between 1908 and the time of his death in 1919, Renoir, severely crippled with arthritis and rheumatism, had himself photographed in his studio at Cagnes. He is seated in a wheelchair, fully clothed for the outdoors, and his hands are bandaged to protect the palms. To the right, with one hand resting on the back of his chair in a protective gesture, and one hand seemingly holding together her bodice, stands his model. To the left, occupying the remaining space – for the interior is darkly impenetrable – is a canvas resting on an easel. Painted on the canvas we clearly discern the figure of a naked woman.

The construction of male artist, female model, and painting which either metaphorically or mimetically incorporates and reproduces the female presence is a familiar one. We will see it in Courbet's *The Painter's Studio* (see plate 32) (and again in Brassai's photograph of Matisse in his studio and in Picasso's studies of painters and their models).[1] Durer's diagramatic depiction of the artist in his ingenuity seeking mastery over the three-dimensionality of nature in the form of a naked female model lies at the root of all these images.[2] Here again, as in the first chapter, we see how the representation of woman can be seen to stand as cypher for the act of representation itself. The female body in art becomes the site of the struggle for mastery over the process of mimesis.

The photograph constructs Renoir in his capacity as an artist, as one able to transform into nudity the nakedness that the clothed model will reveal when her bodice is opened and her clothes fall to her feet. I use the term nude in its sense of the conventions within which the naked body is represented within high art forms, observing unwritten rules concerning such matters as pose, gesture and the absence of body hair. The

distinction between nakedness and nudity, as we have established, is enshrined in nineteenth-century cultural discourse. T. J. Clark has pointed out that it is through the strenuous maintenance of this distinction that the politically dangerous discourses of sex could be controlled. As Maxime Du Camp wrote in 1863:

Art should have no more sex than mathematics. The naked body is the abstract being, and thus it must preoccupy and tempt the artist above all ... but to clothe the nude in immodesty, to give the facial features all those expressions which are not spoken of, that is to dishonour the nude and do something disreputable.[3]

Unlike Courbet and Matisse, Renoir does not wield the brush and his body is projected as enfeebled, crippled, inactive. We might anticipate that this would in some way detract from the image of artistic power but quite the opposite seems to be

31. Anon., Photograph of Pierre Auguste Renoir

the case. Occupying the apex of the inverted triangle, Renoir's
inert and muffled body appears to command the two terms of
the feminine, in 'art' and in 'life', that flank his presence. How
does the fact that this masculine body is crippled affect our
reading of this relationship? The juxtaposition of immobile,
crippled and aged masculinity with feminine youth and beauty
invokes the commonly held belief in the therapeutic effects of
youthful animality on ageing bodies.[4] It also, however, invokes
the type of the entombment as reiterated, for example, in
Manet's *Christ between Angels* (1864, New York, Metropolitan
Museum).

I have concentrated at length on this photograph for a
number of reasons. As an image it offers the apparent contra-
diction of a body which is at one and the same time the heroic
male artist in the Courbet mould and a suffering Christ-like
figure whose power to affect is, like Christ's, determined by the
promised destruction of that physical body. This contradiction
also poses a problem of intertextuality. In 1897, Renoir fell off
his bicycle and broke his arm, precipitating attacks of arthritis
and rheumatism that slowly paralysed him. Against this trajec-
tory of declining health and decreasing mobility can be set the
gradual manifestation of an obsession with the naked female
body transformed into the nude through the agency of a style
which grew increasingly fluid in proportion to Renoir's own
loss of physical movement. The popular view is that Renoir
struggled and, despite his disabilities, achieved an increasingly
open and painterly style.[5] My argument is that the artist's body
as narratised through family dramas and as produced in repre-
sentation (photographic and verbal) in a structural relationship
with the body of the model is inscribed in and across the series
of late nudes that are a major – and difficult – feature of his art.
The discourse of the sickness of the masculine body thus under-
pins the discourse of the female nude and its health.[6]

The production of paintings characterised by health, clean-
liness, mobility and nature (and publicly acclaimed in those
terms) takes place in the context of a public and a private
discourse of bodily decay. Thus we have Renoir suffering at
Cagnes, recorded in detail by Jean Renoir and by Ambroise
Vollard, both of whom, by virtue of their roles as son and as
collector, stood in special relationship to the artist within the
narratisation of the body of the artist and the body in his art:

His body became more and more petrified. His hands with the fingers
curled inwards could no longer pick up anything. The truth was that his
skin had become so tender that contact with the wooden handle of the
brush injured it. To avoid this he had a little piece of cloth inserted into

85

the hollow of his hand ... His nights were frightful. He was so thin that the slightest rubbing of the sheet caused a sore ... In the evening he would put off as long as possible the moment when he would have to undergo the 'torture of the bed'.[7]

The visitors, we are told, came to Renoir because he couldn't go to them. The life thus remained a public spectacle even though the artist lived in retirement. The ritualised last visit of the frail and crippled artist to pay homage to the paintings in the Louvre is at one and the same time an affirmation of his status in the public arena and a display of his own physical decay.[8]

The photograph of Renoir in his studio at Cagnes is also a significant starting point because it aptly poses for us the central problem of the autobiographical. Photography, as is now widely recognised, does not offer unmediated truth or special access to history.[9] Nor does autobiography, which constructs self as other, thus problematising the notion of 'I' and the notion of 'other'.[10] Renoir did not take his own photograph or write his autobiography. The photograph resulted from the intervention of an anonymous photographer, and the account of Renoir's life, views, opinions and actions appears under the signature of his son. At some level, however, these are authorised productions in which Renoir as object is also Renoir as subject. They are texts within which Renoir inscribes his name and registers his presence. They are fictive accounts that work to produce an identity 'artist' with a referent that is the female body in art. The blurring that occurs between the biography and the autobiography is part and parcel of a politics of representation which we cannot afford to ignore in our rejection of a simplistic and unifying 'man and his work' narrative of artistic production.

The Renoir literature, and in particular the memoirs of Jean

32. Albrecht Durer, *Draftsman Drawing a Nude*, from *Unterweysung der Messung*, 1538

Renoir and of Julie Manet,[11] invites a view of Renoir as a
confessional individual, imparting intimate information.
'Anyone can look at my materials or watch how I paint – he
will see I have no secrets', he is recorded as having declared.[12]
'There is no secret museums in his work', says Duret.[13] Yet, as
John House has pointed out, this is a man who also possessed a
high degree of reticence and reserve, failing to introduce his
common-law wife, Aline, to the Morisot circle or tell them of
her existence until his son, Pierre, was six.[14] This is the man for
whom it would seem that the secrets of women and the
intimacy of sisters were ever an object of fascination as his
frequent renderings of pairs of women suggests. There are,
indeed, notable resonances between some of Renoir's depic-
tions of women in intimate communication and the narrative
of secrecy in Freud's case history of Dora, an account which has
been analysed in a substantial literature as symptomatic of late
nineteenth-century conflict between patriarchal law and female
sexuality.[15]

Above all, we might observe that Renoir devoted the last
years of his life to the most powerful signifiers of secrecy –
women's unclothed bodies. If it seems paradoxical to describe
the nude as secret, it is precisely the very public nature of the
nude as a motif in high art that ensures the perpetuation of
female nakedness (with all its sexual connotations) as a discourse
of secrecy. For the nude is invariably the site of surveillance and
control, the point of generation of discourses on sexuality, even
if those discourses centre on the absence rather than the
presence of visible signs of sexuality. Woman's sex is, as
Irigaray puts it, that 'nothing to be seen'.[16] And it is worth
pointing out that the absence of sexual identity in Renoir's
images of women was an issue that concerned at least one
contemporary critic:

La femme, surtout, l'obsédante femme ... Pourquoi aurait-elle un cœur,
un cerveau, une âme? Elle est jolie! Elle est jolie! ... Et cela lui suffit et
cela nous suffit ... A-t-elle même une sexe? Oui mais qu'on devine sterile
et seulement propre à nos pueriles amusailles.[17]

Woman, above all haunting woman ... Why would she have a heart, a
brain, a soul? She is pretty! She is pretty! ... And that is enough for her
and that is enough for us ... Has she even a sex? Yes but one which we
can guess is sterile and only appropriate for our childish amusements.

The autobiographical is, therefore, foregrounded as
problematic in this consideration of Renoir's late work rather
than either ignored on the one hand or taken as fact on the
other. For, as Paul de Man claimed, the distinction between

87

fiction and autobiography is not an either/or polarity but is undecidable.[18] He asks whether it is possible not that 'life *produces* the autobiography as an art produces its consequences' but that 'the autobiographical project may itself produce and determine the life and that whatever the writer *does* is in fact governed by the technical demands of self-portraiture and thus determined, in all its aspects, by the resources of his medium'.[19] To register the production of self as other is not to admit of a reductive or a causal biographical reading. It is not to claim that the particular psychological or physical condition of the artist is expressed in such and such a way on the canvas. But it is to recognise the need to disassemble the homogeneous category of the artist's subjectivity that has functioned so powerfully in the writing of histories of artists such as Renoir, to scrutinise its construction and to recognise what Derrida calls the domain of the inscription of a subject inside his [*sic*] text. The passage, from Derrida's work on Freud, is worth quoting in full:

Beyond [*the Pleasure Principle*], therefore, is not an *example* of what is allegedly already known under the name of autobiography, and one cannot conclude from the fact that in it an 'author' recounts a bit of his life that the document is without value as truth, science, or philosophy. A 'domain' is opened in which the inscription, as it is said, of a subject in his text, (so many notions to be re-elaborated) is also the condition for the pertinence and performance of a text, of what the text 'is worth' beyond what is called an empirical subjectivity, supposing that such a thing exists as soon as it speaks, writes, and substitutes one object for another, in a word as soon as it *supplements*. The notion of truth is quite incapable of accounting for this performance.

There is a further point of reference that the photograph of Renoir serves to introduce. Recent work on Renoir has rightly drawn attention to a historiography within which Renoir is constructed as a 'natural' and intuitive artist.[20] It is a construct that needs little rehearsal but it is nonetheless worth pointing out that this view of Renoir spans the spectrum from the editor of the *Revue de l'Art* to the Soviet republic's to the soviet Republic's First People's Commissar of Education. Roger de Miles, in 1899, said of Renoir's paintings:

Ce ne sont pas seulement des portraits, ce sont des états d'âme, des caractères, c'est une information constante, un document biographique authentique, exact, ou tout est écrt; et c'est exquis, et c'est de la réalite et du rêve, et c'est de l'enchantement.[21]

These are not only portraits, they are states of the soul, characters, they are permanent information, an authentic biographical document, exact, in which everything is inscribed, exquisite, and they are made of reality and of dream, and of enchantment.[22]

In a similar vein, Lunacharsky, writing in 1933, says of Renoir:

His earth is a beauty rejoicing under a smiling heaven. for that, great thanks are due to him. We should not forget how many good things fate has granted us or – at the very least – how happy we might be. If that is what you ask of Renoir – he will give it. If you ask the clarity of soul of an almost holy man – he will give it. Is that not enough?[23]

The organisation of the catalogue of the Hayward Gallery exhibition which juxtaposes a nude bather and a still life of onions on a double-page spread tacitly affirms the view of an artist in whose work the body is pure visual pleasure and in which fruits, vegetables and bodies are signifiers of the same order.[24] It is a view which has its origins, of course, in Renoir's self-inscription, in carefully preserved remarks like 'I paint with my prick' and 'my models don't think at all' and 'we have freed painting from the importance of the subject' and 'you don't talk about paintings, you look at them; you don't look at paintings, you live with them.'[25]

The tradition through which Renoir's rendering of women's flesh is seen as outside an ideological construction of womanhood and existing rather as an extension of a natural will to form – producing works that are to be lived with not looked at – has been analysed by Tamar Garb.[26] Garb places Renoir's production and the discourses to which it gave rise in the context of debates about the 'woman question', showing how Renoir's apparent political neutrality operates powerfully to reinforce the notion of separate spheres. Garb points out that the 'silence' over Renoir's subject matter (the tendency to deploy abstract terms like 'beauty' and 'soul') has two sources: in the first place there is the dominance of Modernist perspectives which has characterised the writing of much art history from Renoir's time to our own, positing a painting practice 'which is said to be pure and acutely aware of its means'; in the second place there is the continuation in our own century of a way of seeing women which is compatible with the construction that Renoir and his contemporaries produced.

I want to suggest, further to this account, that one of the reasons for the silence of contemporaries on the iconography of woman in Renoir's work was that this iconography served to articulate two apparently contradictory systems of perception that were so widely held as to be popularly unquestioned. It is significant that the theme of bathers – whatever their pedigree in actual or imaginary realms of Antiquity – should predominate within a culture that, as Corbin has pointed out, was deeply suspicious of washing and in which, in 1900, only Paris

apartments with very high rents were furnished with bath-rooms.[27] An idyllic and Rousseauesque vision of the country-side – location for Renoir's late nudes – survived into the nineteenth century but as the century progressed and towns were slowly cleared of their refuse, the relationship of the town to rural space was reversed. The stench of villages was decried. The town 'became the place of the imputrescible – that is, of money – whereas the countryside symbolised poverty and putrid excrement'.[28] By situating bathing women in non-specific countryside, Renoir's art served to maintain a network of fictions linking femininity, health and the timeless, spaceless domain of the rural.

Furthermore, and arising out of the issue of Modernism that, as Garb has established, has been one of the reasons for the reluctance to address the dominant subject matter of woman in Renoir's art, I am concerned to reintroduce questions of facture, of dimension, of the paint surface, of painting as material object. these questions have to be reintroduced on different terms. The photograph, with its smooth surface and its suggestiveness of technical mastery over the momentary, apparently rendering the instantaneous permanent, is a reminder of the complex role of photography in ironing out the discomforting presences of paintings, in cutting down to size objects that are embarassingly large and accommodating them within the sanitised pages of books and the spaces of the bourgeois home. These objects – in Renoir's case – appalled some viewers when they reappeared in the exhibition of the artist's work in 1985.[29] After exposure to the group of works – the late nudes – that have always been the low-point of popularity in the oeuvre of this favourite among nineteenth-century artists, one reviewer who typically waxed enthusiastic over the Renoir of the *Bal du Moulin de la Galette* and *Les Canotiers*, wrote of 'those fleshly, corn-fed bathers who sit around at the end of the show like turkeys waiting for the oven'.[30]

II

Renoir commenced *The Judgement of Paris* (plate 33) in 1908: there exist two large oil paintings and a number of studies.[31] The three goddesses and Paris who kneels – or rather squats – before them are in a flowery meadow of which little is seen since they are painted on a large scale and occupy most of the field of vision. One of the goddesses carries a towel which links the painting thematically to the artist's paintings of bathers.

The goddesses are heavily built and naked; Paris is dressed in a belted tunic and a kind of bonnet, with a staff in one hand and sandals that fasten round the ankle.

A number of interesting issues are raised by the depiction of female nudity through this myth, in this particular way, by an ageing and crippled artist employing certain models and certain techniques. The story of Paris and the three goddesses is paradigmatically about gender and power. Paris appears to have the power since he can choose to whom to award the golden apple but the goddesses, in their ever-fascinating trio, embody celestial power as well as female beauty and its accompanying authority. Renoir, for reasons that cannot be separated from his biography, chose to subvert the mainspring of this confrontation by using a female model for Paris and by ensuring that the image of the youth retained a sufficiently female appearance for him/her to share many of the visual characteristics with which he endows the three goddesses. In fact, it was Gabrielle, Renoir's children's nurse, who modelled for Paris. Faced with the necessity of depicting a naked male

33. Pierre Auguste Renoir, *The Judgement of Paris*

91

model (he had once embarassed his wife by joking of himself as a painter of male organs[32]) Renoir was greatly disturbed. 'He felt more at ease' using Gabrielle as a model than the athletic actor Daltour whom he had hired, we are told. But Renoir's own recorded remark was: See how like a boy she is! I have always wanted to do a Paris but I've never been able to find a model.'[33] So we have here a depiction of a myth from which all male presence is evicted; Paris is a woman and, furthermore, the boy Cupid who is often in attendance on Venus (as he is in, for example, Rubens's *Judgement of Paris*, London, National Gallery) is absent. Renoir set the scene in his garden at Les Collettes near Cagnes and he gave the goddesses bodies that are connotative of the maternal.

The theme of three women was already well established in Renoir's work by the time he began *The Judgement of Paris* in 1908. But the female body in Renoir's late work possesses the plenitude of the maternal form; the nubile pre-sexual body of *The Bathers* (plate 34) of 1884–7 is replaced by a heavy, fuller, more mature body with broad hips, small apple-like breasts and thick ankles though the faces remain plump and relatively ageless. Attempts to define the erotic require a cultural and historical framework that is notoriously difficult to establish. One might cite, for example, the disparity in readings of the

34. Pierre Auguste Renoir, *Bathers*

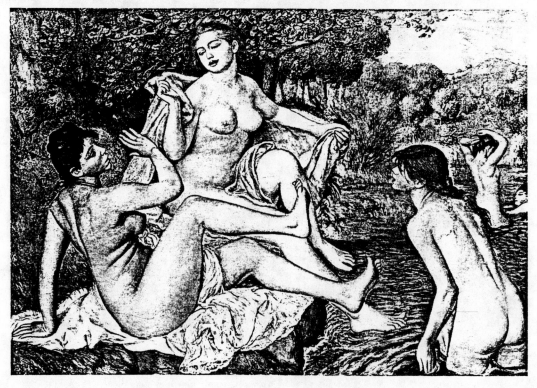

naked body of Rubens's wife as represented in *Het Pelsken*
(Vienna, Kunsthistorisches Museum). Julius Held has drawn
attention to the range of evaluation from the appreciation of
Hélène Fourment's body as magnificently youthful to the
supposition that she has lost weight through many pregnancies
and that her breasts are sagging and need the support of her
arm.[34]

Attempts to define a universal 'maternal' body would be
equally problematic but what is not in doubt here is the
substantial shift in female physical type in Renoir's late work
and the loss of some of the playfulness of the earlier renderings
of the female figure in favour of weight and monumentality.
The figures also become larger and occupy more of canvases
which are themselves of greater dimensions. For all that Renoir
declared that 'every woman nursing a child is a Raphael
Madonna', with a few notable exceptions like his portrait of
Aline and his infant son, now known as *Maternite* but originally
entitled *Enfant au Sein* (St Petersburg, Florida, Museum of Fine
Arts), the maternal body is customarily present in Renoir's
work without an accompanying child. The earlier bathers of
the 1880s were young women often wearing wedding rings;
the bathers of the 1900s, such as *Les Grandes Baigneuses*, have

35. Pierre Auguste
Renoir, *Les Grandes
Baigneuses*

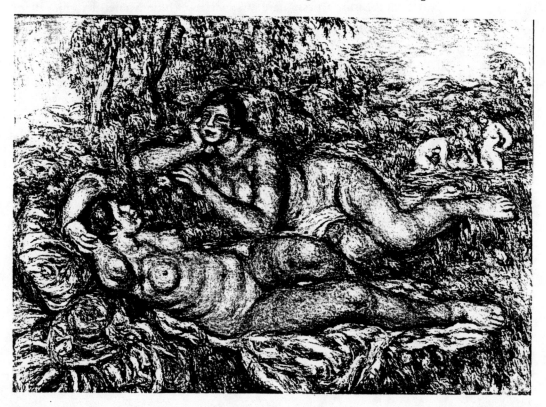

massive child-bearing bodies, tiny heads and vacant gazes. They function as signs for female fertility in analogously lush landscapes.

Renoir's interest in classical themes such as *The Judgement of Paris* is usually explained in stylistic terms. Thus Keith Wheldon, quoting Renoir's comment that the life of the Greeks 'was so happy that they imagined the Gods came down to earth to find Paradise and Love', states that there is in Renoir's late manner an epic breadth, a style 'stimulated by the thought of the classical ideal'.[35] We might note in passing the evident wish-fulfilment, the dominant note of fantasy and reparation in Renoir's wistful verbal evocation of the happiness of the Greeks. And if we look at those subjects Renoir chose to paint from classical literature, the notion that the choice of subject is somehow accidental, having no other significance outside a general appeal to the style of a lost past, rapidly evaporates. The golden age, whether of the classical past or of the subject's infancy, is restituted through the depiction of the mature female body.

The eroticised theme of the mother/son relationship underpins two canvases of Tannhauser which Renoir executed in 1879 for Dr. Émile Blanche, celebrated psychiatrist and, like Renoir, a passionate Wagnerian.[36] Julie Manet describes them along with other works by Renoir in the collection:

Il a des merveilleuses baigneuses de M. Renoir, si faites et si parfaites. Puis aussi de lui deux dessus de portes peints pour sa maison de Dieppe représentant le Tannhauser, celui ou se retrouve Venus seulement vetu d'une ceinture d'or, tenant Tannhauser endormi, est absolument delicieux.[37]

There are wonderful Bathers by M. Renoir, so finished [*faites*] and so perfect. Then also by him there are two paintings for over the doorways in his Dieppe house, representing Tannhauser; the one where we redscover Venus clothed only in a gold belt, holding the sleeping Tannhauser, is absolutely delicious.

A further instance of interest in oedipal themes occured in 1898 when Renoir painted Jocasta recoiling in horror in a flaming cloak, an isolated figure on a grey background. There is no attempt to suggest a context or establish a narration. The figure of the dramatised mother is all.[38]

Renoir's favourite model and the woman who posed for many of the late bathers was Gabrielle, who was employed in the Renoir household as nursemaid to his children. She is the embodiment of health in an existence of sickness and the ambodiment of life in a world of paralysis, the inexorable

condition in which the only movement is that towards death. In 1901 Renoir's youngest child, Claude, was born. Renoir was sixty. It was the year in which his legs became so bad that he had to use two sticks and his fingers became even more deformed. His wife, Aline, was also sick. So Gabrielle the model and nursemaid was effectively also the mother. She was nursemaid to Renoir and his art and mother to his children.

We can establish a connection here which will permit us to identify the maternal presence in the late nude subjects of Renoir. The model is mother substitute not only to Renoir's child but also, since Renoir is child-like in his immobility, to Renoir himself. But if there is something reassuring about the dimensions of these huge sprawling figures (plate 35), whose size on the canvas recreates for the viewer the experience of the child's sight of the all-powerful mother's body, there is also something threatening. Moreover, the loose and vigorous way in which traces of paint are left on the canvas replicates not only the movement of which the artist is being deprived by the condition of his ageing body but also that to which the child aspires in seeking to master the world.

In postulating Renoir here as child, it is worth recalling the remarks of the critic Aurier who, in a rare attack on the artist, named him as a baby at play in his art in terms that suggest an analogy between auto-eroticism and artistic practice:

Il me faut imaginer ... une âme-enfant, ignorant nos grognons pessimismes, s'égayant, s'éjouissant, s'extasiant dans le monde vrai, comme un bébé dans un bazar plein de poupées, de ballons et d'arches de Noë, comme un bébé très malin et quasi sceptique avec tant de bon coeur! et tant de candeur![39]

I have to imagine an infant-mind, ignoring our pessimistic groans, amusing himself, giving himself pleasure [s'ejouissant], giving himself ecstasy in the real world, like a baby in a store full of dolls, balloons and Noah's arks, like a very smart [malin] and almost sceptical baby with so much good will! and so much candour!

In her interrogation of motherhood, Julia Kriesteva identifies the 'baleful power of women to bestow mortal life' with the theme of the two-faced mother in Céline, the figure who gives life but without infinity.[40] In presenting abjection as the state of the subject weary of fruitless attempts to identify with something on the outside, Kristeva describes the state of fear which makes all objects alien, a state that is the condition of the child 'who has swallowed up his parents too soon':

Out of the daze that has petrified him before the untouchable, impossible, absent body of the mother, a daze that has cut off his impulses from

their objects, that is, from their representations, out of such daze he causes, along with loathing, one word to crop up – fear. The phobic has no other object than the abject. But that word, 'fear' – a fluid haze, an elusive clamminess – no sooner has it cropped up than it shades off like a mirage and permeates all words of the language with nonexistence, with a hallucinatory, ghostly glimmer. Thus, fear having been bracketed, discourse will seem tenable only if it ceaselessly confront that otherness, a burden both repellent and repelled, a deep well of memory that is unapproachable and intimate: the abject.[41]

The nostalgia for a past world in Renoir's late nudes does not re-enact an iconographic programme or a style from the past; rather it postulates the state of abjection in relation to the maternal body. Elsewhere Kristeva has pointed out that the 'so-called poetic dimension of language leads one to believe in the existence of the Mother, and consequently of transcendence'.[42] Renoir's production of an imagery that signifies in paint a pre-oedipal relationship with the lost mother reproduces what Kristeva identifies as the maternal body: as the place of splitting which 'even though hypostatised by Christianity, nonetheless remains a constant factor of social reality'. Motherhood is here, again, two-headed, for paradoxically 'the mother is *master* of a process [i.e. gestation] that is prior to the social-symbolic-linguistic contract of the group' and therefore motherhood is biological and eludes social intercourse, 'the representation of pre-existing objects and the contract of desire'. On the other hand we immediately deny this unsymbolised instinctual presence because 'Mama is there, she embodies this phenomenon: she warrants *everything is* and that it is representable.'[43]

What this discussion of Kirsteva serves to emphasize is the simultaneous reassurance and instability of motherhood as symbolic order, its fundamental importance to acts of communication (the making of art) and its perpetual bifurcation. If we turn back now to *The Judgement of Paris* (plate 33) we can begin to understand what its peculiar configuration signifies. In an essay entitled 'The Theme of the Three Caskets', Freud explores the theme of three women as it is manifest in folk epic and medieval narrative.[44] The three caskets in *The Merchant of Venice* and the three sisters in *King Lear* are equally concerned with a man faced with a choice of three women, a choice in which it is the third sister (the pale lead casket, the silent Cinderella and the speechless Cordelia) who is the good choice. Aphrodite, the third of the Graces, is not silent in the original story but, as Freud points out, by Renoir's time she had become so.[45] If silence and dumbness mean Death, then, Freud

suggests, we are faced with a contradiction in the Judgement of Paris story because the third sister is the goddess of love and no one chooses death willingly. Freud perceives the answer to lie in understanding this story as exemplary of the greatest triumph of wish fulfilment conceivable. In fact man has no choice in the matter of death but, through myth, he permits himself choice even in this ultimate matter and substitutes love for death. Shakespeare in *King Lear*, as Freud points out, brings us nearer the ancient myth by making the man who makes the choice aged and dying.

Renoir's three goddesses were modelled by three women who were part of his household; they are also three women who belong to a long line of paintings of bathers. Having discarded the professional male actor-model, he gives the part of Paris (the part that he himself, as an artist, has played in life and the part he must now play in death) to his favourite model and his children's nurse, to Gabrielle, the mother substitute. As the desire to be able to choose her who can reaffirm life – even if she cannot guarantee transcendence – becomes ever more pressing, as the desire to ward off death becomes more powerful, Renoir fills his canvases with maternal bodies. By painting *The Judgement of Paris* in such a way that the three graces are three mothers, Renoir is engaging with the greatest triumph of wish fulfillment. By making Gabrielle stand in for Paris/Renoir he takes the process of protecting himself from death a stage further. By removing all masculine presence and, particularly, by removing the child Cupid, Renoir reproduces his own pre-oeidipal drama. He claims the stage of the maternal for himself in an act that brings together the desire for a classical past in art with the desire for that presence which will warrant that things are as they are and that the Master-Mother is there.

INTERIOR PORTRAITS

I

This chapter explores particular paintings by male artists which work with images of female physiology; like the previous chapter, it is grounded in the view that a categorisation of the male artist as inalienable, ahistorical and monumental which is a feature of the historiography of art is untenable in today's analysis of visual culture of the past. When I read 'Most images of female nudity imply the presence (in the artist and/or viewer) of a male sexual appetite',[1] I want to ask not only how that appetite may be encoded in the visual image but also how we can possibly assume something called 'male sexual appetite' in the abstract and without specificity of any kind.

While the shift of attention away from the artist as individual producer of a unique image towards a consideration of pictures as sites of the production of meanings in any given social and political context may have provided a healthy antidote to the practice of connoisseurship and the exercise of author function, we are in danger of ignoring the evidence that acknowledgement of the particular existence of a male artist may offer in understanding the meanings of works of art as they operate in our own cultural contexts and as they functioned in the past.

Here I shall further investigate the difficult relationship between autobiographical texts and images produced by the writers of those texts in order to problematise the issue of desire as historically defined. The question that I shall address in this chapter concerns the invisibility of female fertility and the discourses of the body that this lack of visible identity generates in nineteenth-century texts. While scientific and medical representation — in so far as it is popularly apprehended as a way of looking and depicting — provides a point of reference in this

discussion, the main object of study turns on the imaginative engagement of male artists with the fertility of the women who are their habitual models.

The discovery of radium and development of X-ray photography made available internal images that were diagnostic tools. But, as Susan Sontag has pointed out, the way that photography appears to 'imprison reality, understood as recalcitrant, inaccessible ... making it stand still' implies for representation a power to mutate documents into emblems of desire. Photographs can 'enlarge a reality that is felt to be shrunk, hollowed out, perishable, remote'. Sontag illustrates her argument by reference to Thomas Mann's *The Magic Mountain*, where to Hofrat Behrens the pulmonary X-rays of his patients are diagnostic tools but to Hans Castorph, serving an indefinite sentence in Behrens's sanatorium, '"Claudia's X-ray portrait, showing not her face but the delicate bony structure of the upper half of her body, and the organs of the thoracic cavity, surrounded by the pale, ghostlike envelope of flesh" is the most precious of trophies'. The transparent portrait is a far more powerful image than the exterior portrait upon which Hans had once gazed with such longing.[2]

The mapping of the body's interior is, of course, no new phenomenon but it would appear that during the course of the nineteenth century the systems of encoding physiology established in scientific discourse provided the ground for specifically gender-related acts of fantasy. In his book *Sex, Politics and Society*, Jeffrey Weeks argues that what is strikingly absent in nineteenth-century thought is any concept of female sexuality which is independent of men's.[3] This raises the question of how 'thought' manifests itself. Certainly a preoccupation with female reproductive organs and their functioning, or with female physiology generally, might not be deemed evidence of thought about female sexuality. And yet such a preoccupation (even if it be religious awe at the wonders of creation or the clinical visual grammar of the text-book on gynaecology) could contribute to the definition of gender and, by implication, also of female sexuality.[4] It is evident that men were fascinated by the internal configurations of women's bodies and that a great deal of information – much of it in graphic form – became available to the lay person through publications in the course of the nineteenth century. I am asking how, in the case of a small group of artists, this fascination is mediated in the visual image.

Take, for instance, Michelet's vision of the cervix and ovaries as revealed to him in the anatomical diagram he consulted in

the library in 1849 when seeking knowledge that might enable him to consummate his months-old marriage:

Rien ne m'impressiona plus, cette semaine, que la vue des planches anatomiques. J'en fus ému extremement, croyant voir des portraits, le portrait intérieur de la personne que j'aime tant. J'en fus touché et attendri. La forme de la matrice surtout, si delicate (et visiblement dune vie élèvée) entre tant de parties rudes en comparaison, faites pour l'usage habtuel, la fatigue et le frottement, – la matrice, dis-je, me penetra d'une attendrissement religieux. Sa forme est déja d'une être vivant et ses appendices (trompes, ovaires, pavillon) sont d'une forme delicate, tendre, charmante et suppliante, on le dirait: faible et forte à la fois, comme d'une vigne qui jette ses petites mains, ses doigts délicats autour de son appui. O doux, sacré, divin mystère![5]

Nothing impressed me more, this week, than the sight of the anatomical drawings. I was extremely moved, thinking myself to be seeing portraits, the internal portrait of the person I love so much. I was touched and felt tender. Above all the shape of the womb, so delicate (and visibly of a superior life) among so many bits that were coarse by comparison, made for regular use, for toil and friction, – the womb, I say, penetrated me with religious tenderness. Its [her] shape was already that of a living being and its [her] appendices (tubes, ovary, entry[6]) are of a delicate, tender, charming and suppliant form, one would say of them: weak and strong at the same time, like a vine which throws forth little hands, its delicate fingers around its support. O sweet, sacred, divine mystery!

Michelet's effusions on the subject of woman have attracted attention from scholars seeking to understand the peculiarities of Michelet's psychological and intellectual make-up. Most notably Barthes' curiously hostile yet admiring textual dialogue seeks to identify Michelet through a series of namings: Michelet-as-voyeur, Man-as-chambermaid, Michelet's lesbianism, and so on.[7] But Michelet's writing also testifies to the values attached to woman's reproductive organs in relation to the remainder of her body (values that replicate woman's valorisation in society), and to the way in which anatomical drawings idealise, sever and in other ways privilege certain parts of the anatomy over others. It is a visual image that provokes Michelet's reverie and provides the grounds for his verbal representation; imagery establishes the conditions for the discourse of feminine physiology. It is hard today – familiar as we are with the characteristics of diagrammatic representations of female sex organs – to share Michelet's wonder. The fact that admiration, wonder and scientific knowledge were employed oppressively against women should not discourage us from examining the manifestations of this preoccupation of the male psyche, be it individual or corporate. Even if only in order to recognise the pervasiveness of the female reproductive cycle as

idea and image, that Other so elegantly invoked by Michelet, we should seek the connections between this preoccupation and the images of women we are concerned to understand as part of a social order.

In psychoanalytic terms such manifestations as I shall be discussing, such allusive latent content in images of women by men, would be explained by what Luce Irigaray has defined as 'the enactment of sadomasochistic fantasies, these in turn governed by man's relation to his mother: the desire to force entry, to penetrate, to appropriate for himself the mystery of this womb where he has been conceived, the secret of his begetting, of his "origin". Desire/need, also to make blood flow again in order to revive a very old relationship – intrauterine, to be sure, but also prehistoric – to the maternal.'[8]

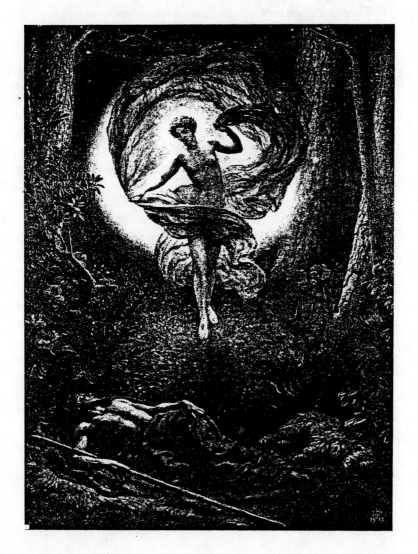

36. Sir Edward Poynter,
Vision of Endymion

Invisibility, the theme of Irigary's polemic, can itself become the dominant discourse in art forms. Irigary's concern is with the denial of female sexuality, its invisibility, its difference. This sex (woman's) which is not one (that is, not single) because it is formulated of parts which touch each other; this sex which is not one because it is culturally denied to be one. One of the problems with Irigary's work for an art historian is its ahistoricity. Thus, for example, elsewhere in the same essay she refers to Greek statues of female figures as illustrative of the invisibility of woman's sex in culture ('Woman's genitals are simply absent, masked, sewn back up inside their "crack"').[9] This account ignores, however, the conventions of representation in Greek art that differentiate mortals from goddesses as well as dismissing other cultural determinants.

There is nevertheless pictorial and textual evidence to suggest that the invisibility of woman's sex exercised the nineteenth-century imagination more widely than Barthe's critique of Michelet's particular proclivities would suggest. A painting by Courbet known since 1930 as *L'origine du Monde* (c. 1870, location unknown) and depicting a woman's open thighs and her lower abdomen seen in full frontal pose was described at the time of its making as a study from life in which the artist had failed (through some lapse of memory) to represent 'the feet, the thighs, the belly, the hips, the chest, the hands, the arms, the shoulder, the neck and the head'.[10]

Euphemism, metaphor and displacement function visually as well as verbally in nineteenth-century descriptions and evocations of female anatomy. As an instance we might cite Sir Edward Poynter, who produced in 1903 a *Vision of Endymion* (plate 36) in which a naked woman, the subject of the dream, is depicted emerging from an organic aperture, the entrance to which is encircled with poppy plants and other wiry types of foliage. Courbet's Michelet's and Poynter's expressions of interest in the invisibility of woman's sex suggest that visual imagery in the nineteenth century may offer further evidence of the attempt to encompass the unseen within the seen, to possess the 'origine du monde' by representations within which the unseen co-exists with the seen, the interior with the exterior. In the remainder of this chapter I shall examine two paintings in detail in the light of this preoccupation.

II

Feminist art historians have drawn attention to the way in which flowers or fruit are frequently used as metaphors for

female sex organs and for woman's availability. Such meta-
phors are the most obvious manifestation of the correlation
between Woman and Nature discussed in chapter 1. The work
of Gauguin is replete with such images and Parker and Pollock
have contrasted them with images in the work of women
artists.[11] But if we look at one of Gauguin's best-known
paintings, *The Vision after the Sermon* (1888), the equation
Woman–Nature is evidently not present in the form of fruit,
flowers, pubescent girls and other motifs familiar from Gau-
guin's Tahitian pictures (see plate 37). Yet women nonetheless
dominate this painting.

The powerful affectiveness of *The Vision after the Sermon*
derives from a different structure, one that depends on a set of
symbolic relationships rather than a system of equivalences.
Art-historical explanations of the imagery of *The Vision after
the Sermon* tend to develop around a series of correspondences.
There is the biographical explanation of Gauguin's interest in
Breton subject-matter during his stay in Pont Aven.and there is
the extension of this that addresses the artist's concern with
'primitive' ethnic costumes and customs. There is also the
argument that focuses on Gauguin's self-conscious emulation
of earlier artists, and in particular of Delacroix, who had
executed a depiction of Jacob wrestling with the angel in the
Church of St Sulpice in Paris from 1854. Then there is the
account of the painting which traces a relationship between
Gauguin's work and Piero di Cosimo's *Forest Fire* through the
agency of the cow which prances in the background of *The
vision after the Sermon.*[12] The explanation that focuses upon the
artist's development of certain non-naturalistic techniques of
representation is a further approach. A feminist intervention
into this discussion might well draw attention to the construc-
tion of *The Vision after the Sermon* (where the priest closes the
line of women's heads) as connotative of the power of ritual in
the church and in the organisation of women's lives.[13] It might
also address questions raised by the production of an image
featuring a rural 'primitive' community of women for con-
sumption by an urban audience in a decade during which
female emancipation was a contentious issue.

These questions, important though they be, are not part of
this present enquiry. What concerns me here is the symbolic
function of woman within a visual narration based upon a
rarely represented Biblical text. The sermon, by which the
Biblical text is disseminated, is anterior to the action that forms
the subject of the painting and which concerns the vision of
women. Jacob wrestling with the angel thus becomes, at one

level, the property of the female imagination. Gauguin's method of depiction is startling; the painting is one of the best-known icons of post-Impressionist (what is popularly perceived as 'modern') art and probably the National Gallery of Scotland's single most popular painting. The visual field and field of the vision (which is also a field in the geographical and agrarian sense) is tipped up so that we look down upon this space even though we, the viewers, are at eye level with the women who experience the vision. A tree trunk severs the field and separates the wrestling pair from the solitary cow. All the observers are women except for the priest at the extreme right.

In narrative terms Gauguin adopts what is essentially a medieval convention (and one which survives in serial imagery and strip cartoons) in which we are presented with those who experience a vision in one part of the picture-space and with the substance of what they see in another. The ambiguity that clings to the idea of 'vision' – what is seen *and* what is imagined, the faculty of sight *and* the object(s) seen – is perpetuated in the absence of any distinguishing features or technique to separate

37. Paul Gauguin, *The Vision after the Sermon*

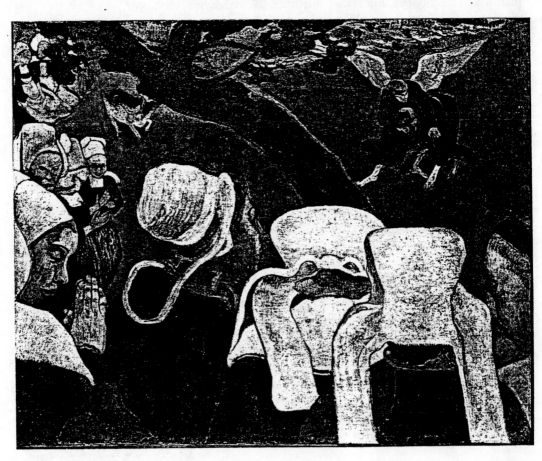

the women from what they see. Visually the most arresting quality of the painting is the fact that the field is crimson. What is compositionally empty is actually full, of colour, of red.

Let us turn briefly to the story of Jacob wrestling with the angel. The story runs as follows: after crossing the ford Jabbock with his wives, servants and sons, Jacob was left alone. A man wrestled with him till daybreak and when he saw that he was not winning the contest he touched the hollow of Jacob's thigh which went out of joint. And the man said 'Let me go for the day breaketh' but Jacob would not let go without being blessed. The man then asked Jacob's name and, being told it, said he would now be called Israel 'for as a prince has thou power with God and with men, and hast prevailed'. Jacob asked the man's name and he blessed him. Jacob then called the name of the place Peniel 'for I have seen God face to face, and my life is preserved'. Because it was Jacob's thigh that was touched and sharnk the children of Israel 'eat not of the sinew which shrank'.[14]

Barthes has established the folkloric nature of this Biblical narrative. He describes it as a '*metonymic montage* encompassing the themes of crossing, strugle, naming and alimentary rite'.[15] Metonymic logic is, he points out, that of the unconscious, and he refers to the 'symbolic explosion' of the text. The introduction of an overriding presence of women – praying, passive women in Gauguin's rendering of the story – serves to reinforce the Law of the Father; that is, the story of God's authority passed through the angel to man in the person of Jacob. Woman is essential to the unfolding of the narration (Jacob, in Gauguin's painting, is still locked in the moment of struggle with the angel) which will culminate in a blessing and a naming. But she is also separate and passive. The women frame the biblical text both in the sense that the narrative is experienced by them as a vision and in the pictorial sense that their white coifs provide for the viewer an obstacle to be crossed and a tonal contrast with the domain in which the wrestling takes place.

The historical explanation for the red field is either that Gauguin had seen red fires and red flags in Brittany or that the red has been carried over from the functional red of Piero di Cosimo's *Forest Fire* along with the cow. The psychological explanation is that the event is happening on the inverse of optical reality (fields should be green and this one is green's opposite, red) thus indicating that its medium is the dream.[16] I want to suggest, however, that within an exploration of the symbolic structure of *The Vision after the Sermon* the connotative

relationship between the women whose vision it is and the crimson field is one of fertility in general and menstruation in particular. The alimentary rite with which the Biblical story concludes is one of a fundamental series of taboos which organise and shape experience. The notion of prohibition reappears in visual terms through a representation of the distinction between animal and vegetable. Blood indicates the animal in Biblical and anthropological terms, which might also explain the presence of the cow. It also, however, as Kristeva points out, refers to women and fertility and thus becomes 'a fascinating semantic crossroads, the propitious place for abjection where *death* and *feminity*, *murder* and *procreation*, *cessation of life* and *vitality* all come together'.[17] This association is reinforced by a composition in which the field with its severing and severed tree has the quality of an anatomical diagram, a visual image that demands to be read schematically like a form of ritual.

A story which possesses all the ingredients of the fairy story, in which the hero crosses a barrier (a river in this case), is tested and prevails, and is blessed by God, a story fundamental to which is the phallic Law of the Father, is enacted in a field of blood before a host of mute female witnesses. Woman is notably absent in the Biblical text but, as co-founder of Jacob's dynasty, she is also powerfully present. Gauguin restores the 'invisible' woman to the narrative. It is worth recalling here that in Freud menstruation is experienced as castration.[18] The horror of the Medusa's head in mythology is traced to the association between the decapitated head and the castrated penis. The bleeding female, devoid of penis, is thus also an emblem of castration and consequently an object of horror – and of fascination. In the vibrant red field man struggles detached and isolated but caught and contained within the 'frame' of woman. Thus it is the gendred physicality of the condition of woman and her fertility that are the field of struggle and the terrain for the giving of birth to the vision and consequently to the story. The red field acts both as a metaphor for the encounter of Jacob with the angel (the confrontation with the unknowable) and as the site of the vision experienced by the women. The two interact so that one narrative is contained within the other in the internalising manner of the 'portraits' which so fascinated Michelet. the story of Jacob wrestling with the angel can be read as an allegory of birth culminating in a naming and the acquisition of identity. In the light of this, Gauguin's painting enacts not only fertility but also maternity.[19]

Take Your Son, Sir! has long been regarded as Ford Madox Brown's most puzzling picture (plate 38). It is also incomplete. The failure to complete a painting need not necessarily relate to the difficulty of the artist in relationship to a particular subject matter; paintings are unfinished because patrons abandon the project, because technical problems become overwhelming, because artists get bored or outgrow a project or for a host of other reasons. However, the failure to complete a work and evidence of a long-drawn-out relationship with the painting may signal for us an area of disturbance.

The painting shows a woman seen from the front bearing before her a naked child supported in a mass of rumpled clothing. Behind the woman's head is a mirror in which a reflected interior is clearly visible. To her left is the end of a cradle. The woman's face, the mirror and its reflection, the baby and the cradle are all in a finished or near-finished state. The remainder of the canvas is scarcely worked but the whole is signed with the title and the artist's name.

The popular interpretation of the painting describes the subject as a kept woman, seen as haloed magdalen, presenting their bastard to the reluctant father.[20] On the basis of a detailed analysis of the interior visible in the mirror Mary Bennett concludes, however, that the painting is a celebration of marriage and parenthood with the young mother in a madonna-like pose against a simulated starry background, the mirror, which acts as a halo and at the same time reflects and enfolds both her and her husband to whom she offers their son.[21]

Neither view addresses the possibility that this is not a documentary painting but one in which inconsistencies are essential to the imaginative whole. The tendency to see nine-teenth-century paintings as social documents has distracted attention from the evidently compelling endeavour (an endeavour never completed) to reconcile the discourse of desire with the framework of Victorian pictorial conventions. When the picture was first exhibited (in 1897) the complexity and the disturbing personal nature of this imagery were recognised by at least one reviewer:

The sculpturesque perfection of presentment, the imaginative realism of it carries us beyond the real into the essential heart of things, to another sphere, another spiritual plane. It conveys the feeling that one is looking not at a picture, it is hardly complete enough for that, but through a lens of crystalline emotion into the creator's chamber of imagery, where the enthroned mother, her head haloed by the great mother symbol of the mirror, becomes the type image of life – the ostended child, the token of that miraculous fusion of spirit which is the fount of life.[22]

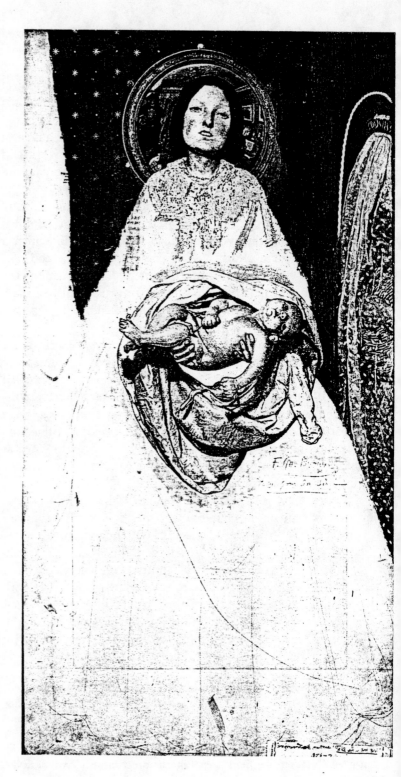

38. Ford Madox Brown,
Take Your Son, Sir!

The 'creator's chamber of imagery' is an apt expression. The device of the convex mirror probably derives from Van Eyck's Arnolfini Marriage portrait which had been in the National Gallery since 1842; it is not merely a formal debt since the theme of fecundity implied in Van Eyck's portrait runs through Madox Brown's work. It is a clever means of obliging the spectator to read the events going on behind via the mediating facial expression of the woman. It also establishes two distinct levels of reality: experience is behind and perception before. It seems unlikely that a happy wife and mother would present her child to his father with the curt instruction, 'Take your son, sir!' No does the objection that it is unlikely that Madox Brown would have shown a middle-class interior and his wife and son in key roles had he intended a painting of social comment carry much weight. He did not hesitate to use his wife, Emma, in *The Last of England* (1852–3, Birmingham City Art Gallery). But the painting does not, it seems to me, lend itself readily to either of these fixed interpretations. The two most eccentric features of the painting appear to have escaped notice. In the first place the cradle to the woman's left and our right is an object strangely transmuted beyond its everyday existence. Admittedly we are today unfamiliar with draped cradles of this variety but even to a contemporary audience the angle of vision must have produced a curious reading of this object which looks so much like a shroud. We don't commonly see shrouds either but they were nonetheless familiar items and can be seen on monuments such as that which the poet John Donne had made to his specifications by Nicholas Stone and which is still to be seen in the crypt of St Paul's Cathedral in London. In the second place the woman is offering the child in embryo as we can see readily if we compare the painting of the child in its crumpled surround of clothing with the study of the child in the uterus from William Hunter's *Anatomia uteri humani gravidi* (plate 39), first published in 1774 and reproduced in encyclopaedias and home medical handbooks throughout the nineteenth century.[23]

The similarity of the uterus to the funerary urn and of the shroud to the cradle with its covering creates a striking coherence which becomes less puzzling if we think of the frequency of imagery which juxtaposes or conflates urns and wombs, death and birth in art and in literature. One might cite, for example, the words of Donne's last sermon, *Death's Duel*, which relate to the particular form of the tomb mentioned above:

But then this *exitus a morte* is but *introitus in mortem*; this issue, this diliverance, from that death, the death of the womb, is an entrance, a delivering over to another death, the manifold deaths of this world; we have a winding-sheet in our mother's womb which grows with us from our conception, and we come into the world wound up in that winding sheet, for we come to seek the grave.[24]

Ben Jonson's *To the Immortal Memory and Friendship of that Noble Pair, Sir Lucius Cary and Sir H. Morison* is a poem about a baby that does not care for the world it sees and wishes to return to the womb:

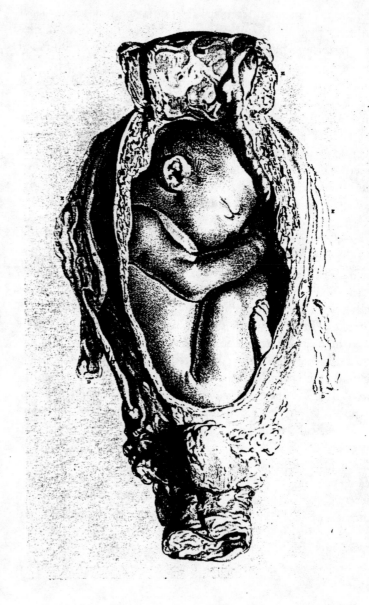

39. William Hunter, illustration to *Anatomia uteri humani gravidi*, 1774

Thou looking then about,
Ere thou wert half got out,
Wise child, didst hastily return,
And mad'st thy mother's womb thine urn.[25]

What Jonson calls 'the horrors of the sack' foreshadows the words of Samuel Beckett's Pozzo: 'They give birth astride of a grave, the light gleams an instant, then it's night once more.'[26] Recognising a strong and recurrent connection between imagery of the womb and the idea of death, *Take Your Son, Sir!* Can be seen to incorporate the threat posed to the male spectator by the act of birth and, by extension, by female frtility. Looking at Ford Madox Brown's painting in this cultural context the mother recedes, framed by the mirror in which are inscribed the minutiae of everyday material domestic life, and the subject of the picture - beneath which the artist places his signature - becomes assertively the uterus and the child.

The foregrounding of the 'uterine' child, the startling unconventionality of the symmetrical composition, the lack of finish and the trance-like expression on the face of the mother combine to produce a set of relationships which bring together questions of the maternal and of fertility with questions of death and abnegation. In her study of fear and psychic structure, Kristeva proposes the stage of fusion between mother and child as the *chora*, a stage which has to be repressed in order for the ego to move towards another object and accept the exactness of the ego only as narcissistic. The prohibition placed on the maternal body as a defence against auto-eroticism and incest may thus be presumed to be a symbolic function of man's entry into the Law of the Father.[27] This formulation may help to explain what is effectively another 'inside-out painting, another image in which a schematic technique of representation is used in configuring *externally* and symbolically the *idea* of female fertility via a form of encoding that suggests female *internal* physical structure.

There appears to be a specific set of historical circumstances that support this reading. The painting was begun in 1851, abandoned, then resumed again after a gap of some five years during the course of which three children had been born to the artist and his wife. We do not know how much of the picture was completed before it was laid aside. It is, however, interesting in view of the birth-death imagery that an analogous text, the artist's diary, narrates conflict within his marriage at this period as minifest in dreams concerning potency and castrtion. This writing re-enacts the preoccupation with a triangular

relationship of borth, death and castration.[28] These narratives, recounted by Ford Madox Brown, tell of a quarrel with Emma (his wife) in July 1855, during which she refused to speak to him or to allow him into her bed. Afterwards Brown dreamed he had been 'dining with Ruskin who boasted he had got *one* child out of his late spouse, at least, whatever the slanderous world might say'. Ruskin's failure to consummate his marriage with Effie and her elopement with Millais were common enough knowledge. The next night he 'dreamt all night about Seddon & his wife, how a week's marriage had well nigh killed him, but with a ghastly whisper, having lost his voice, he was telling me that he liked being married exceedingly & would marry every week if women would have him ... I woke up laughing and could think of nothing else.' At the beginning of August, feeling ill and very depress, he took to his bed:

Had a mushroom for tea and thoughts about death – which after all seems to me a very natural consummation. A young farmer cut his throat last week after being married just one week to a very pretty girl because he failed to loose the marriage knot. That, as it would seem, too often guardian [Gordian?] knot to these Ruskins. This poor fellow, however, behaved like a gentleman.[29]

Loss of voice and loss of potency, both forms of castration, are associated with punishment by death which appropriately might be carried out by cutting one's own throat. Getting a child out of the marriage is articulated as the demonstrable proof of manliness. Entry into manhood is thus, by his account, accompanied by fear of femininity and particularly by fear of female sexuality. *Take Your Son, Sir!* is therefore not a piece of social commentary. Motherhood and illegitimacy in the socio-logical sense are not what this work thematises; rather it centres on the embryonic child who is both a reward and a threat, both a sign of the male fear of the *chora* and a reward for entry into the adult authority of paternity. Take your son, sir!

GUESS WHO'S COMING TO LUNCH? ALLEGORY AND THE BODY IN MANET'S *LE DÉJEUNER SUR L'HERBE*

Manet has been a focus of attention for art historians during the past decade. In an important sense, to contribute to the debate on *Olympia* initiated by T. J. Clark in 1980[1] and pursued in the pages of books and journals from *Block* to the *New York Review of Books*, is to earn one's art-historical spurs in the competitive lists of Modernist critique. In all this there has been a remarkable silence on the subject of *Le Déjeuner sur l'herbe*, which Manet exhibited at the Salon de Refusés in 1863 and which predates *Olympia* by two years. This chapter releases the textural conditions that have determined that silence and offers a reading of a work whose notoriety at the time of its exhibition equals that of *Olympia* in recent historiography.

In the work of those writers who have addressed *Le Déjeuner sur l'herbe* there have been a number of different approaches: it has been identified as pure painting in opposition to allegory on the one hand and described as a classical allegory in the Panofskyan manner on the other;[2] it has been lined with popular graphics of the period and it has been identified as a painting of modern life whose origin lies in Manet's expressed intention to 'do a nude ... for them ... in the transparent air, with people like those we can see over there'.[3] My view is that Manet's *Le Déjeuner sur l'herbe* interrogates the symbolic function of women in the organisation of the world through pictorial representation and in so doing renders allegory problematic. In other words, the painting does not construct an allegory but it foregrounds allegory as actually problematic.

I want to argue in this chapter that *Le Déjeuner sur l'herbe* refuses the kinds of revelation implied in the question: 'Guess who's coming to dinner?' I suggest that the painting can be understood in relation to a crisis about how nudity is represented and thus also about how allegory is constructed. Allegory regularly requires the body and commonly requires nudity; it therefore serves to reinforce the role of women in

representation.[4] For, although the nude male figure belongs to an important tradition in Western art, and predates in its dominance of the Renaissance period the powerful presence of the female nude, as William Aglionby stated in 1685: 'Nudity signified properly any Naked Figure of Man of Woman; but most commonly of Woman; as when they say "Tis a Nudity", we mean the Figure of a Naked Woman.'[5]

A crisis of nudity (and of allegory) is contiguous with a crisis of meaning. I shall propose that *Le Déjeuner sur l'herbe* makes out a space which is neither social nor allegorical but which is between the social and the allegorical; it is a space where there are no meanings, only the signs of absent meanings. In referring to woman I am not referring to the essential woman of French feminisms nor to woman as historically determined, but to woman as hypostatised, as a term in a symbolic structure. I shall look at some familiar landmarks before coming to examine the question of allegory more closely.

In 1932 Paul Jamot described Manet as 'grand artiste qui situe la réalité dans l'irréel' (a great artist who places reality in

40. Edouard Manet, *Le Déjeuner sur l'herbe*

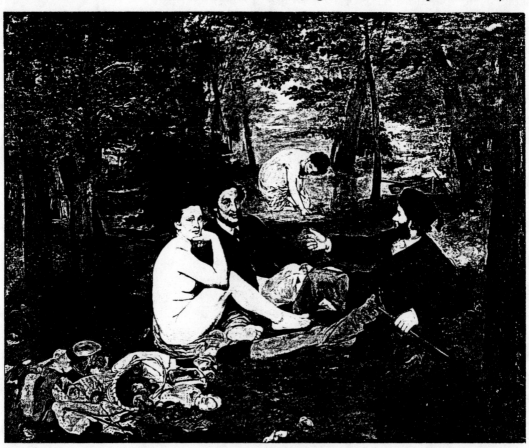

unreality).[6] If *Olympia* with its 'auguste jeune fille' (as Olympia is described in the Astruc poem that Manet appended to the painting) explores definitions that locate social woman in the process of mythicisation; then *Le Déjeuner sur l'herbe* explores mythical woman at the interface with socialisation.

To be allegorical is not to be real. To be allegorical in an age which declared its commitment to the painting of modern life is to transgress. Since the power of absolutist rulers tends to be inscribed through allegorising acts of communication, allegory *as a method* has particular political resonances. One might cite, for example, Rubens's series of the *Life of Marie de' Medici* (e.g. '*The Fortunate Reign*', Paris, Louvre) or Le Brun's *The Conquest of the Franche Comté* (Versailles, Palais de Glaces; see plate 41), in which Louis XIV is shown stepping over the Rhine personified as a river god with Hercules and Mars in attendance. Allegory was linked in the nineteenth century with what was perceived as an outmoded preoccupation with history painting and aademic convention (*la grande peinture*) and was thus a contested field in French artistic production under the second Empire.

Baudelaire in 1859 saw the age as inimical to History painting and extolled the religious painting of Delacroix as works of an artist 'as great as the old masters, in a country and a

41. Charles Le Brun, *The Conquest of the Franche Comté*

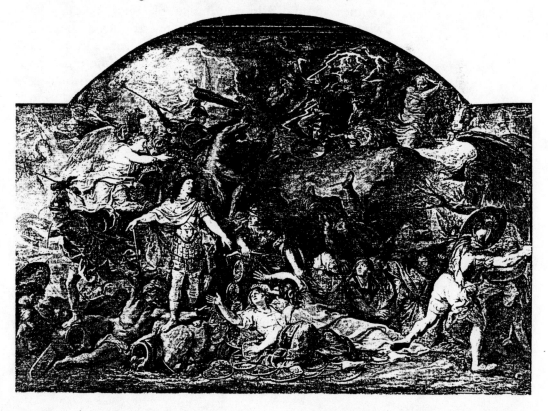

century in which the old masters would not have been able to survive'.[7] Odilon Redon also identified the period as unsympathetic to the non-naturalist and remembered the first half of the decade of the 1860s as a time when 'we were in the midst of Avant-Garde naturalism' and it was peculiarly difficult for an artist attracted by 'the uncertain at the boundary of thought', a quality he found epitomised in the proto-allegorical figure of Durer's *Melancholia*..[8] Most symptomatic of the contestation were the government reforms of 1863 which wrested control of the Ecole des Beaux-Arts from the Academy and which provoked an intense debate about the definition of artistic originality and the educational system most likely to foster high art, within which, of course, allegory plays a major role.[9]

The rhetoric of the real dominates the avant-garde of the 1850s and 1860s. Courbet declared in his letter to a group of students in 1861: 'I also believe that painting is an essentially CONCRETE art and can only consist of the representation of REAL AND EXISTING objects. It is a completely physical language that has as words all visible objects, and an ABSTRACT object, invisible and non-existent, is not part of painting's domain.'[10] By situating, to use Jamot's words, the real in the unreal, Manet's painting transgresses the imperatives of the avant garde to which, at this time, the allegorical is inimical. By deploying the mechanism of History painting, the genre and the practice which a modernist historiographic trajectory tends to define as oppressive, Manet's image ruptures the polemics of the avant-garde. But since History in the sense of *istoria*, the grandest and most venerated of genres, has to coexist with such signs of modernism as contemporary dress and freely-handled paint in *Le Dejeuner sur l'herbe*, the idea of History is deployed also to critique the very traditions upon which History painting depends.[11] In Courbet, for instance, it is popular art forms and the lower genres that penetrate and threaten the plenitude of *la grande peinture*. But with Manet it is *la grande peinture* that becomes the instrument of transformation and, through its deployment against the body of History, produces a movement against the perceived tide of history.

Baudelaire advocated many different and contradictory qualities in the art that he reviewed and promoted: imagination, dream, religion, pathos, naturalism and so on. But the advocacy for which he is perhaps best remembered by students of the nineteenth-century Salons, and through which his name has been inerradicably linked with that of Manet, concerned the heroism of modern life: the poetry and drama of contemporary Paris. '*The nude*', he wrote in 1846, – that darling of the artists,

that necessary element of success – is just as frequent and necessary today as it was in the life of the ancients; in bed, for example, or in the bath, or in the anatomy theatre. The themes and resources of painting are equally abundant and varied; but there is a new element – modern beauty.'[12] Baudelaire's deliberate dy-mythicisation of the nude (the insistence on a commonality of experience for woman as lover and as surgical patient – surely an extraordinary levelling) might be seen to correspond on a simple level to Manet's conjunction of the nude of History with the picnic of contemporary Parisian leisured males. But the tendency to read Manet through Baudelaire must be resisted, tempting though it be when faced with *Le Déjeuner sur l'herbe* to refer to Baudelaire's friendship with Manet and his remarks back in 1845 *à propos* the epic painter of the heroism of modern life for whom he, Baudelaire, is searching, and who will 'snatch its epic quality from the life of today and ... make us see and understand, with brush or with pencil, how great and poetic we are in our cravats and our patent-leather boots.'[13] Invoking Baudelaire's words on modernity forecloses the debate on how modernity is construed in Manet; the cravats and boots, uniform items of male clothing that can be passed around, serve to create the impression that we have solved the problem and that we can now move on to *Olympia* which, as we shall see later, is where the critic really wants to be.

I have argued throughout this book that the relationship of the nude or semi-nude woman to the clothed world in the nineteenth century is a problematic one. But I do not intend simply to suggest that the problem is one between the conventional painting of Salon nudes on the one hand and the disruption of those conventions by an avant-garde on the other.[14] If empirical justification were required for bringing together two of the century's most enduring images, Delacroix's *Liberty* (fig. 19) and Manet's *Le Déjeuner* (plate 40), one would point not only to that very fact of their enduring nature but also to their capacity for transformation, for appropriation, and for inversion.

In the case of *Liberty*, discussed in chapter 3, the tendency has always been one of separating and isolating, or removing the woman from the retinue of the real which is male and thereby subduing those disturbing signifiers of the real that attach to her (like the rifle and the hair under her arm) to make her more effectively accomplish her allegorical task. In *Le Déjenuner* ... (or *Le Bain* as Manet originally called it) what is irresistible is not separation or isolation but either the process of participation

(as with the record cover of *Bow wow wow* (plate 42) or that of inversion. With an image of men who are fully clothed and women who are unclothed or partially clothed there is, it would appear, an invitation to participate. What Nochlin has described as the 'vital centre' of her recent essay on Courbet's *The Painter's Studio* (plate 43), a passage in which she fantasises an inverted scenario with Courbet as a naked model and Rosa Bonheur as artistic creator,[15] is in keeping with this tadition. The binary opposition of two women and two men that Manet constructs (and in doing so deviates from at least one of his

42. *Bow Wow Wow, Go Wild in the Country,* record sleeve

formal sources[16]) invites the carnivalesque inversion whereby the woman is clothed and the men exposed; the humorous potential of this inversion and, through it, the implications for a politics of gender, are exploited by Sally Swain in *Mrs Manet Entertains in the Garden*.

Here I would like to say a word about clothing. It sometimes seems as though the domestic and the public spaces of nineteenth-century French painting are littered with cast-off garments. One thinks, for example, of works as various as Courbet's *Demoiselles au bord de la Seine* (1856–7), Delacroix's *jacob Wrestling with the Angel* (1847–61) and Degas' *Intérieur* (*Le Viol'*) (c. 1868–9). The Renaissance counterparts of these images offer no such potent reminders of the encultured body. The drapery of the Renaissance nude is just that – drapery – but what the nineteenth century offers us is cast-off clothing, unfolded and jumbled. While there are instances (particularly with Courbet) in which the 'scandalous intermediary state' as Nochlin calls it, of being neither fully clothed nor completely naked[17] denotes a particular set of social meanings, we should not ignore the importance of clothing as a persistently subversive language with its own grammatical imperatives. Clothing, as Elizabeth Wilson suggests, is an extension of the body yet not quite part of it. It is that which not only links the biological body to the social being, forcing recognition that the human body is more than a biological entity, but more clearly

43. Gustave Courbet, *The Painter's Studio*

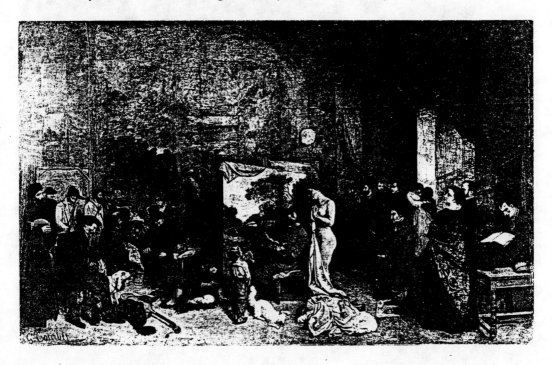

separates the two. The body with its open orifices is danger-
ously ambiguous; clothing negotiates those ambiguities but it
also conceals them. The nude, as a form of visual rhetoric, also
serves to mask the body and to deny its condition as cultural
construct. If this is so, then these strewn garments indicate that
nakedness is impermanent rather than permanent, that the
body having by this indicator once been clothed may again
assume its socially specific mask. By this sleight the nineteenth
century challenges the very idea of permanence and timeless-
ness invested in notions of truth and beauty that are embodied
in the nude female form. The whole point abut the nude is that
she foregrounds the unclothed body. The presence of cast-off

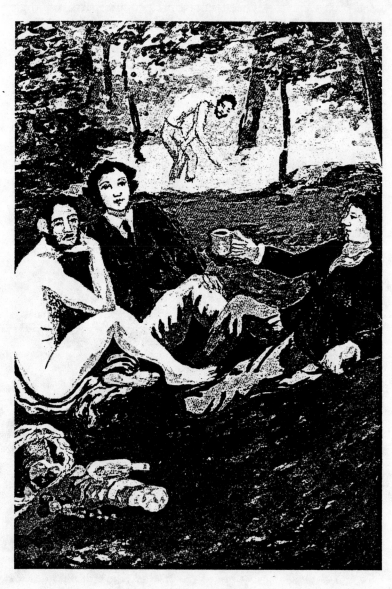

44. Sally Swain, *Mrs.
Manet Entertains in the
Garden*

clothing problematises the status of the body as nude and thus also problematises the body as an allegorical site. To put it another way, the presence of cast-off clothing points up the instability of the body as sign.

In *Le Déjeuner/Bain* the second woman in her shift at first sight appears to represent an intermediary state suspended between the fully clothed and the wholly unclothed. But then, looking closely, we observe that the seated woman who appeared wholly unclothed by contrast to her companions still wears her black cap and ear-rings. The discourse of clothing perpetually challenges the discourse of nudity in nineteenth-century French iconic art just as the discourse of allegory clashes with discourses of the real. This is clearly seen in Gérôme's *Truth Coming out of her Well to Shame Mankind* (1896, Moulins, Musée d'Art et d'Archéologie).[18] Just as the nude cannot confidently assume authority in the presence of cast-off clothing, so the allegorical is a point on a scale of relativity. Nudity here cannot be absolute; it carries with it the signs of its own other condition. The figure can put the clothes on and become a woman; this apparent possibility implies a future (and a past) and undermines the iconic status of the visual. So allegory, too, which presupposes the nude, threatens to collapse into the real. And Courbet's *The Painter's Studio: A Real Allegory summing up Seven years of my Artistic life* (see plate 43) is a key text for our ability to comprehend this structural relationship. Everyone notices the apparent strangeness of the fact that Courbet is painting a landscape inside his studio and ignoring the nude model who – very much an undressed figure whose clothes lie at her feet – stands and looks over his shoulder.

There are, of course, many ways of reading the central group in *The Studio of the Painter*. We may wish to note the contrast between the lay figure in its deadness and artifice and the naked woman in her 'reality', or we may wish to see the female figure in the traditional role as muse, the source for the artist's inspiration as he re-presents the material world on canvas as with, for instance, Ingres, *Cherubini and the muse of Lyric poetry* (Paris, Louvre, 1842). The most persuasive reading to date of this central group, and one which has particular resonance for my discussion of *Le Déjeuner sur l'herbe*, is Linda Nochlin's essay on 'Courbet's Real Aggegory . . .'[19] Nochlin agrees with Fried that the central group of Courbet, model and boy child replicates the oedipal triangle in a grouping that 'represents representation.'[20] But the sign woman is, says Nochlin, 'infinitely malleable in the representation of representation' and

the female model can be read consequently as 'wife, mother, mistress or inspiring muse'. Gender in this painting, argues Nochlin, is 'overtly and blatantly positioned as opposition – and domination'. And the fact that the painting on the easel is a landscape points up the direct interchangeability of woman and landscape as objects of male desire and manipulation.[21] What interests me, however, is the relationship of this nude female figure and her cast-off clothing to the uneasy oscillation in this work between allegory and naturalism. The presence of an unclothed woman, who has been and may again be clothed, in the company of many clothed figures, secures the possibility of allegory without loss of the sight of the real. This figure is, if you like, the mechanism that enables the contradition of a 'real allegory', as Courbet called his painting, to work. The discarded clothing is the link with the other figures in the studio, that which can reinscribe woman into the real. This possibility is important because it anchors the transgressive tendency of the allegorical.[22]

I would like to reinforce this general point about the threat that the female nude posed to the empirical world of the nineteenth century, and the trangression that allegory implied. If one is tempted to argue that the reason why Courbet represents a naked model in the studio is because he is a painter of nudes, it is worthwhile to compare Courbet's work with a nineteenth-century British painting that narratises the scenario of Courbet's *Studio* in a sort of mini-*Rake's Progress*. In a pair of pendants entitled *The Eton Boy* (plates 45 and 46), the studio is presented as a place where paintings are sold as well as where works of art are created. The difficulty of bringing together those two functions in a visually acceptable form when the essential component of the studio was the female nude whose presence belonged in are (and indeed in allegory) but not in real life is resolved in Frank Hyde's work by turning the Life Class into a tea-room where the model – now clothed – entertains the Eton boy and engages him in conversation.

The Oxford English Dictionary defines allegory as 'a description of a subject under the guise of some other subject of aptly suggestive resemblance' or 'an instance of such description, a figurative sentence, discourse, or narrative, in which properties and circumstances attributed to the apparent subject really refer to the subject they are meant to suggest' or 'an extended or continued metaphor'. There are, therefore, according to the dictionary definition, several essential components to allegory:

45. Frank Hyde, *The Eton Boy* I

46. Frank Hyde, *The Eton Boy* II

1 It must suggest something other than itself.
2 It must be discursive, presupposing a speaker and a listener and referring to a spatial and temporal situation.
3 It must be sequential, a continued and extended metaphor rather than an iconic sign.

In asking how far Manet's painting fulfils the requirements of the allegorical, we need to recognise that the allegory does not exist without a material context and that, definitions notwithstanding, it cannot be understood merely as a set of regulations. *Le Déjeuner sur i'herbe* may be seen to be doing these allegorical things but there is always some aspect that is supplementary to the definition; the definition is always subverted. On one simple level, we might wish to point out that the sheer improbability (the absence of decorum) in the depiction of a naked woman seated in a wood in the company of two fully and fashionably dressed men signals a narrative that suggests something other than itself. It reminds us of scenes from Medieval romance (the *chansons de geste* or the *Roman de la Rose*), or even from Cervantes, in which nothing is as it seems. In these stories well-born male travellers (knights errant) encounter temptation personified as a beautiful woman displaying her nakedness to tempt the knight (and his trusty squire) from the straight and narrow. The sensuality and the invitation to consume that are embodied in the contents of the basked – *petit pain*, peaches, cherries, liquor etc. – reinforce the allusions to the 'Bower of Bliss' with its promise of pleasure – and of punishment.

Source spotting has been a major industry among Manet scholars. Interpretations of *Le Déjeuner sur l'herbe* include the ingenious tooth-comb of Mauner[23] at one extreme who argues – by reference to the many iconographic models identifiable – that the painting constitutes a philosophical meditation upon the binary opposition between the material and the spiritual. Mauner takes for granted the most fundamental of oppositions – that constituted by gender; the opposition that he identifies as the pivot for the painting's meaning, an opposition between the material and the spiritual, as well as the terms which that opposition take, are grounded in the very issue of gender which goes unnoticed in his elaborate interpretation. On the other hand there is Hanson who sees it as a painting of modern life and stresses the parallels in lithography and other contemporary popular imagery.[24]

I do not subscribe to Mauner's narrowly iconographic reading – indeed I want to argue that iconographic 'meaning' is

precisely what is confounded in the painting. Nor can I believe Hanson's suggestion that Manet's contemporary audience would have seen the *Conçert Champêtre* in the Louvre attributed to Giorgione not as an allegory but as a realistic portrayal of life in the Veneto.[25] I will settle for the view that a series of loose quotations from Renaissance imagery and a scene that brings together improbable participants at an unlikely venue is ·enough to alert us to the possibility of an allegorical frame of reference. At the same time, I must acknowledge, it is not clear how the apparent subject – the déjeuner sur l'herbe – refers to a subject it is meant to suggest. In the case of *Liberty on the Barricades*, the central figure (however much the precise political meanings may be contested) is recognisably a symbol and is labelled accordingly in the painting's title.

Allegory has been described by another professional definer of terms as 'a structural rather than a textual symbolism – large scale exposition in which problems are conceptualised and alalysed into their constituent parts in order to be stated, if not solved.'[26] It is precisely this intentionalist character, the motion that the work is a means to an end, that there is a meaning to be dug out of it, that has made allegory unfashionable in Modernist criticism. Yet Manet's painting – in terms of historiography *the* Modernist painting – exhibits the kinds of binary oppositions, universal boundaries and generalised statements that are the stock-in-trade of allegorising discourse. The indeterminate terrain lacks all those topographically specific clues of 'naturalist' painting, the time of day is non-specific, the space is disposed in broad areas of dark and light, the depth of the water is uncertain, the boat is empty that is moored by a river, or is it a lake, or a pool? The mapping of these features is assertive but yet uncertain, as though data of an empirical or too precise kind will detract from the narrative. What is, on the other hand, offered with great clarity is a series of oppositions – not of the Christian or philosophical kind urged by Mauner – but of a structural kind. Manet's title was *Le Bain* and then *Le Déjeuner sur l,Herbe* (which translates poorly as "the picnic"); the complementary rituals of washing and eating, of cleanliness and sustenance, are thus encompassed by one image. Since sexuality is also present by virtue of the encounter between the sexes, we might conclude that the painting offers us human existence in essence bounded and defined by its social rituals. it raises, as Benjamin might say, the enigmatic questions not only of the nature of human existence as such, but also of the biographical historicity of the individual.[27]

There is a certain symmetry – a formal analogue to the

thematisation of ritual – in the arrangement of four individuals in an image that both demonstrates and disrupts the boundaries and rules of representation for the four genres.

Two men are in opposition to two women; the two men correspond to each other but the two women do not correspond to one another. The town (via the men's clothes) is opposed to the country (which is the setting);[28] the explicit and heterogeneus pile in the left foreground (the detritus of culture) is opposed to the homogenous and enigmatic pile of the woman's body that is placed next to it. The boundaries between genres that had been so closely policed by the École des Beaux-Arts and the Academy are here challenged in a work which coterminously and symptomatically presents examples in all four genres: the nude of history painting (courtesy of Marcantonia after Raphael), the contemporary portrait (the painter's brother Gustav and the Dutch sculptor Ferdinand Leenhof, and Victorine Meurand), landscape, and still-life in the foreground. The structural relations between these separate components are secured by the variation in the handling of paint in different parts of the canvas. Most notably the naked woman is painted with a high degree of finish in contrast to the liquid approximation of the painting of the landscape background.

A further condition of the allegorical mode is that it must be a sentence, a progression of moments, a narrative, an extended metaphor. The arguments of Lessing's *Laokoon* concerning the relative capacities of literature and art were by no means dead in Second Empire France, especially when it came to issues of art education. The Zola–Degas relationship is one manifestation of this interest in *Ut Pictura Poesis* and the problems encountered by the Impressionist artists in *plein-air* practice might be viewed within the framework of an interest in the synchronic as opposed to the diachronic. Manet might be said to produce imagery that has to be read as diachronic in so far as it invokes allegory; and is a sentence. This would allow us, for example, to take the two women to be the same person. However, one common view of Manet is that he produces an autonomous surface rather than a series of narratives to be unravelled. One of the nice ironies of critical practice is that this view originates in Zola's proposition that Manet's painting is devoid of meaning.[29] There is, however, another point of view.

The frozen moment of *Le Déjeuner sur l,herbe* involves the telling of a story that will never be told either to the participants or to us. In this *conçert champêtre* translated into an approximate nineteenth-century idiom, the emphatic finger

signals the speaker's power. But the condition of the pictorial militates against narrative and, in any case, within the narrative of a painting in which a story is evidently being told, no-one is listening to the speaker. The signifier of the raised hand and pointing finger has a referrent in the concept of communication by speech but what is being told is not revealed and cannot be inferred. This mechanism directly challenges those many devices employed in art since the Middle Ages and codified by Le Brun expressly to overcome the problem of knowing the message in visual art. Thus we have portrayed a condition of speech that cannot be construed as narrative; it is equivalent to imagery that refuses the deductions of an iconographic programme. Through this we are invited to confront precisely the limitations of painting as well as its possibilities.[30]

If the conversation partners appear to ignore each other (as Mauner suggests) then this is arguably no conversation but a pronouncement or a monologue. The untold story is central to this least dramatic of dramas. We are presented with the circulation of empty signs through the gesture and the look. If the three central figures are a group, then the spectator is partnered with the distant woman who is inexplicably up to her knees at the shallow margins of the water and who is engaged in an action which equally fails to signify. Moreover, she has no sight – unlike the others who all look. The line of vision cuts through the centre of the group via the authoritative gesture of the spoken word, passing through the centre of the scene of telling, to the self-engrossed figure. The fact that this figure is not only vague, anatomically uncertain, socially indeterminate and engaged in actions that fail to yield iconic clarity, forces the gaze back to the triangular group. Here the story which will never be told turns back upon itself, establishing a circularity through which we as viewers are drawn into the circuit of exchange. The speaker addresses two people who gaze out of the painting towards the spectator but in different directions. The depth of field and the centrality of the distant figure establish alongside this dynamic a direct link from us as viewers through the centre to the rear. If viewing is constituted as narcissistic or voyeuristic (looking at oneself or looking, unseen, at another) then the two matching and fully clothed male figures are narcissistic reflections of each other and it is the direct gaze of the undressed woman (the gaze unmasked as well as the body) that invites us to contemplate that narcissistic exchange. For us as viewers, however, the two figures on the left stage the narcissistic while the man on the right stages the voyeuristic. By this account the painting

dramatises the ways in which voyeurism and narcissism are gendered and how they work in relation to one another rather than as fixed conditions of viewing. In this it differs markedly from *Olympia* which, with its well-recognised boldness of gaze, refuses the very idea of viewing by returning the look in a uniquely confrontational manner. In both *Le Déjeuner* and *Olympia*, woman as unclothed but carrying the accoutrements of the socialised body plays the lead in the drama of the look.

Part of the fascination of *Le Déjeuner sur l'herbe* derives from the oscillation between voyeurism and narcissism. Through this oscillation the subjectivity of the viewer is brought into question. It is for this reason that the aspirant avant-gardism of *Bow wow wow* (plate 42) is so satisfactorily fulfilled by its participation and why it is, in the event, so affective and, presumably, so commercially conductive. By entering the space of the painting the group reconstructs itself as object of its own gaze, confounding the notions of distance upon which narcissism and voyeurism are predicated.

Le Déjeuner sur l'herbe therefore addresses the fundamental problem of narrative for pictorial art and it addresses this question in relation to subjectivity. *Whose story is it?* might be a suitable sub-title and the answer has to be, of course, the

47. Posy Simmonds, *Le Déjeuner sur l'herbe, The Guardian*, 1980

viewer's. Nochlin's shrewd formulation of the relations of authoritarianism which the reading of allegory produces might usefully be invoked here. Writing of her own response to Courbet's *The Painter's Studio* (plate 43), she refers to 'the role of authorial authority in allegory, an authority that calls for a similar authoritativeness, not to say authoritarianism, in its interpreters'.[31] The many narratives constructed around *Le Déjeuner sur l'hjerbe* in words and in images testify to this impulse to demystify by explication, a process that can only be achieved through furthering the narrative movement towards some kind of closure. *Bow wow wow's* appropriation of the stage of *Le Déjeuner sur l'herbe* is one attempt at resolving the arrested narrative via dismissal of the rightful, if silent, actors. Posy Simmonds apologises to Manet for twice using his painting (plate 47), and Ian Daniels iconoclastically demotes the supposed allegorical narrative to a conversation about motors while constructing the two other figures of the central triangle as partners (plate 48). Both Simmonds and Daniels attempt to resolve the narrative by seeming to deflect attention away from the sexual connotations of the naked female body. Jocasta Wright, the art student, removes her clothes in an (ironic?) act of protest against manufacturing industries and patriarchal cant

48. Ian Daniels, *Edouard Manet presents The After-Dinner Bore*

while Daniels's figure proposes undressing as a way of getting rid of the guest who has overstayed his welcome. Nor are art historians immune to the desire to endow narrative closive to this image. Wayne Andersen weaves an elaborate narrative through which the paris of myth, introduced via the borrowing from Raphael, is Paris the city and Manet's painting becomes a programmatic rendering of the artist's position in relation to the art world of 1863, a sort of visual and mythicised autobiography.[32]

Let us look more closely at how the theme of the clothed and unclothed body relates to this question of the necessary sequentiality of allegorical accounts. Here I want to propose that by invoking as its central motif the story that can't be told (the allegory that has no referent) the painting directs attention as a consequence to the act of its reading. And this is crucially a qustion of authority, for the protagonist who holds the story's secret hold the power. But the formation of power in narrative can be disrupted and one of the ways in which it is challenged is by nakedness. We can, perhaps, see this more clearly if we look for a moment at a verbal rather than a visual contstruction. In Howard Barker's play *The Bite of the Night*,[33] the last Classics professor in a ruined university, searching for truth in the many-layered ruins of innumerable Troys, encounters Gay, the disaffected (anti-mythical) and fiercely pragmatic daughter of Helen. She challenges the classicist, Professor Savage, to a kind of dual in a scene where the power of speech, classical learning and knowledge (the machinery of Manet's painting) confronts nakedness which has no claim to innocence.

Savage is meditating upon the way in which even horror may become routine when Gay breaks in:

SAVAGE On Monday I washed the body of the old woman.
 On Tuesday I cut the throat of a stranger.
 On Wednesday I lifted potatoes from the allotment.
 On Thursday I seduced the mother of my lover.
 On Friday I was ashamed and unable to act.
 On Saturday I read the works of great authors.
 On Sunday I lay and wished I was a baby.
 On Monday ...
 On Monday I washed the body of the old woman ...

GAY I'll take my clothes off, shall I?

SAVAGE It's night ...!

GAY I will, if you will ...

SAVAGE The dictator stirs inside his bunker ...

GAY (*removing her shoes*). Shoes first ...

SAVAGE The executioners are checking their weapons . . .
GAY Then socks . . .
SAVAGE And intellectuals rip the membranes of humanity in
 their shuddering cots All right, undress!
GAY If I am naked and you are not, what then?
 (*SAVAGE shakes his head*) One of us has the advantage,
 but who . . . ?

Who has the advantage, who has the power? – this is the
question that is also posed by Manet's painting. Which speaks
with greater authority, the word of the body? In *Le Déjeuner
sur l'herbe*, man has the word and woman has the body. But
man's word, like Savage's monotonous litany, is without
meaning or conclusion. His authority is empty. But nor does
the body appear to have the advantage. The question is, why
not? Here I would like to call up again the image of the naked
woman's discarded clothing. She was not constructed naked
but made herself so or was made so by the removal of her
garments. Upon this apparently slight distinction between the
passive and the active everything hangs. For to remove your
own clothes may be, as Gay intends and as Posy's students
intend, an act that disrupts the dominant structure of power, an
act of claiming authority; to have your clothes removed against
your will is, on the other hand, an act of violation. The removal
of clothing in social terms is not only an act of eroticisation but
also an act of humiliation; performed upon prisoners under
interrogation it is powerfully symbolic of depriving the indi-
vidual of their protective layers and exposing their vulner-
ability. Thus the matrix which is constituted of naked female
body in its relation to clothed male bodies and discarded female
garments is profoundly disturbing in its ambiguity. It is
characterised by utterly opposing terms. Nakedness by this
token must always invoke the danger of change and carry with
it the capacity to determine what happens around it. The naked
female body as seen in Manet seems to be locked in relation to
the spoken male word; they are as terms in a structure that
denotes the act of representation, the ambiguities of nakedness
ever threatening the explicative authority of the word. Only
acts of reading can unlock this relationship. And those acts of
reading may be construed in terms of the power relations that
are determined by the structural relationship between the
clothed body and what is known (expected/feared) to lie
beneath its layers. The pleasure of the text, by Barthes' account,
lies not in the act of corporeal strip-tease where there is no fear
and no edge. The entire excitement of the act of reading lies in
an oedipal pleasure, the pleasure of denuding and knowing, of

learning the origin and the end of the story. As Barthes puts it: 'if it is true that every narrative (every unveiling of the truth) is a staging of the (absent, hidden, or hypostatized) father – [this] would explain the solidarity of narrative forms, of family structures, and of prohibitions of nudity, all collected in our culture in the myth of Noah's sons covering his nakedness'.[34]

Le Déjeuner foregrounds the act of reading. Therefore the function of the naked woman's body in the painting is precisely that of embodying the balance of power. Strip-tease offers no pleasure to the reader; it is, in Barthes's words, 'hope of seeing the male sexual organ' or the 'knowledge of the end of the story' that constitutes desire. The impulse to enter into the world of the painting, to participate in its drama, to challenge – or indeed to reverse – its order by dressing the woman and undressing the man can thus be seen as an attempt to fulfil that desire. *Le Déjeuner sur l'herbe*, the occasion of ritual cleansing and consumption, is also the occasion of confrontation with desire in the text. Power is mediated through desire for the object, the knowledge of the end of the story. Woman in her unclothed state (and in the semi-clothed state from which she became unclothed) stands as a reminder both of what man is not (that is, naked, castrated, vulnerable, de-socialised) and as a reminder of the impossibility of attaining the desired knowledge.

Ultimately the text refuses to deliver both the allegorical and the modern which its configurations promise. The idea that Manet's painting is about nothing but painting has been around for a long time;[35] it has been hotly contested by those who wish to find reasons why the content is as it is and to rescue Manet from the dubious privilege of proto-modernist/proto-sbastract artist. The point I want to make is, again, a point which brings together questions of thematics with questions of discursive practice. *Le Déjeuner sur l'herbe* is not only a scene of story-telling, it is arguably the moment of a particular sort of story, the story of seduction. But the story of seduction is one that fails to seduce an audience that desires interpretation. As Baudrillard says, 'the meaning of an interpretative discourse . . . has never seduced anyone. Every interpretative discourse . . . wants to get beyond appearances'.[36] *Le Déjeuner sur l'herbe* is precisely about appearances. Faced with the refusal of *Le Déjeuner* to offer up its apparent allegory (for allegory here is mere appearance) or, indeed, to release its sexuality, reader after reader moves with relief to the *Olympia* of two years later. Georges Bataille, for all his interest in seduction, transposes on to the artist his own feelings of frustration with the *Le Déjeuner* of 1863 and his relief before *Olympia* of 1865:

The nude would be a woman – a real woman, like those bathing in the Seine. But the stridency of the finished picture, with its inevitable effects of incongruity, left him dissatisfied; he felt that there was something arbitrary about the systematic elaboration of the *Dejeuner*. Though he said nothing, he now deepened his enquiry into the effects to be drawn from the transposition of one world into another. He abandoned the men in frock coats, clearing the stage of everything except the nude herself and a maidservant, as he had seen them in the *Urbino Venus* ... In the intimacy and silence of her room, Olympia stands out starkly, violently, the shock of her body's acid vividness softened by nothing, intensified, on the contrary, by the white sheets.[37]

T. J. Clark names *Le Déjeuner* as one of those paintings that exemplify the city as a 'free field of signs and exhibits', typifying the combination of display and equivocation which he takes to be the chief new characterisation of modern life. But he is remarkably uninterested in the painting, considering it exclusively (and very briefly) as a contrast with *Olympia* before which the critics failed, it is argued, to notice the quotations and revisions they had laughed at in the *Le Déjeuner sur l'herbe*.[38] This annexation of *Le Déjeuner* as a somewhat awkward prelude to *Olympia*, a painting that can become the site of debates over class and urbanisation without much more than an over-the-shoulder glance at gender, is a most revealing episode in the recent masculinist history of Western art history.

So if the untold story of *Le Déjeuner sur l'herbe* is a seduction story – and woman within heterosexual sociaty (and arguably particularly within French culture) is the crucial object of the discourse of seduction as well as its initiator[39] – the nude is the sign of seduction as well as its site. In terms of the production of marks in pigment on a particular canvas, she is also the pivot in the brilliant surface that conspires to uproot meaning, to refute the something-other-than-itself to which allegory must always refer, to insist upon the secrecy of seduction as opposed to the relevation of interpretation.

Power is no transparent commodity and the power of the nude stands here as a reminder that the object of desire lies elsewhere. The naked expanse of female flesh is mere form, a page (and painted with appropriate flatness) on which the sotry that can never be told would be written. By her nakedness woman raises the staging of the hidden father and thus the pleasure of the text. The interdependency of male and female in *Le Déjeuner sur l'herbe* is thus grounded not in Christian or Pagan iconography, nor in contemporary life, but in textual strategy. The questions of source material and the question of a painting of modern life are not irrelevant; to want to know the end of the story is to wish for the allegorical account which the

arrangement of figures and their allusion to specific sources have led us to anticipate. To demand a painting of modern life is to demand a new configuration of the real in which we 'snatch its epic quality from the life of today' and understand 'with brush or with pencil, how great and poetic we are in our cravats and our patent leather boots',[40] to quote again Baudelaire's vision of masculine modernity. Epic art is art that narrates rather than represents; the ironic resonance of Baudelaire's declaration signals the contradiction inherent in the notion of 'snatching' at something as cumbersome as the epic and hints — through the metonymic structure of masculine clothing — at the fragmentation of the narrative form which, above all others, tells of the deeds of heroes. *Epos*, from which the word epic is derived, is an unwritten and collective art. Masculinity and individuality will only be reassembled and spoken if *epos* becomes epic through narrative closure and through the delivery of the story. The presence of woman unclothed in Manet's *Le Déjeuner sur l'herbe* transforms to the condition of the allegorical a composition which might (with its chivalric overtones) otherwise simply have fulfilled Baudelaire's requirements for epic (as for instance did *Musique aux Tuileries*, 1862, London, National Gallery). By challenging the authority of the word, the female body here thematises the impossibility of narrative closure and, therefore, of masculine power. The epic — and hence masculine — expectation of the avant-garde is subverted by the allegorical method. It is the alienating effect of this event that provokes the participatory acts that we have seen to be a characteristic of the history of Manet's *Le Déjeuner sur l'herbe*.

NOTE

Introduction

1 I. M. Young, 'Impartiality and the Civic Public', in S. Benhabib and D. Cornell, eds., *Feminism as Critique. Essays on the Politics of Gender in Late-Capitalist Societies*, Oxford, 1987, pp. 66–7.

2 In my review of Lynda Nead's book *Myths of Sexuality. Representations of Women in Victorian Britain* (1988), in *Art History*, March 1989.

3 Review of Nead, in the *Myths of Sexuality*, *Observer*, 15 May 1988.

4 M. Baxandall, *Painting and Experience in Fifteenth Century Italy. A Primer in the Social History of Pictorial Style*, Oxford, 1972.

5 Peter Fuller's *Seeing Berger. A Revaluation*, London, 1980, offers an important critique of Berger's methodology.

6 I am referring here to R. Barthes, 'The Death of the Author' (1968) in R. Barthes, *Image Music Text*, Essays selected and translated by Stephen Heath (1977), London, 1982 and M. Foucault, 'What is an Author?' in *Language, Counter-Memory, Practice. Selected Essays and Interviews*, ed. D. Bouchard, Ithaca NY, 1977.

7 P. Kamuf, *Signature Pieces*, Ithaca NY, 1988, p. 15.

8 I. M. Young, 'Impartiality and the Civic Public, p. 67.

9 I am thinking here particularly of such classic texts as E. Said, 'Opponents, Audiences, Constituencies and Community', in H. Forster, ed., *Postmodern Culture*, London, and Sydney, 1985 and J. Baudrillard, *For a Critique of the Political Economy of the Sign*, trans. C. Levin, St. Louis MO, 1981.

10 Titian's *Venus with a Mirror* (Washington, National Gallery of Art) was used to advertise British Rail Intercity services in August 1988 (*The Guardian*); Delacroix's *Liberty* was incorporated into an advertisement for *Price Waterhouse Information Technology Review*, *The Times*, 2 December 1987. The use of Millais' *Bubbles* to advertise Pears' soap offers a prototype.

11 M. Foucault, 'Body/Power', in *Power/Knowledge. Selected Interviews and Other Writings 1972–1977*, ed. C. Gordon (1980), Brighton, 1988, p. 59.

12 See J. Derrida, 'Freud and the Scene of Writing', *Writing and Difference* (1978), London, 1981, and J. Derrida, *The Post Card: From Socrates to Freud and Beyond* (1980), trans. A. Bass, Chicago and London, 1987.'

13 V. Burgin, *The End of Art Theory. Criticism and Postmodernity*, London, 1986, p. 121:
Unlike most other animals, the human infant is born into a state of nurseling dependency in which it is incapable of actively seeking its food;

nourishment must be brought to *it*, as when the mother provides the breast. When hunger reasserts itself, therefore, the suckling initially has no recourse but to attempt to resurrect the original experience of satisfaction in hallucinatory form; thus Freud writes: 'The first wishing seems to have been a hallucinatory cathecting of the memory of satisfaction'. We may see in this scenario the Lacanian schema according to which 'desire' insinuates itself between 'need' and 'demand': the infant's *need* for nourishment is satisfied when the milk is provided; the infant's *demand* that its mother care for it is also met in that same instant; *desire*, however, is directed neither to an object (here the substance, 'milk') nor to a person, but to a *fantasy* – the mnemic traces of the lost satisfaction.

14 See S. Faunce and L. Nochlin, *Courbet Reconsidered*, New Haven CT and London, 1988.

1 Reading the body

1 K. Clark, *The Nude: A Study of Ideal Art* (1956), Harmondsworth, 1960, preface.

2 J. Berger, *Ways of Seeing*, Harmondsworth, 1972 reprinted eleven times between 1972 and 1981.

3 See, for example, Wendy Leeks, 'Ingres Other-wise', *The Oxford Art Journal*, 9:1, 1986, part of Leeks' research for her PhD thesis which is imminently to be presented at the University of Leeds; Carol Armstrong 'Edgar Degas and the Representation of the Female Body', in S. Suleiman, ed., *The Female Body in Western Culture. Contemporary Perspectives*, Cambridge MA and London, 1986; E. Lipton, *Looking into Degas. Uneasy Images of Women and Modern Life*, Berkeley and Los Angeles, 1986; L. Nead, 'Representation, Sexuality and the Female Nude', *Art History*, June 1983, pp. 227–36. Nead's book on the nude, now in preparation, should alter this state of affairs. Among the works on the nude written with a more popular audience in mind, the most interesting is L. Hudson's *Border of Knowledge: The Psychological Significance of the Nude in Art*, London, 1982.

4 The exceptional cases have been Manet and, more recently, Degas whose work has been scrutinised as part of the academic economy of studies of Paris in the nineteenth century.

5 *The Spectator*, quoted on the back cover of the first Pelican edition of K. Clark, *The Nude*, K. Clark, quoted on the back cover of H. Honour and J. Fleming, *A World History of Art* (1982), London, 1985.

6 M. J. Friedlander, *On Art and Connoisseurship* (1942), London, 1943, p. 104.

7 K. Clark, *The Nude*, p. 68.

8 Ibid., p. 67.

9 Ibid., pp. 1, 3.

10 E.g. M. Friedlander, *On Art and Connoisseurship*, p. 104: 'Nudity is timeless'.

11 The most substantial challenge, to date, has been Norman Bryson's *Vision and Painting: The Logic of the Gaze*, London, 1983.

12 H. Honour and J. Fleming, *A World History of Art*, p. 384; pp. 383–6.

13 E. H. Gombrich, *The Story of Art* (1949), London, 1957, pp. 239–40. In the fourteenth edition, enlarged (1984), p. 251, the passage is expanded but remains substantially the same and the phrases I have quoted remain.

14 See, for example, R. Parker and G. Pollock, *Old Mistresses: Women, Art and Ideology*, London, 1981, ch. 4 and D. Cherry and G. Pollock, 'Woman as Sign in Pre-Raphaelite Literature: A Study of the Representation of Elizabeth Siddall', *Art History*, June 1984.

15 B. Castiglione, *The Book of the Courtier* (1528), trans. G. Bull, Harmondsworth, 1967, p. 211.

16 A particularly interesting recent intervention is P. Kamuf, *Signature Pieces: On the Institution of Authorship*, Ithaca NY and London, 1988.

17 J. Berger, *Ways of Seeing*, p. 63.

18 Ibid., 54.

19 Ibid., p. 64.

20 Ibid., p. 61.

21 The Princes Gate Collection is part of the Courtauld Institute Galleries, Somerset House. Other versions are in the Norton Simon Collection, California; the Fitzwilliam Museum, Cambridge; and in the Dresden Museum. See *The Princes Gate Collection*, 48, 1981.

22 S. B. Ortner, 'Is Female to Male as Nature is to Culture?', in M. Rosaldo and L. Lamphere, eds., *Woman, Culture and Society*, Stanford, 1974, p. 73.

23 Ibid., pp. 86–7.

24 C. Duncan, 'Virility and Domination in Early Twentieth-Century Vanguard Painting', in N. Broude and M. Garrard, eds., *Feminism and Art History: Questioning the Litany*, New York and Toronto, 1982.

25 L. Mulvey, 'You don't know what is happening, do you, Mr. Jones?', *Spare Rib*, 8, 1973; reprinted in R. Parker and G. Pollock, eds., *Framing Feminism: Art and the Women's Movement 1970–1985*, London and New York, 1987.

26 G. Saunders, *The Nude. A New Perspective*, London, 1989, p. 80.

27 Gérôme executed four versions, c. 1890, of which one is now in the Metropolitian Museum, New York (See G. M. Ackerman, *The Life and Work of Jean-Léon Gérôme*, London and New York, 1986, cat. 385–8); Burne-Jones's series of four paintings were executed 1869–79 (Birmingham City Museum and Art Galleries).

28 Sotheby's, London, 25 November 1987 (71).

29 J. Berger, *Ways of Seeing*, p. 51.

30 J. Lacan, 'The Mirror Stage as Formative of the Function of the I as revealed in Psychoanalytic experience', in *Ecrits. A Selection* (1966), trans. A. Sheridan, London, 1977.

31 The most cogent account of this phenomenon is to be found in K. Flint, 'Moral Judgement and the Language of English Art Criticism 1870–1910', *The Oxford Art Journal*, 6:2, 1983.

32 See A. Rorimer, *Drawings by William Mulready*, London: Victoria and Albert Museum, 1972, pp. 3–33.

33 According to J. A. Kestner, *Mythology and Misogyny: The Social Discourse of Nineteenth-Century British Classical Subject Painting*, Madison WI and London, 1989, p. 42, depictions of the suffering and abandoned Clytie were executed by G. F. Watts (1868) and De Morgan (1886–7). I do not, however, concur with Kestner's view that Victorian misogyny can be read off from images that function as cyphers. The importance of Apollonian imagery and mythography in the nineteenth century is discussed in J. B. Bullen, ed., *The Sun is God: Painting, Literature and Mythology in the Nineteenth Century*, Oxford, 1989.

34 S. B. Casteras, *Images of Victorian Womanhood in English Art*, Cranbury NJ, London and Mississauga, 1987, p. 104.

2 Psychoanalysis and art history

1 E. Kris, *Psychoanalytic Explorations in Art*, New York, 1952, p. 21.

2 D. LaCapra, 'History and Psychoanalysis', in F. Meltzer, ed., *The Trial(s) of Psychoanalysis* (1987), Chicago and London, 1988, p. 34.

3 L. Tickner, 'Feminism, Art History, and Sexual Difference', *Genders*, 3, Fall 1988, p. 111.

4 See P. Gay, *Freud for Historians*, New York and Oxford, 1985, p. 17.

5 H. Wolfflin, *Die klassiche Kunst* (1899), trans. as *Classic Art* (1952), London, 1959, p. 240.

6 N. Pevsner, *The Englishness of English art*, London, 1955, p. 19.

7 'It seems to me that his method of inquiry is closely related to the technique of psychoanalysis. It, too, is accustomed to divine secret and concealed things from despised or unnoticed features, from the rubbish-heap, as it were, of our observations.' S. Freud, 'The Moses of Michelangelo' (1914), Pelican Freud Library, vol. XIV, *Sigmund Freud: Art and Literature*, Harmondsworth, 1985, p. 265.

8 The best account of the trade is still to be found in J. Baudrillard, *For a Critique of the Political Economy of the Sign*, trans. C. Levin, St. Louis, 1981.

9 See S. Freud, 'Leonardo da Vinci and a Memory of his Childhood' (1910), Pelican Freud Library, vol XIV; *Sigmund Freud: Art and Literature*, Harmondsworth, 1985. N. Schor, in *Reading in Detail: Aesthetics and the Feminine*, London, 1987, p. 163, n. 11, points out that the question of Leonardo's kite/Freud's vulture has become a psycho-critical topos. See, also, M. Schapiro, 'Leonardo and Freud: An Art-Historical Study', *Journal of the History of Ideas*, 17, 1957.

10 See E. Kirsi, *Psychoanlytic Explorations*, ch. 4; R. and M. Wittkower, *Born under Saturn*, New York, 1963; R. Kuhns, *Psychoanalytic Theory of Art*, New York, 1983, ch. IV.

11 E. H. Gombrich, 'Psychoanalysis and the History of Art', read before the British Psycho-analytical Society in November, 1953, published in *Meditations on a Hobby Horse*, London and New York (1963) 1971, p. 30, p. 31.

12 P. Fuller, *Art and Psychoanalysis*, London, 1980.

13 D. LaCapra, 'History and Psychoanalysis', p. 11.

14 L. Tickner, 'Feminism, Art History, and Sexual Difference', p. 112.

15 T. J. Clark, *The Painting of Modern Life, Paris in the Art of Manet and his Followers*, London, 1984, p. 98.

16 A. Rifkin, 'Marx's Clarkism', *Art History*, December 1985, p. 495 discusses Clark's treatment of the question of gender in relation to Manet's *Olympia*.

17 C. Pajaczkowska, 'Structure and Pleasure', *Block*, 9, 1983, p. 13.

18 K. Silverman, *The Acoustic Mirror*, Bloomington and Indianapolis, 1988, p. 2.

19 H. Wolffflin, *Classic Art*, p. 82.

20 See, for example, V. Burgin, 'Seeing Sense', in V. Burgin, *The End of Art Theory: Criticism and Postmodernity*, London, 1986; L. Mulvey, 'You don't know what is happening, do you, Mr. Jones?', in R. Parker and G. Pollock, eds., *Framing Feminism: Art and the Women's Movement 1970–1985*, London and New York, 1987.

21 G. Pollock, 'Woman as Sign: Psychoanalytic readings', in G. Pollock, *Vision and Difference: Femininity, Feminism and the Histories of Art*, London, 1988.

22 The most notable exception, aside from Steinberg's work mentioned earlier, is Pat Simons's work on Renaissance portraiture in which she 'attempts a dialogue rather than a confrontation between historical and psychoanalytic interpretations'; see P. Simons, 'Women in Frames', *History Workshop*, 25, Spring 1988, p. 7.

23 Steinberg's book essentially relies on the methods of historical iconography but it does deal with sexuality, the common ground of all forms of psychoanalytic theory. Thus, by implication, it deals with collective repression of forms of historical evidence that are manifestly to do with sexuality. Steinberg's book was greeted in Britain with a mass chorus of dissent. He lists Benedict Nicholson, Anthony Blunt, E. H. Ramsden, Paul Joannides, Michael Levey, E. H. Gombrich, Marina Warner, Richard Wollheim and Charles Hope among those who have greeted his interpretaive approach to the history of art with hostility (letter to the author, 1986).

24 W. Hood, 'The State of Research in Italian Renaissance Art', *Art Bulletin*, 69, 1987, p. 184.

25 T. J. Clark, *Image of the People: Gustave Courbet and the 1848 Revolution*, London, 1973.

26 F. Jameson, *The Political Unconscious: Narrative as a Socially Symbolic Act*, London, 1981, p. 208–9.

27 C. Ginzberg, *The Enigma of Piero della Francesca* (1981), London, 1985, chs. III and IV.

28 See S. Frosh, *The Politics of Psychoanalysis: An Introduction to Freudian and Post-Freudian Theory*, London, 1987; the sharpest and most cogent criticism is to be found in G. Deleuze and F. Guattari, *Anti-Oedipus: Capitalism and Schizophrenia* (1972), London, 1983.

29 D. LaCapra, 'History and Psychoanalysis', p. 14.

30 M. Fried, *Realism, Writing, Disfiguration, in Thomas Eakins and Stephen Crane*, Chicago, 1987, p. 10. I shall not be discussing the essay on Crane which constitutes a discrete section of this book.

31 'The center of the action, the patient, is almost hidden; his face is covered by the anesthetist's cloth...', Fried, *Realism*, p. 10.

32 Ibid., p. 7.

33 Ibid., p. 41 (my italics). In fact, as Elizabeth Johns points out (E. Johns, *Thomas Eakins: The Heroism of Modern Life*, Princeton NJ, 1983, p. 48, n. 6) 'the surgical operation was specified in the catalogue of the exhibition of the Centennial as "an operation for the removal of a dead bone from the femur of a child"'. Furthermore, Johns establishes that the woman was identified in 1876 as 'a female relative' (p. 48, n. 10). Not until 1918 was she named as the mother of the patient.

34 See Fried, *Realism*, pp. 10–11.

35 Ibid., p. 69.

36 Ibid., preface, my italics.

37 J. Derrida, 'Freud's Legacy' in *The Post Card: From Socrates to Freud and Beyond*, trans. A. Bass, Chicago and London, 1987; first edn. *La Carte Postale: De Socratre à Freud et au-delà*, Paris, 1980; J. Derrida, 'Coming into one's own', in G. Hartman, ed., *Psychoanalysis and the Question of the Text*, Baltimore and London, 1978. Geoff Bennington has pointed out to me that the ideas in 'Freud's Legacy' were available even before 1978 through Derrida's lectures in American universities.

38 This reader of Fried's essay on Eakins was immediately reminded of propositions such as: 'The *symptomatic* form of the return of the repressed:

139

the metaphor of writing which haunts European discourse, and the systematic contradictions of the onto-theological exclusion of the trace. The repression of writing as the repression of that which threatens presence and the mastering of absence'. J. Derrida, 'Freud and the Scene of Writing', *Writing and Difference* (1978), London, 1981, p. 197.

39 J. Derrida, 'Coming into one's own', in G. Hartman, *Psychoanalysis and the Question of the Text*, pp. 114–15; the equivalent passage in *The Post Card* is on p. 295.

40 Ibid., pp. 119–20; the equivalent passage in *The Post Card* is on p. 303.

41 Fried, *Realism*, p. 69, n. 61.

42 Ibid., p. 40.

43 Ibid., p. 35.

44 Ibid., p. 70. 'Thus for example we fail to grasp, and by this I mean something more than simply note, the exclusiveness of the hunter's concentration on his target, the weight but also the balance of the shotgun in his hands, even the pressure of his finger against the resistance of the trigger.'

45 M. Fried, *Absorption and Theatricality: Painting and Beholder in the Age of Diderot*, Berkeley and Los Angeles, 1980.

46 For an extremely acute but nonetheless sympathetic review of Fried's work on Eakins and Crane see L. Jordanova, 'Probing Thomas Eakins', *Art History*, March 1988. The most complete examination of *The Gross Clinic* and *The Agnew Clinic* in relation to the history of medicine is G. H. Brieger, 'Sense and Sensibility in Late Nineteenth-Century Surgery in America', in W. F. Bynum and R. Porter, eds., *Medicine and the Five Senses*, Cambridge, forthcoming.

47 Fried, *Realism*, p. 40.

48 Ibid., p. 44.

49 Ibid., pp. 45–6.

50 See J. Culler, 'Reading as a Woman', in *On Deconstruction: Theory and Criticism after Structuralism*, London, 1983; A. Jardine and D. Smith, eds., *Men in Feminism*, New York, 1987; M. A. Doane, 'Film and the Masquerade: Theorising the Female Spectator', *Screen*, 23, 1982.

51 S. Heath, 'Lessons from Brecht', *Screen*, 17:4, 1970, quoted in K. Silverman, *The Acoustic Mirror*, p. 6.

52 S. Freud, 'Fetishism', Pelican Freud Library vol. VII, *Sigmund Freud on Sexuality*, 1983, Harmondsworth, p. 352.

53 J. Lacan, 'The Split between the Eye and the Gaze', ch. 6 of *The Four Fundamental Concepts of Psychoanalysis* (1973), trans. A. Sheridan, Harmondsworth, 1977. See especially pp. 72–3:
But it is not between the invisible and the visible that we have to pass. The split that concerns us is not the distance that derives from the fact that there are forms imposed by the world towards which the intentionality of phenomenological experience directs us – hence the limits that we encounter in the experience of the visible. The gaze is presented to us only in the form of a strange contingency, symbolic of what we find on the horizon, as the thrust of our experience, namely, the lack that constitutes castration anxiety.

54 K. Silverman, *The Acoustic Mirror*, p. 3, drawing on Christian Metz: 'cinema is the story of missed encounters, of the "failure to meet of the voyeur and the exhibitionist whose approaches no longer coincide."

55 Fried, *Realism*, pp. 11–12.

56 See, for example, *Taking the Count* (1898), New Haven, Yale University

Art, Gallery; *Between Rounds* (1899), Philadelphia Museum of Art; *Salutat* (1898), Andover MA; Addison Gallery of American Art, Phillips Academy; all reproduced in L. Goodrich, *Thomas Eakins*, Cambridge MA and London, 1982, vol. II, plates 211, 214, 217.

57 Elizabeth Johns, *Thomas Eakins*, offers the richest range of possible visual references for *The Gross Clinic*.

58 See L. Goodrich, *Thomas Eakins*, vol. I, pp. 45–6.

59 Reproduced in G. M. Ackerman, *The Life and Work of Jean-Léon Gérôme*, London and New York, 1986, p. 158.

60 E. Johns, *Thomas Eakins*, pp. 79–80.

61 L. J. Jordanova, *Sexual Visions. Images of Gender in Science and Medicine between the Eighteenth and the Twentieth Centuries*, Hemel Hempstead, 1989, p. 29.

62 See J. L. Epstein, 'Writing the Unspeakable: Fanny Burney's Masectomy and the Fictive Body', *Representations*, Fall 1986. Removal of the breast 'by direct operation, together with the associated lymph-spaces and lymphatic glands' was regarded (until very recently) as the only safe course (*Encyclopaedia Britannica*, XVII, 1911). The operation was not uncommon in the eighteenth century (see, for example, R. Porter, ed., *Patients and Practitioners*, Cambridge, 1985, ch. 6, p. 149). The operation was 'perfected' in the USA by William Stewart Halsted (1852–1922) of Johns Hopkins (see D. Guthrie, *A History of Medicine* (1945), Edinburgh, London and Paris (1945), 1947, p. 331).

63 As, for example, did Elizabeth Garrett Anderson in 1870.

64 C. Bell, *The Anatomy and Philosophy of Expression as Connected with the Fine Arts* (1806), 7th edn. revised, London, 1886, p. 194.

65 See L. Goodrich, *Thomas Eakins*, vol. I, ch. x.

66 Medical College of Thomas Jefferson University, Philadelphia; L. Goodrich, *Thomas Eakins*, vol. I, plate 20. The formal antecedents to these figures are clearly Courbet's somnolent women.

67 Philadelphia Museum of Art, L. Goodrich, *Thomas Eakins*, vol. II, plate 182.

69 Ibid., plate 98, p. 222.

69 See L. Mulvey, 'Visual Pleasure and Narrative Cinema', *Screen*, 16:3, 1975; K. Silverman, *The Acoustic Mirror*, p. 26.

70 Fried, *Realism*, p. 68.

71 Ibid., p. 69.

72 The leg, here visually separated from the body to which it belongs and gleaming in the illumination of the operating theatre, can be read as a substitute for the penis. It is significant in relation to this reading that the operation for the removal of the dead bone in the leg that is here in progress is designed to prevent amputation, a form of surgery that symbolically relates to castration.

73 There are many references to Eakins's often embarrassing tendency to ask any women he met to pose for him; Goodrich, *Thomas Eakins*, pp. 94–5 gives a contemporary reference to Eakins being 'starved of the nude'.

74 The term 'veiled' I have appropriated from L. J. Jordanova, whose excellent study of the concept of the veiling-unveiling of women and nature is to be found in *Sexual Visions*, ch. v, Paris, 'Nature Unveiling before Science'.

75 Fried, *Realism*, p. 11.

76 Dated to the early 1870s, Philadelphia Museum of Art; L. Goodrich, *Thomas Eakins*, vol. I, plate 17.

77 See K. Silverman, *The Acoustic Mirror*, pp. 15–16; Lacan's *objet petit à,*
which might appropriately be invoked here, describes all those losses
which constitute the condition of desire.

78 For details of the exhibition and reception of the clinic paintings, see L.
Goodrich, *Thomas Eakins*, vol. I, pp. 130–8; vol. II, pp. 47–51.

3 Liberty on the Barricades

1 E. Hobsbawn, 'Man and Woman in Socialist Iconography', *History
Workshop Journal*, 6, Autumn 1978, p. 122.

2 T. J. Clark, *The Absolute Bourgeois: Artists and Politics in France 1848–51*,
London, 1973, p. 19.

3 L. Johnson, *The Paintings of Eugène Delacroix, A Critical Catalogue,
1816–1831*, Oxford, 1981, no. 144.

4 *Lettres Intimes*, quoted in ibid.

5 H. Toussaint, ed., *'La Liberté guidant le peuple' de Delacroix*, catalogue,
Paris: Réunion des Musées Nationaux, 1982. Toussaint points out that
the artist's immediate sources for the figure of Liberty were sketches from
an episode in the Greek–Turkish war. Italo Calvino used the occasion of
the 1982 exhibition to publish an essay entitled 'Un romanzo dentro un
quadro', reprinted in I. Valvino, *Collezione di Sabbia*, Milan, 1984.

6 See H. Adhémar, 'La Liberté sur les Barricades de Delacroix', *Gazette des
Beaux-Arts*, 43, 1954.

7 There is a very full account of this imagery in N. Hadjinicolaou, '"La
Liberté guidant le peuple" de Delacroix devant son premier plan', *Actes
de la Recherche en Sciences Sociales*, June 1979, pp. 3–26. See also Hadjini-
colaou's comments in 'Disarming 1830: A Parisian Counter-Revolution',
Block, 4, 1981, p. 13.

8 M. J. Lasky, '"Lady on the Barricades", (1.) Margit, *Encounter*, July 1972,
p. 17. I am indebted to Ulriche Hanna Meinhof for this reference.

9 Moffat's portrait belongs to the National Galleries of Scotland; George's
painting (collection of the artist) is reproduced in C. Jencks, *Post-
Modernism. The New Classicism in Art and Architecture*, New York, 1987,
p. 69. It is interesting to note, in view of the argument that will be
developed in this chapter, that two other shadowy images of women are
presented in Moffat's painting – one is a stripper, the other a street-
walker. In George's painting Liberty is an artist's model and thus
conforms to the type discussed in ch. 1 section iii. I am grateful to
Dorothy Scruton for drawing this painting to my attention.

10 Exhibited in London: Marlborough Fine Art, 25 January–1 March 1985.

11 Schnetz's painting used to hang in Paris in the Petit Palais and has more
recently acquired greater visibility in the Musée d'Orsay.

12 M. Warner, *Monuments and Maidens. The Allegory of the Female Form*
(1985), London, 1987.

13 Ibid., p. 271.

14 L. Johnson, *The Paintings of Eugène Delacroix*, no. 144.

15 *The Guardian*, 16 April 1984.

16 Natalie Davis points out that sexual reversals, including the trans-
formation of women into warriors like other rites and ceremonies of
reversal, are ultimately sources of order and stability in a hierarchical
society: 'Women on Top: Symbolic Sexual Inversion and Political
Disorder in Early Modern Europe' in B. A. Babcock, ed., *The Reversible
World. Symbolic Inversion in Art and Society*, Ithaca NY and London, 1978.

17 It should be noted that a woman dressed thus was almost fully clothed and that many women, laundresses for instance, worked in their *jupons*.

18 L. Johnson, *The Paintings of Eugène Delacroix*, no. 144.

19 H. Adhémar, 'La Liberté sur les Barricades de Delacroix', states that the story was invented to promote sales of the engraving after the painting.

20 It is now in the Louvre. The fulles art-historical discussions of how the allegory is constructed are to be found in G. H. Hamilton, 'The Iconographical Origins of Delacroix's Liberty', in *Studies in Art and Literature for Bel da Costa Greene*, Princeton NJ, 1984 and W. Hofmann, 'Sur la "Liberté" de Delacroix', *Gazette des Beaux-Arts*, September 1975.

21 *Journal des Artistes*, 1831, quoted in H. Adhémar, 'La Liberté sur les Barricades de Delacroix'.

22 N. Davis, 'Women on Top', p. 184.

23 Sotheby's Belgravia, London, 12 December 1978. Other works that centre on the theme of the heroic unknown woman warrior are Ingres's *Joan of Arc* (Louvre, Paris), Wilkie's *The Maid of Saragossa* (Royal Collection, London), Goya's *What Courage (Desastros)*, Karoly Kisafuldy (d. 1830) *A Magyar* (Budapest, Hungarian National Museum).

24 T. J. Clark, *The Absolute Bourgeois*, p. 25.

25 Now lost but reproduced in ibid.

26 Quoted Clark, ibid., pp. 25–6.

27 M. Agulhon, *Marianne into Battle: Republican Imagery and Symbolism in France 1789–1880*, trans. J. Lloyd, Cambridge, 1981, p. 65.

28 D. Bellos, 'On Interpretation: Delacroix's La Liberté', unpublished paper (Edinburgh 1982), p. 4.

29 Author's translation. Gustave Planche, as Adhémar points out ('La Liberté sur les Barricades de Delacroix'), argued that the picture's grey tone derived from the terrible dust of the struggle. The quotations come from Ambroise Tardieu and from an anonymous review in *La Tibune*. Hadjinicolaou gives an extremely detailed account of the pejorative comments of critics and points out how these have been suppressed by art historians (Hadjinicolaou, '"La Liberté guidant le peuple"', pp. 22–4).

30 The poem 'La Curée' (the rush from spoils) was published in Barbier's *Iambes*. It is also quoted by Agulhon, *Marianne into Battle*, p. 40. Author's translation.

31 Hadjinicolaou, '"La Liberté guidant le peuple"', p. 25.

32 T. J. Clark, *The Painting of Modern Life: Paris in the Art of Manet and his Followers*, London, ch. 2.

33 D. Bellos, 'On Interpretation'.

34 M. Douglas, *Purity and Danger, an Analysis of the Concept of Pollution and Taboo* (1966), London and Boston, 1984, p. 35.

35 E. Hobsbawm, 'Man and Woman', p. 124.

36 M. Rose, *Marx's Lost Aesthetic. Karl Marx and the Visual Arts*, Cambridge (1984), 1988, pp. 18–23.

37 E. Hobsbawm, 'Man and Woman', p. 127.

38 S. Alexander, A. Davin and E. Hostettler, 'Labouring Women: A Reply to Eric Hobsbawm', *History Workshop Journal*, 8, 1979.

39. M. Agulhon, *Marianne into Battle*, p. 18.

40 In his reply to Hobsbawm, *History Workshop Journal*, 8, 1979, p. 168, and *Actes de la Recherche en Sciences sociales*, 28, Agulhon states: 'a dichotomy between the explicit significance of a painting and the implicit significance of formal beauty, exists in all works of art, and does not by itself allow a painting to be labelled as erotic, for otherwise all myth and

allegory would be so.' An interesting and perceptive critique of Agulhon is to be found in A. Rifkin, 'The Sex of French Politics', *Art History*, Sept. 1983.

41 N. Hadjinicolaou, '"La Liberté guidant le peuple"', p. 25.

42 T. J. Clark, *The Absolute Bourgeois*, p. 18.

43 B. Brown and P. Adams, 'The Feminist Body and Feminist Politics', *M/F*, 3, 1979; an interesting recent attempt to explore this question is to be found in D. Outram, *The Body and the French Revolution: Sex, Class and Political Culture*, New Haven CT and London, 1989, ch. 8, 'Words and Flesh: Mme Roland, the Female Body and the Search for Power'.

44 B. Brown and P. Adams, 'The Feminist Body', p. 35.

45 The most interesting discussion of this subject (along with a great deal of imagery inadequately documented) is to be found in K. Theweleit, *Male Fantasies*, vol. 1 (1977), trans. S. Conway *et al.*, Oxford, 1987.

46 S. Ringborn compares Delacroix's *Liberty* and Guérin's *Iris and Morpheus* in 'Guérin, Delacroix and "The Liberty"', *Burlington Magazine*, 1968, pp. 270–4. It does seem extraordinary that these works can be compared for their formal similarities without their enormous differences in colour and handling being signalled.

47 See, for example, Guérin's *Henry de Rochejaquelin* (Salon of 1817), Municipal Museum, Cholet.

48 As, for example, with Léopold Robert, *The Arrival of the Harvest Waggon*, 1830, Paris: Musée de Louvre.

49 D. Bellos, 'On Interpretation', p. 3.

50 D. Cherry and G. Pollock, 'Woman as Sign in Pre-Raphaelite Literature: A Study of the representation of Elizabeth Siddall', *Art History*, June 1984.

51 The reference to Bicêtre is Auguste Jal's, quoted by Hadjinicolaou, '"La Liberté guidant le peuple"'; Adhémar, 'La Liberté sur les Barricades de Delacroix', quotes Maxime du Camp's criticism of the picture when it was exhibited at the 1855 Exposition Universelle: 'Non, non, il n'y a rien de commun entre la vierge immortelle et féconde que nous adorons et cette drolesse echappée de Saint-Lazare' (No, no, there is nothing in common between the immortal and fecund virgin whom we adore and this hussy escaped from St Lazare).

52 M. Foucault, *The History of Sexuality*, vol. 1, *An Introduction*, trans. R. Hurley, Harmondsworth, 1978.

53 Illustrated in K. Theweleit, *Male Fantasies*, p. 200. The cartoon is inscribed 'PRENKI DO GURE' which cannot be identified wth any Slav language. Timothy J. Reiss has kindly informed me that 'Reci do Gory' would mean 'Hands up!' in Polish (thus offering a sexual pun). There may also be a play on the Polish word 'Pret' (pronounced 'pryent') meaning something stick- or cable-like. Theweleit offers no explanation for the inscription.

54 N. Bryson, *Tradition and Desire*, Cambridge, 1984, ch. 3.

55 Marina Warner alone has acknowledged the significance of this figure (*Monuments and Maidens*, p. 272) but treats it chiefly at an iconographic level.

56 Reproduced in J. Root, *Pictures of Women*, London and Boston, 1984, p. 62.

57 L. Steinberg, *The Sexuality of Christ in the Renaissance and Modern Oblivion*, New York, 1983.

58 J. L. E. Meissonier, *La Barricade, rue de la Mortellerie* (Salon of 1851), Paris: Musée d'Orsay; E. Manet, *La Barricade*, 1871, lithograph.

59 C. Baudelaire, *Eugène Delacroix, His Life and Work*, ed. S. J. Freedberg, New York and London, 1979.

60 N. M. Athanassoglou-Souyoudjoglou in *French Images from the Greek War of Independence 1821–1827: Art and Politics under the Restoration*, Ann Arbor MI, 1980, p. 115, points out the connection between Delacroix's painting of *Greece* and the 1825 French translation of 'Dithyrambe sur la Liberté' by the Greek poet Dionysios solomos.

61 L. Johnson, *The Paintings of Eugène Delacroix*, no. 98.

62 P. Kamuf, *Signature Pieces. On the Institution of Authorship*, Ithaca NY and London, 1988, pp. 12–13.

4 Biography and the body in late Renoir

1 The Brassai is reproduced in G. Saunders, *The Nude: A New Perspective*, London, 1989, p. 112. Matisse frequently participated in constructions of this kind. See, for example, the photograph on the cover of the Arts Council catalogue, *Henri Matisse. Drawings*, London: Hayward Gallery, 1985 and the photography by Hélène Adant reproduced on p. 162 of J. Russell, *The World of Matisse*, Time Life, Amsterdam, 1972 showing Matisse at work in a wheelchair watched by one of his models.

2 A. Durer, *Draughtsman Drawing a Nude* from *Unterweysung der Messung*, Nuremberg, 1538.

3 Quoted by T. J. Clark, *The Painting of Modern Life: Paris in the Art of Manet and his Followers*, London, 1984, p. 128.

4 See A. Corbin, *The Foul and the Fragrant: Odor and the French Social Imagination*, (1982) Leamington Spa, Hamburg and New York, 1986, p. 37 for examples, including that of the artist J. L. David.

5 See, for example, K. Wheldon, *Renoir and His Art*, 1978, p. 107.

6 It is possible that the act of painting and exhibiting depictions of whole and wholesome bodies was a part of the artist's attempted self-healing. There is evidence that Renoir, who devised a great many exercises to try to keep his fingers sufficiently supple to be able to paint, was interested in therapeutic practices. An interesting exploration of the connections between painting and health is to be found in S. Schoenbaum, 'The Challenge of Loss', *Art and Text*, April 1985, p. 92.

7 J. Renoir, *Renoir, My Father* (1958), trans. R. & D. Weaver, London, 1962, p. 399, p. 401.

8 Ibid., p. 403.

9 See, for example, J. Tagg, *The Burden of Representation. Essays on Photographic Histories*, London, 1988.

10 P. Lejeune, *Je est un autre: l'autobiographie de la littérature aux médias*, Paris, 1980, p. 7 speaks of the apparent deregulation that is produced by Rimbaud's formulation 'Je est un autre'. Not the banal 'Je suis un autre' nor the incorrect 'je est un autre' but 'Je est un autre'. What Je? And other than whom?

11 J. Renoir, *Renoir*; J. Manet, *Journal 1893–1899*, Paris, 1979.

12 W. Pach, *Renoir*, New York, 1950, p. 22.

13 T. Duret, *Renoir* (1924), trans. M. Boyd, New York, 1937, p. 16.

14 J. House, 'Renoir's worlds', in Arts Council, *Renoir*, London: Hayward Gallery, Paris: Grand Palais, and Boston: Museum of Fine Arts, 1985–6, p. 12.

15 See particularly C. Bernheimer and C. Kahane, *In Dora's Case, Freud–Hysteria–Feminism*, London, 1985.

16 L. Irigaray, *This Sex which is not One* (1977), trans. C. Porter with C. Burke, Ithaca NY, 1985, p. 26.

17 G. Albert Aurier, 'L'Impressionisme', *Oeuvres posthumes*, ed. Rémy de Gourmont, 1893, p. 228. I am grateful to Juliet Simpson for drawing my attention to this passage.

18 P. de Man, 'Autobiography as Defacement', in *The Rhetoric of Romanticism*, New York, 1984, p. 70.

19 Ibid., p. 69.

20 J. Derrida, *The Post Card: From Socrates to Freud and Beyond* (1980), trans. A. Bass, Chicago and London, 1987, p. 322.

21 See K. Adler, 'Reappraising Renor', *Art History*, September 1985, p. 378 and articles by Tamar Garb, John House, Fred Orton and Desa Philippi in *The Oxford Art Journal*, 8:2, 1985.

22 *Revue de l'Art*, November 1899, pp. 50–1.

23 A. Lunacharsky, *On Literature and Art* (1933), USSR, 1973, p. 298.

24 Arts council, *Renoir*, pp. 106–7.

25 J. Renoir, *Renoir*, pp. 185, 207.

26 T. Garb, 'Reviewing Renoir', *Oxford Art Journal*, 8:2, 1985, p. 2.

27 A. Corbin, *The Foul and the Fragment*, p. 175. Eunice Lipton has considered the iconography of the bathtub in the work of Degas in relation to signifiers of prostitution. E. Lipton, *Looking into Degas. Uneasy Images of Women and Modern Life* (1986), Berkeley and Los Angeles, 1988, pp. 164–78. Renoi'rs bathers indicate that there is no simple analogue between class, profession and cleanliness in nineteenth-century Paris.

28 Ibid., pp. 154–6.

29 Arts Council, *Renoir*.

30 W. Januszczak, 'The Sweet Smell of Success: A Contemporary View of Pierre Auguste Renoir 1841–1919', *Connoisseur*, October 1985, p. 129.

31 I take as my example here the version in an unlocated private collection in Japan. The painting measures 81.3 × 101 cm and formerly belonged to Charles Laughton.

32 J. Renoir, *Renoir*, p. 203.

33 Ibid., p. 315 and Arts Council, *Renoir*, no. 108.

34 J. Held 'Rubens' "Het Pelsken"', in *Essays in the History of Art presented to Rudolf Witkower*, 1967, pp. 188–92.

35 K. Wheldon, *Renoir and his Art*, p. 106.

36 All four *Tannhauser* paintings are in private collections. See F. Daulte, *Auguste Renoir: Catalogue Raisonné de l'oeuvre peint, 1860–1890*, Lausanne, 1971, nos. 315–18.

37 J. Manet, *Journal*, p. 230.

38 Reproduced in K. Wheldon, *Renoir and his Art*. Jean Renoir records his father as saying he loved women before he learned to walk and says that he talked incessantly about his mother. Jean anxiously insists that this was no 'oeidipus complex' and that his father was the most normal of children just as he was to be the 'most normal of men'. But later Jean suggests, perhaps as a response to the late nudes, that 'the feelings aroused in him by a woman's body were perhaps associated with the idea of maternity' (J. Renoir, *Renoir*, pp. 80, 185).

39 G. Albert Aurier, 'L'impressionisme'.

40 J. Kristeva, 'Females who can Wreck the Infinite', in *Powers of Horror. An Essay on Abjection* (1980), trans. L. S. Roudiez, New York, 1982, pp. 158–9.

41 J. Kristeva, 'Approaching Abjection', p. 6.

42 J. Kristeva, 'Motherhood according to Giovanni Bellini' in J. Kristeva, *Desire in Language. A Semiotic Approach to Literature and Art* (1977), trans. T. Gora, A. Jardine and L. S. Roudiez, Oxford, 1984, p. 242.

43 Ibid., pp.237–8.

44 S. Reud, 'The Theme of the Three Caskets' (1913), *The Standard Edition of the Complete Psychological Works of Sigmund Freud*, London, 1958, vol. XII.

45 Offenbach makes her so in *La Belle Hélène*; he was Renoir's favourite composer but the artist was also a great admirer of Wagner and so would have known the Valkyries.

5 Interior portraits

1 C. Duncan, 'Virility and Domination in Early Twentieth-Century Vanguard Painting', in N. Broude and M. Garrard, eds., *Feminism and Art History: Questioning the Litany*, New York and Toronto, 1982, p. 298.

2 S. Sontag, 'The Image World', in *A Susan Sontag reader* (1982), Harmondsworth, 1983, p. 356.

3 J. Weeks, *Sex, Politics and society: The Regulation of Sexuality since 1800*, London and New York, 1981.

4 For a particularly acute analysis of how representation functions in this way, see L. J. Jordanova, 'Gender, Generation and Science: William Hunter's Obstetric Atlas', in W. F. Bynum and R. Porter, eds., *William Hunter and Medicine in the Englightenment*, Cambridge, 1985.

5 Jules Michelete's journal, 18 June 1849, quoted in J.-P. Aron, ed., 'Une Gynocologie passioné', *Misérable et glorieuse, la femme du XIX^e siecle*, Paris, 1980, pp. 157–8.

6 The word used is *pavillon* which means literally a gate-lodge or canopy.

7 R. Barthes, *Michelet* (1954), trans. R. Howard, 1987.

8 L. Irigaray, *This Sex which is not One* (1977), trans. C. Porter and C. Burke, Ithaca NY, 1985, p. 25.

9 Ibid., p. 26.

10 Maxime du Camp, quoted by F. Haskell, 'A Turk and his Pictures in Nineteenth-Century Paris', *Oxford Art Journal*, 5:1, 1982, pp. 41–2; The precise identification of this painting and the appropriate way of describing it in words remain the subject of intense controversy among art historians. See, for example, *Les Réalismes et l'histoire de l'art*, colloque de l'Université de Besançon, mai 1978, in *Histoire et critiques des arts*, 45, May 1978, pp. 107–8.

11 R. Parker and G. Pollock, *Old Mistresses: Women, Art and Ideology*, London, 1981, pp. 119–21.

12 W. Andersen, *Gaugin's Paradise Lost*, London, 1972.

13 As far as I know no such analysis has been attempted elsewhere. D. H. Fraser (*Gauguin's Vision after the Sermon*, London, 1969), discusses the painting in terms of Jungian/Freudian dream analysis; V. Jirat-Wasintynski ('Paul Gauguin's Self-Portraitsa dn the Oviri: The Image of the Artist, Eve and the Fatal Woman', *Art Quarterly*, 2, Spring 1979) offers an elaborate interpretation of Gauguin's self-portraits in which he suggests that Gauguin in his role as creative artist identified with the role of Even, 'that is of woman as consenting victim in the creation of new life', but does not mention *The Vision after the Sermon*.

14 Genesis, 32:22–32.

15 R. Barthes, 'The Struggle with the Angel', in *Image Music Text*, Essays selected and translated by Stephen Heath (1977), London, 1982, p. 140.

16 D. H. Fraser, *Gaugin's Vision after the Sermon*, p. 25.

17 J. Kristeva, 'Semiotics of Biblical Abomination', in *Powers of Horror. An Essay on Abjection* (1980), trans. L. S. Roudiez, New York, 1982, p. 96.

18 S. Freud, 'The Taboo of Virginity' (1918), Pelican Freud Library vol. VII, *Sigmund Freud on Sexuality*, Harmondsworth, 1983, p. 281. For a discussion of the origins of this view see J. Mitchell, *Psychoanalysis and Feminism* (1972), Harmondsworth, 1984, p. 123.

19 It is worth noting here that the recorded events of Gauguin's life suggest a powerful preoccupation with the mother. Gauguin's mother, Aline Chazal Gauguin, was the daughter of Flora Tristan.

20 E.g. J. H. Plumb, 'The Victorians Unbuttoned', *Horizon*, Autumn 1969.

21 M. Bennett, entry in *The Pre-Raphaelites*, London: Tate Gallery, 1984, p. 34.

22 H. Wilson, quoted in ibid.

23 See L. J. Jordanova, 'Gender, Generation and Science'.

24 'Death's Duell', *The sermons of John Donne*, vol. , ed. G. R. Potter, Berkeley and Los Angeles, 1962, pp. 231–2.

25 *Ben Jonson. The Complete Poems*, ed. G. Parfitt, Harmondsworth, 1975, p. 212.

26 S. Beckett, *Waiting for Godot* (1955), London, 1965, act 2.

27 J. Kristeva, 'Approaching Abjection', p. 14.

28 Freud has made us familiar wth this relationship, particularly through his case studies of Little Hans and the Rat Man.

29 *The Diary of Ford Madox Brown*, ed. V. Surtees, New Haven CT and London, 1981.

6 Guess who's coming to lunch?

1 T. J. Clark, 'Preliminaries to a possible Treatment of "Olympia" in 1865', *Screen*, 21, Spring 1980. I owe the title of this chapter to John House's witty question.

2 G. Mauner, *Manet, Peintre-Philosophe*, Pennsylvania, 1975, ch. 2.

3 A. Proust, *Edouard Manet, Souvenirs*, 1913, p. 43.

4 A phenomenon explored in an overall way by Marina Warner in *Monuments and Maidens. The Allegory of the Female Form* (1985), London, 1987.

5 W. Aglionby, *Painting Illustrated in Three dialogues...*, London, 1685, 'An Explanation of some Terms of the Art of Painting'.

6 P. Jamot, Extraits de *l'Introduction au catalogue de l'exposition Manet*, Musée de l'Orangerie, 1932, in P. Cailler, ed., *Manet raconté par lui-même et par ses amis*, 1953, p. 198.

7 C. Baudelaire, Salon of 1859, in *Art in Paris 1845–62. Salons and other Exhibitions reviewed by Charles Baudelaire* (1965), trans. and ed. J. Mayne, Oxford, 1981, p. 168.

8 O. Redon, *A Soi Même*, journal (1867–1915), trans. E. G. Holt in *From the Classicists to the Impressionists: Art and Architecture in the Nineteenth Century, A Documentary History of Art*, vol. III, New York, 1966, pp. 493–4; It is interesting to notice that, as Nochlin points out (S. Faunce and L. Nochlin, *Courbet Reconsidered*, New Haven CT and London, 1988, p. 26), Durer's *Melancholia* can be figured 'as the mother of allegory as it has been interpreted for our times' and lies at the centre of Wlater Benjamin's *Trauerspiel* (W. Benjamin, *The Origin of German Tragic Drama* (1928), trans. J. Osborne, 1977.

9 See A. Boime, *The Academy and French Painting in the Nineteenth Century*, London and New York, 1971, p. 181 passim.

10 G. Coubet, Letter to a group of students, first published in *Le Courrier du dimanche*, 29 December 1861, reprinted in translation in E. G. Holt, *From the Classicists to the Impressionists*, New York, 1966, pp. 351–3.

11 This complexification of genre might be said to compare with the ambiguous position occupied by Ingres in relation to academic theory and explored by Adrian Rifkin in 'Ingres and the Academic Dictionary: An Essay on the Ideology and Stupefaction in the Social Formation of the Artist', *Art History*, 6:2, June 1983. Jean Clay's comment (in 'Ointments, Makeup, Pollen', *October*, 27, Winter 1983) that Manet 'makes a nature out of culture' (p. 5) and Françoise Cachin's observation that Manet reverses the operation to be performed in the studio according to school doctrine, and transforms the ideal into the real (*Manet*, Paris and New York, 1983, p. 170), while noteworthy, fail to recognise the subversive nature of such a practice.

12 *The Salon of 1846*, reprinted in *Art in Paris 1845–1862, Salons and other Exhibitions reviewed by Charles Baudelaire*, trans. J. Mayne, Oxford, 1965, p. 119.

13 *The Mirror of Art, Critical Studies by Charles Baudelaire*, trans. and ed. J. Mayne, ????, 1955, pp. 37–8, quoted in B. Farwell, 'A Manet Masterpiece Reconsidered', *Apollo*, 78, 1963, p. 47.

14 I would, however, affirm the importance at the time of publication (and prior to the relocation of works in the Musée d'Orsay) of T. J. Clark's examination of the Salon nudes of Cabanel, Baudry, Bouguereau and others. T. J. Clark, *The Painting of Modern Life, Paris in the Art of Manet and his Followers*, London, 1984, pp. 117–30.

15 S. Faunce and L. Nochlin, *Courbet Reconsidered*, p. 37.

16 Although Mauner, *Manet*, suggests a source for the second woman in Raphael's St John in *The Miraculous Draught of Fishes*, he does not account for the change of gender between the two texts. In the case of the major group, which it has long been recognised, derives from Raimondi after Raphael, *The Judgement of Paris* and from Giorgione's *Concert Champêtre* in the Louvre, the gender relationships remain the same.

17 S. Faunce and L. Nochlin, *Courbet Reconsidered*, p. 34.

18 G. M. Ackerman, *The Life and Work of Jean-Léon Gerôme*, London and New York, 1986, no. 424.

19 L. Nochlin, 'Courbet's Real Allegory: Rereading "The Painter's Studio"' in . Faunce and L. Nochlin, *Courbet Reconsidered*.

20 See M. Fried, 'Representing Representation: On the Central Group in Courbet's "Studio"', in S. J. Greenblatt, ed., *Allegory and Representation*, London, 1981.

21 L. Nochlin in S. Faunce and L. Nochlin, *Courbet Reconsidered*, pp. 31–2.

22 Nochlin adopts Benjamin, Eagleton and Jameson on allegory. This chapter was written in its first form before Nochlin's essay became available to me. While I find interesting her formulation of allegory as a (hopeless) attempt to restore continuity, one which ultimately only serves to emphasise the gaps between meaningsand things (ibid., pp. 22–3), I think this account (derived from literary models) misses both the disruptive role that allegory can play in visual form (demanding forms of recognition based on iconographic encoding and simultaneously inviting misrecognition) and the function of the body in allegorical narration.

23 Mauner, *Manet*.

24 A. C. Hanson, *Manet and the Modern Tradition*, New Haven CT and London, 1977.

25 Ibid., p. 75.

26 R. Fowler, *A Dictionary of Modern Critical Terms*, London, 1973.

27 W. Benjamin, *The Origin of German Tragic Drama*, p. 166.

28 Benjamin notes that in allegory 'the observer is confronted with *facies hippocratica* of history as a petrified primordal landscape?' Ibid., p. 166.

29 In 1867 he wrote: 'understandably the nude woman in *Le Déjeuner* is only there to provide the artist with an opportunity to paint a piece of flesh', reprinted in G. H. Hamilton, *Manet and his Criticis* (1954), New Haven CT and London, 1986, p. 97.

30 W. Benjamin, *The Origin of German Tragic Drama*, p. 175 observes that 'Considered in allegorical terms ... the profane world is both elevated and devalued. This religious dialectic of content has its formal correlative in the dialectic of convention and expression. For allegory is both: convention *and* expression; and both are inherently contradictory.'

31 L. Nochlin, 'Courbet's Real Allegory', p. 21.

32 W. Andersen, 'Manet and the Judgement of Paris', *Art News*, February 1973, 72·2, pp. 63–9.

33 Staged by the Royal Shakespeare Company at the Barbican Theatre, London, 1988.

34 R. Barthes, *The Pleasure of the Text* (1975), trans. R. Miller, London, 1976, p. 10.

35 It was first put forward by Zola in his article on Manet in the *Revue du XIX^e siècle* in 1867, see G. H. Hamilton, *Manet and his Critics*, p. 97.

36 J. Baudrillard, 'On Seduction', in *Jean Baudrillard: Selected Writings*, ed. M. Poster, Oxford, 1988, p. 150.

37 G. Bataille, *Manet*, trans. A. Wainhouse and J. Emmons, New York, 1955, p. 74.

38 T. J. Clark, *The Painting of Modern Life*, pp. 48, 95.

39 The popularity of *Les Liaisons Dangéreuses*, staged by the Royal Shakespeare Company in 1987 and now filmed, might be taken to illustrate this point; Jane Gallop's article 'Annie Leclerc, reading a letter with Vermeer', *October*, 33, Summer 1985, contains an interesting introductory discussion of this question.

40 C. Baudelaire, *The Mirror of Art*.

BIBLIOGRAPHY

Ackerman, G. M., *The Life and Work of Jean-Léon Gérôme*, London and New York, 1986.

Adhémar, H., 'La Liberté sur les Barricades de Delacroix', *Gazette des Beaux-Arts*, 43, 1954.

Adler, K., 'Reappraising Renoir', *Art History*, Sept. 1985.

Aglionby, W., *Painting Illustrated in Three Dialogues...*, London, 1685.

Agulhon, M., *Marianne into Battle: Republican Imagery and Symbolism in France 1789–1880*, trans. J. Lloyd, Cambridge, 1981.

Alexander, S., Davin, A. and Hostettler, E., 'Labouring Women: a reply to Eric Hobsbawm', *History Workshop Journal*, 8, 1979.

Andersen, W., *Gauguin's Paradise Lost*, London, 1972.

'Manet and the Judgement of Paris', *Art News*, Feb. 1973.

Armstrong, C., 'Edgar Degas and the Representation of the Female Body', in S. Suleiman, ed., *The Female Body in Western Culture. Contemporary Perspectives*, Cambridge, MS and London, 1986.

Aron, J. P., ed., *Miserable et glorieuse, la femme du XIXᵉ siècle*, Paris, 1980.

Arts Council, *Henri Matisse. Drawings*, London: Hayward Gallery, 1985.

Renoir, London: Hawyward Gallery; Paris: Grand Palais; Boston: Museum of Fine Arts, 1985–6.

Athanassoglou-Souyoudjoglou, N. M., *French Images from the Greek War of Independence 1821–1827: Art and Politics under the Restoration*, Ann arbor MI, 1980.

Aurier, G. A., 'L'Impressionisme', *Oeuvres Posthumes*, ed. Rémy de Gourmont, Paris, 1893.

Barrell, J., *The Dark Side of the Landscape: The Rural Poor in English Painting 1730–1840*, Cambridge, 1980.

Barthes, R., *Image Music Text*, Essays selected and translated by Stephen Heath (1977), London, 1982.

Michelet (1954), trans. R. Howard, Oxford, 1987.

The Pleasure of the Text (1975), trans. R. Miller, London, 1976.

Bataille, G., *Manet*, trans. A. Wainhouse and J. Emmons, New York, 1955.

M. Baxandall, *Painting and Experience in Fifteenth Century Italy. A Primer in the Social History of Pictorial Style*, Oxford, 1972.

Baudelaire, C., *Art in Paris 1845–62, Salons and other Exhibitions reviewed by Charles Baudelaire*, trans. and ed. J. Mayne (1965), Oxford, 1981.

Eugene Delacroix, His Life and Work, ed. S. J. Freedberg, New York and London, 1979.

Baudrillard, J., *For a Critique of the Political Economy of the sign*, trans. C. Levin, St. Louis MO, 1981.

BIBLIOGRAPHY *Jean Baudrillard: Selected Writings*, ed. M. Poster, Oxford, 1988.

Beckett, S. *Waiting for Godot* (1955), London, 1965.

Bell, C., *The Anatomy and Philosophy of Expression as connected with the Fine Arts* (1806), 7th edn, revised, London, 1886.

Benhabib, S., and Cornell, D., eds., *Feminism as Critique. Essays on The Politics of Gender in Late-Capitalist societies*, Oxford, 1987.

Ben Johnson. The Complete Poems, ed. G. Parfitt, Harmondsworth, 1975.

Benjamin, W., *The Origin of German Tragic Drama* (1928), trans. from the German version of 1963 by J. Osborne, London, 1977.

Berger, J., *Ways of Seeing*, Harmondsworth, 1972.

Bernheimer, C. and Kahane, C., *In Dora's Case, Freud–Hysteria–Feminism*, London, 1985.

Boime, A., *The Academy and French Painting in the Nineteenth Century*, London and New York, 1971.

Brown, B. and Adams, P., 'The Feminist Body and Feminist Politics', *M/F*, 3, 1979.

Bryson, N., *Tradition and Desire*, Cambridge, 1984.
 Vision and Painting: The Logic of the Gaze, London, 1983.

Bullen, J. B., ed., *The Sun is God: Painting, Literature and Mythology in the Nineteenth Century*, Oxford, 1989.

Burgin, V., *The End of Art Theory: Criticism and Postmodernity*, London, 1986.

W. F. Bynum and R. Porter, eds., *Medicine and the Five Senses*, Cambridge, forthcoming.

Cachin, F., *Manet*, Paris and New York, 1983.

Cailler, P., ed., *Manet raconté par lui-même et par ses amis*, Paris, 1953.

Calvino, I., *Collezione di Sabbia*, Milan, 1984.

Casteras, S., *Images of Victorian Womanhood in English Art*, Cranbury NJ, London and Mississauga, 1987.

Castiglione, B., *The Book of the Courtier* (1528), trans. G. Bull, Harmondsworth, 1967.

Cherry, D. and Pollock, G., 'Woman as Sign in Pre-Raphaelite Literature: A Study of the Representation of Elizabeth Siddall', *Art History*, June 1984.

Clark, K., *The Nude: A Study of Ideal Art* (1956), Harmondsworth, 1960.

Clark, T. J., *The Absolute Bourgeois: Artists and Politics in France 1848–51*, London, 1973.
 'Preliminaries to a Possible Treatment of "Olympia" in 1865', *Screen*, 21, Spring 1980.
 The Painting of Modern Life, Paris in the Art of Manet and his Followers, London, 1984.

Clay, J., 'Ointments, Makeup, Pollen', *October*, Winter 1983.

Corbin, A., *The Foul and the Fragrant: Odor and the French Social Imagination* (1982), trans. M. L. Kochan, Leamington Spa, Hamburg and New York, 1986.

Culler, J., *On Deconstruction: Theory and Criticism after Structuralism*, London, 1983.

Dali, S., *The Tragic Myth of Millet's The Angelus*, Paris, 1963.

Daulte, F., *Auguste Renoir: Catalogue Raisonné de l'Oeuvre Peint, 1860–1890*, Lausanne, 1971.

Davis, N., 'Women on Top: Symbolic Sexual Inversion and Political Disorder in Early Modern Europe', in B. A. Babcock, ed., *The Reversible World. Symbolic Inversion in Art and Society*, Ithaca NY and London, 1978.

Deleuze, G. and Guattari, F., *Anti-Oedipus: Capitalism and Schizophrenia* (1972), London, 1954.

Derrida, J., *The Post Card: From Socrates to Freud and Beyond* (1980), trans. A. Bass, Chicago and London, 1987.

Writing and Difference (1978), London, 1981.

Doane, M. A., 'Film and the Masquerade: Theorising the Female Spectator', *Screen*, 23, 1982.

Donne, John, 'Death's Duell', *The Sermons of John Donne*, vol. x, ed. G. R. Potter, Berkeley and Los Angeles, 1962.

Douglas, M., *Purity and Danger. An Analysis of the Concept of Pollution and Taboo* (1966), London and Boston, 1984.

Duncan, C., 'Virility and Domination in Early Twentieth-Century Vanguard Painting', in N. Broude and M. Garrard, eds., *Feminism and Art History: Questioning the Litany*, New York and Toronto, 1982.

Duret, T., *Renoir* (1924), trans. M. Boyd, New York, 1937.

Encyclopaedia Britannica, Cambridge, 1911.

Epstein, J. L., 'Writing the Unspeakable: Fanny Burney's Mastectomy and the Fictive Body', *Representations*, Fall, 1986.

Farwell, B., 'A Manet Masterpiece Reconsidered', *Apollo*, 78, 1963.

Faunce, S. and Nochlin, L., *Courbet Reconsidered*, New Haven CT and London, 1988.

Flint, K., 'Moral Judgement and the Language of English Art Criticism 1870–1910', *The Oxford Art Journal*, 6:2, 1983.

Foucault, M., *Language, Counter-Memory, Practice. Selected Essays and Interviews*, ed. D. Bouchard, Ithaca NY, 1977.

Power/Knowledge. Selected Interviews and other Writings 1972–1977, ed. C. Gordon (1980), Worcester, 1988.

The History of Sexuality, vol. 1, *An Introduction*, trans. R. Hurley, Harmondsworth, 1978.

Fowler, R., *A Dictionary of Modern Critical Terms*, London, 1973.

Fraser, D. H., *Gaugin's Vision after the Sermon*, London, 1969.

Freud, S., 'Fetishism' (1927), *Sigmund Freud on Sexuality*, Pelican Freud Library, vol. vii, Harmondsworth, 1983.

'Leonardo da Vinci and a Memory of his Childhood' (1910) and 'The Moses of Michelangelo' (1914), *Sigmund Freud: Art and Literature*, Pelican Freud Library, vol. xiv, Harmondsworth, 1985.

'The Theme of the Three Caskets' (1913), *The Standard Edition of the Complete Psychological Works of Sigmund Freud*, 1958, vol. xii.

Fried, M., *Absorption and Theatricality: Painting and the Beholder in the Age of Diderot*, Berkeley and Los Angeles, 1980.

Realism, Writing, Disfiguration. On Thomas Eakins and Stephen Crane, Chicago, 1987.

'Representing Representation: on the Central Group in Courbet's "Studio"', in S. Greenblatt, ed., *Allegory and Representation*, London, 1981.

Friedlander, M. J., *On Art and Connoisseurship* (1942), London, 1943.

Frosh, S., *The Politics of Psychoanalysis: An Introduction to Freudian and Post-Freudian Theory*, London, 1987.

Fuller, P., *Art and Psychoanalysis*, London, 1980.

Seeing Berger. A Revaluation of Ways of Seeing, London, 1980.

Gallop, J., 'Annie Lecler, Reading a Letter with Vermeer', *October*, Summer 1985.

Garb, T., 'Reviewing Renoir', *Oxford Art Journal*, 8:2, 1985.

BIBLIOGRAPHY Gay, P., *Freud for Historians*, New York and Oxford, 1985.

Ginzburg, C., *The Enigma of Piero della Francesca* (1981), trans. M. Ryle and K. Soper, London, 1985.

Gombrich, E. H., 'Psychoanalysis and the History of Art', in *Meditations on a Hobby Horse* (1963), London and New York, 1971.

The Story of Art (1949), London, 1984.

Goodrich, L., *Thomas Eakins*, Cambridge, MA and London, 1982.

Guthrie, D., *A History of Medicine* (1945), Edinburgh, London and Paris, 1947.

Hadjinicolaou, N., 'Disarming 1830: A Parisian Counter-Revolution', *Block*, 4, 1981.

'"La Liberté guidant le peuple" de Delacroix devant son premier plan', *Actes de la Recherche en Science sociales*, June 1979.

Hamilton, G. H., *Manet and his Critics* (1954), New Haven CT and London, 1986.

'The Iconographical Origins of Delacroix's Liberty', in *Studies in Art and Literature for Bel da Costa Greene*, Princeton NJ, 1984.

Hanson, A. C., *Manet and the Modern Tradition*, New Haven CT and London, 1977.

Hartman, G. ed., *Psychoanalysis and the Question of the Text*, Baltimore and London, 1978.

Haskell, F., 'A Turk and his Pictures in Nineteenth-Century Paris', *Oxford Art Journal*, 5:1, 1982.

Heath, S., 'Lessons from Brecht', *Screen*, 17:4, 1976.

Held, J., 'Rubens's "Het Pelsken"' (1967), in A. W. Lowenthal et al., eds., *Rubens and his circle. Studies by Julius Held*, Princeton NJ, 1982.

Hobsbawm, E., 'Man and Woman in Socialist Iconography', *History Workshop Journal*, 6, Autumn 1978.

Hofmann, W., 'Sur la "Liberté" de Delacroix', *Gazette des Beaux-Arts*, September 1975.

Holt, E. G., *From the Classicists to the Impressionists: Art and Architecture in the Nineteenth Century, A Documentary History of Art*, vol. III, New York, 1966.

Honour, H. and Fleming, J., *A World History of Art* (1982), London, 1985.

Hood, W., 'The State of Research in Italian Renaissance Art', *Art Bulletin*, 69, 1987.

House, J., 'Renoir's Worlds', in Arts Council, *Renoir*.

Hudson, L., *Bodies of Knowledge: The Psychological Significance of the Nude in Art*, London, 1982.

Irigaray, L., *This Sex which is not One* (1977), trans. C. Porter and C. Burke, Ithaca NJ, 1985.

Jameson, F., *The Political Unconscious: Narrative as a Socially Symbolic Act*, London, 1981.

Jamot, P., Extraits de l'*Introduction au Catalogue de l'Exposition Manet*, Paris: Musee de l'Orangerie, 1932, Rpt in Cailler, P., ed., *Manet raconté*.

Januszczak, W., 'The Sweet Smell of Success: A Contemporary View of Pierre Auguste Renoir 1841–1919', *Connoisseur*, October 1985.

Jardine, A. and Smith, D., eds., *Men in Feminism*, New York, 1987.

Jencks, C., *Post-Modernism. The New Classicism in Art and Architecture*, New York, 1987.

Jirat-Wasintynski, 'Paul Gauguin's Self-Portraits and the Oviri: The Image of the Artist, Eve and the Fatal Woman', *Art Quarterly*, 1979.

Johns, E., *Thomas Eakins: The Heroism of Modern Life*, Princeton NJ, 1983.

Johnson, L., *The Paintings of Eugène Delacroix 1848–51. A Critical Catalogue*, Oxford, 1981.

Jordanova, L. 'Gender, Generation and Science: William Hunter's Obstetric Atlas', in W. F. Bynum and R. Porter, eds., *William Hunter and Medicine in the Enlightenment*, Cambridge, 1985.

'Probing Thomas Eakins', *Art History*, March 1988.

Sexual Visions. Images of Gender in Science and Medicine between the Eighteenth and the Twentieth Centuries, Hemel Mepstead, 1989.

Kamuf, P., *Signature Pieces: On the Institution of Authorship*, Ithaca NY and London, 1988.

Karlsruhe, Galerie im Prinz-Max-Palais, *Spitzweg. Schwind. Schleich*, 14 April–24 June 1984.

Kestner, J. A., *Mythology and Misogyny: The Social Discourse of Nineteenth-Century British Classical Subject Painting*, Madison WI and London, 1989.

Kris, E., *Psychoanalytic Explorations in Art*, New York, 1952.

Kristeva, J., *Powers of Horror. An Essay oon Abjection* (1980), trans. L. S. Roudiez, New York, 1982.

'Motherhood according to Giovanni Bellini', in *Desire in Language. A Semiotic Approach to Literature and Art* (1977), trans. T. Gora, A. Jardine and L. S. Roudiez, Oxford, 1984.

Kuhns, R., *Psychoanalytic Theory of Art*, New York, 1983.

Lacan, J., *Ecrits. A Selection* (1966), trans. A. Sheridan, London, 1977.

The Four Fundamental Concepts of Psychoanalysis (1973), trans. A. Sheridan, Harmondsworth, 1977.

LaCapra, D., 'History and Psychoanalysis', in F. Meltzer, ed., *The Trial(s) of Psychoanalysis* (1987), Chicago and London, 1988.

Lasky, M. J., '"Lady on the Barricades" (1.) Margit', *Encounter*, July 1972.

Leeks, W., 'Ingres Otherwise', *Oxford Art Journal*, 9:1, 1986.

Lejeune, P., *Je est un autre: l'autobiographie de la littérature aux médias*, Paris, 1980.

Les Réalismes et l'histoire de l'art in Histoire et critiques des arts, 45 (May 1978).

Lipton, E., *Looking into Degas. Uneasy Images of Women and Modern Life*, Berkeley and Los Angeles, 1986.

Lunacharsky, A., *On Literature and Art* (1965), USSR, 1973.

de Man, P., *The Rhetoric of Romanticism*, New York, 1984.

Manet, J., *Journal 1893–1899*, Paris, 1979.

Mauner, G., *Manet, Peintre-Philosophe*, Pennsylvania, 1975.

Mitchell, J., *Psychoanalysis and Feminism* (1972), Harmondsworth, 1984.

Mulvey, L., 'Visual Pleasure and Narrative Cinema', *Screen*, 16:3, Autumn 1975. Rpt in L. Mulvey, *Visual and Other Pleasures*, London, 1989.

'You don't know what is happening, do you, Mr. Jones?', *Spare Rib*, 8, 1973. Rpt in R. Parker and G. Pollock, eds., *Framing Feminism* and L. Mulvey, *Visual and Other Pleasures*.

Nead, L. 'Representation, Sexuality and the Female Nude', *Art History*, June 1983.

Ortner, S. B., 'Is Female to Male as Nature is to Culture?', in M. Rosaldo and L. Lamphere, eds., *Woman, Culture and Society*, Stanford, 1974.

Outram, D., *The Body and the French Revolution: Sex, Class and Political Culture*, New Haven and London, 1989.

Pach, W., *Renoir*, New York, 1950.

Pajkaczkowska, C., 'Structure and Pleasure', *Block*, 9, 1983.

Parker, R. and Pollocks, G., eds., *Framing Feminism: Art and the Women's Movement 1970–1985*, London and New York, 1987.

Old Mistresses: Women, Art and Ideology, London, 1981.

Paulson, R., *Literary Landscape: Turner and Constable*, New Haven and London, 1982.

Pevsner, N., *The Englishness of English Art*, London, 1955.

Pleynet, M., *Painting and System* (1977), trans. S. N. Godfrey, Chicago, 1984.

Plumb, J. H., 'The Victorians Unbuttoned', *Horizon*, Autumn 1969.

Pollock, G., *Vision and Difference: Femininity, Feminism and the Histories of Art*, London, 1988.

Porter, R., ed., *Patients and Practitioners*, Cambridge, 1985.

Proust, A., *Edouard Manet, Souvenirs*, Paris, 1913.

Redon, O., *A Soi Même*, journal (1867–1915) trans. E. G. Holt, in E. G. Holt, *From the Classicists to the Impressionists: Art and Architecture in The Nineteenth Century, A Documentary History of Art*, vol. III, New York, 1966.

Renoir, J., *Renoir, My Father* (1958), trans. R. and D. Weaver, London, 1962.

Rifkin, A., 'Ingres and the Academic Dictionary: An Essay on the Ideology and Stupefaction in the Social Formation of the Artist', *Art History*, 6:2, June 1983.

'Marx's Clarkism', *Art History*, December 1985.

'The Sex of French Politics', *Art History*, September 1983.

Ringborn, S., 'Guérin, Delacroix and "The Liberty"? *Burlington Magazine*, 1968.

Root, J., *Pictures of Women*, London and Boston, 1984.

Rorimer, A., *Drawings by William Mulready*, London: Victoria and Albert Museum, 1972.

Rose, M., *Marx's Lost Aesthetic. Karl Marx and the Visual Arts* (1984), Cambridge, 1988.

Russell, J., *The World of Matisse*, Amsterdam, 1972.

Said, E., 'Opponents, Audiences, Constituencies and Community', in H. Forster, ed., *Postmodern Culture*, London and Sydney, 1985.

Saunders, G., *The Nude: A New Perspective*, London, 1989.

Schapiro, M. 'Leonardo and Freud: An Art-Historical Study', *Journal of the History of Ideas*, 17, 1957.

Schoenbaum, S., 'The Challenge of Loss', *Art and Text*, April 1985.

Schor, N., *Reading in Detail: Aesthetics and the Feminine*, London, 1987.

Silverman, K., *The Acoustic Mirror*, Bloomington and Indianapolis, 1988.

Simons, P. 'Women in Frames', *History Workshop*, 25, Spring 1988.

Sontag, S. 'The Image World', *A Susan Sontag reader* (1982), Harmondsworth, 1983.

Steinberg, L., *The Sexuality of Christ in the Renaissance and Modern Oblivion*, New York, 1983.

Tagg, J., *The Burden of Representation. Essays on Photographies and Histories*, London, 1988.

The Diary of Ford Madox Brown, ed. V. Surtees, New Haven and London, 1981.

The Pre-Raphaelites, London: Tate Gallery, 1984.

The Princes Gate Collection, London: Coutauld Institute Galleries, 1981.

Theweleit, K., *Male Fantasies*, vol. I (1977), trans. S. Conway *et al.*, Oxford, 1987.

Tickner, L., 'Feminism, Art History, and Sexual Difference', *Genders*, 3, Fall 1988.

Toussaint, H., ed., *'La Liberté guidant le peuple' de Delacroix*, catalogue, Paris: Réunion des Musées Nationaux, 1982.

Warner, M., *Monuments and Maidens. The Allegory of the Female Form* (1985), London, 1987.

Weeks, J., *Sex, Politics and Society: the Regulation of Sexuality since 1800*, London and New York, 1981.

Wheldon, K., *Renoir and his Art*, London, 1978.

Wittkower, R. and M., *Born under Saturn*, New York, 1963.

Wolfflin, H., *Die klassiche Kunst* (1899), trans. as *Classic Art* (1952), London, 1959.